And I'm Glad

An Oral History
of Edisto Island

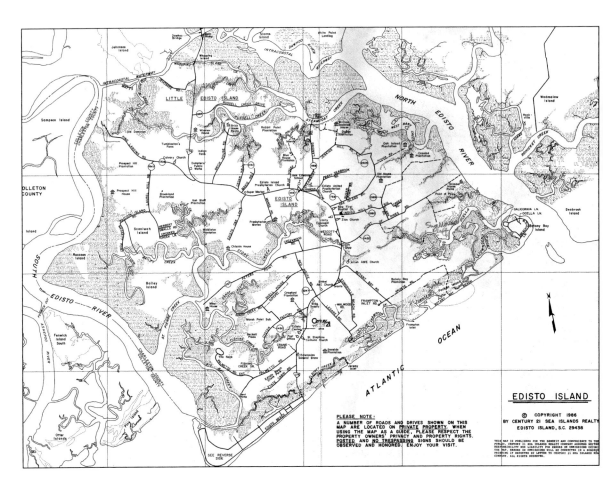

EDISTO ISLAND

These photographs are a prey, taken for our sake
In a long and quiet hunt. Our self as a people,
The people of Edisto, our knowledge of who we are and who we should be,
Our hopes are nourished by them. The photographer who took them
Is like the Blackfoot Indian hunter who walked
Like the rabbit, quail, and puma, thought
Like them so he could take them and bring them home
To his people to nourish and clothe themselves.
He would pray, kneel down
On that hunting ground and pray forgiveness of that time,
Of that bear or puma person, of that world he took them from.
 Amen.

And I'm Glad

AN ORAL HISTORY
OF EDISTO ISLAND

Transcribed and Introduced by Nick Lindsay
Photographs by Julia Cart

ARCADIA

First published 2000
Reprinted 2005

Published by Arcadia Publishing
Charleston SC, Chicago IL, Portsmouth NH, San Francisco CA

Printed in Great Britain

Library of Congress Catalog Card Number: 2004113738

For all general information contact Arcadia Publishing at:
Telephone 843-853-2070
Fax 843-853-0044
E-mail sales@arcadiapublishing.com
For customer service and orders:
Toll-Free 1-888-313-2665
Visit us on the internet at http://www.arcadiapublishing.com

On the Cover: Portrait of Benjamin Brown, son of Bubberson Brown.

CONTENTS

AUTHOR'S PREFACE

There are people in the community who are made uncomfortable by the writing down of these stories of Bubberson Brown and Sam Gadsden and the comments of Sam Ozuzu, stories of the old days and old ways. They are made even more uneasy by finding clear Ibo or Hausa or Ibibio origins for language, or customs, or habits that still continue in these present days. I know the feeling well when people go to writing yet another book about my father or my mother or my sister. It is as though they are trying to freeze me into a sarcophagus mold shaped by things that happened a century ago. But they are not writing about me. I have my own work to do and I just don't fit into that sarcophagus, so these books are a help to me. Telling these old stories gives us a hard job; forgiveness is not easy to come by. It's not easy to accept our own origins from which we have emerged. Lazarus is called forth from his sepulcher, and these turns of language and social custom seem like the grave wrappings that hamper his movements. Forgiveness is what it amounts to. How can we forgive our own people for being what they are and were? I feel the past is a wide-cast net which may still entangle and stifle me. But with enough telling and retelling of these true stories out of the past I am enabled to say, "Well, so there we are and there they were, two peoples responding in the same way, intelligent people doing the very best we know how." The re-telling of these stories is like the unwrapping of the grave garments. "Lazarus, come on out and walk around and let's get on with it. We've got lots to do."

Throughout this volume, boxes appear containing a conversation I had with Sam Ozuzu, a Nigerian psychologist who works in the Florida prison system, about the oral histories of Bubberson Brown and Sam Gadsden. His words serve to enlighten us on some of the West African customs still pervasive on Edisto, and his perspective on the Edisto story is particularly valuable since he was born and raised in the same village culture and within a hundred miles of the original homes of some of the principal figures in the history of Edisto—Kwibo Tom, his brother Woli, and April Frazier. Ozuzu was born in 1941, and his mother was from an old Christian family and was the first and principal wife of a timber contractor, Ozuzu, who believed in the old way of telling the Sacred Story. Their village, Umuezuo, is one of the six villages of Naze, where the old believers revere the goddess Ala, whom they know to be identical with the earth. Slavery continues to be a substantial part of the regular economy. The principal means of communication in the 1940s was by means of footpaths, just as it was on Edisto during those years, and the wealth of a family group was measured not by money, but by how many people there were in it. The anti-democratic idea of "having someone in charge" was counted as much an abomination as the idea that the earth, Ala herself, could be mined, cut up, or sold.

Ozuzu met his wife, Joan Sauder, when they were both teaching school in Nigeria during the Biafran War of the 1960s. I met Ozuzu, who received his doctoral degree in psychology from Western Michigan, when he was teaching Sunday school in the College Mennonite Church at Goshen College in 1971, his topic, "The Sacredness of the Earth to Christians." He and his wife have three children.

PHOTOGRAPHER'S PREFACE

Light is time thinking about itself.
—Octavio Paz, "A Tree Within"

My photographic contribution to this book came about through several paths: my passion for black-and-white photography, my father's love of history, my mother's vivid stories recounted by generations of exceptional storytellers, and my two years spent as a Peace Corps volunteer in Senegal, West Africa.

In 1990, I came to Edisto Island to research my family history at Brick House. Immediately I was drawn to the island's spirit of place: its landscapes, its architectural remains, and its people. The cultural history is palpable, even today. Edisto's earliest inhabitants included American Indians, West Indians, Africans, Spaniards, and British settlers. As I worked, I realized my camera was a "seeing clock," and that I had no time to waste. The island, like so many of South Carolina's smaller, agrarian communities, is falling prey to time's erasures. Many of the landscapes and structures I photographed were not commonly documented. Some were lost before I began my journey; many are endangered by further development, and so I attempt to preserve these images for present and future generations.

It is obvious to me that the roots of African culture run deep and strong on Edisto, and have contributed greatly to the island way of life. Much of this history has been overlooked in previous photographic and textual documentation. The Gullah "song" language, its stories and traditions, are passed along orally from one generation to the next, leaving faint footsteps to follow. Thankfully, Nick Lindsay was able to take up the task of transcribing oral histories from two authentic sources: Sam Gadsden and Bubberson Brown, grandsons of African slaves and Nigerian royalty. Upon reading his books, I knew I wanted to make Lindsay's acquaintance; that his poetic and textual vision would merge and complement my visual voice. Fortunately for me, he decided to open the door one summer day in 1993, and over the course of many fine visits and wanderings, our passions to tell the story combined to bring forth this book.

Except in the closing visual essay, the photographs appear without captions and are placed throughout the main body of the text to give a sense of the island's mood and timelessness. However, for the reader's information, the section at the end of the book, entitled Photographer's Notes, identifies the images. The photographs are reproduced from the original selenium-toned silver prints and platinum/palladium prints.

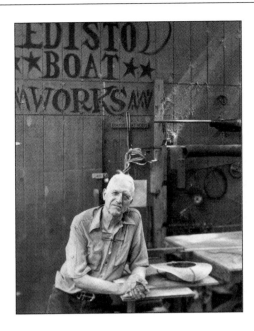

ABOUT THE AUTHOR

Born in 1927, Nick Lindsay is a poet, teacher, carpenter, bricklayer, and boatbuilder from Edisto Island. Since 1955, he and his wife, DuBose, have spent most of their life on Edisto, where they have raised ten children and where survival has always meant adaptability and hard physical labor. Having earned his B.A. at the University of South Carolina and performed graduate work at five universities, including Columbia and Fordham in New York City, Lindsay spent a number of years as a professor at Goshen College in Indiana, where he continues to give lectures and courses on a regular basis. He has taught and lectured in schools, museums, and libraries across the United States, Canada, and Europe.

Lindsay has published seven volumes of poetry, one novel in verse, two volumes of oral histories, and ten broadsides with Pinchpenny Press. Scott Foresman, Zondervann, Curtis Worthington, and others have anthologized a handful of the more popular pieces.

ACKNOWLEDGMENTS

I am much indebted to Harriet Johnson, her wit and fine sense of language for helping me focus and dry up this introduction. The sentimentalities and inaccuracies that remain are my own. There are many others whose good will and revisions to the oral text were crucial—Henrietta Brown, Rachel Gadsden, J.G. Murray Jr., Solomon Brown, Henry Watson, Emily Deas, and the choirs of Allen A.M.E. Church and New First Baptist Church. To detail my debt would take three or four such volumes as this. Much of the oral testimony first appeared in chap book form in Goshen College's Pinchpenny Press, financed in part by a faculty grant. Goshen College, Peggy Adams of Bowie Art Center at Erskine College, the grant for *Views from the Edge of the Century* from the South Carolina Arts Commission and Bank of America have provided both crucial support and encouragement. Julia Cart's passionate enthusiasm has carried this project forward more than once when my energies flagged. Without publisher and editor Mark Berry's constancy and healing good humor, this project would have crashed and burned a year ago. Hooray for hero-editors!

ABOUT THE PHOTOGRAPHER

A self-taught photographer, Julia Cart was born in Quantico, Virginia. She studied art and French at UNC-Greensboro, theater arts at Goddard College in Vermont, and mime, movement, and theater at L'Ecole Jacques LeCoq in Paris. Cart served as a Peace Corps volunteer in Senegal, West Africa. In 1979, she returned to her maternal home where she began to photograph along the back roads, small towns, and sea islands.

Driven by her passion for historic and environment preservation, vernacular architecture, and the early photographers, like Julia Margaret Cameron, Cart works exclusively in black-and-white with medium- and large-format cameras. She prints her images in silver and in platinum/palladium. Currently, she is learning the collodion, or wet-plate process for printing ambrotypes, ferrotypes, and albumen prints.

Julia Cart lives in Charleston with her cat, Simon Ward.

ACKNOWLEDGMENTS

I gratefully acknowledge the presence of the Unexpected in my artistic journey through the islands and the visual gifts thus brought into being. I wish to thank those who have played a role however unexpectedly:

At the beginning: Christopher Jenkins of Brick House, Edisto Island, my grandmother's stories, Mom and Dad, Christopher Keefe, Fred Picker, Roland Barthes, Heidegger, and Octavio Paz.

Along the Way: Susan Harper, the South Carolina Arts Commission, the South Carolina Coastal Conservation League, Bell South, Bill and Sis, Robert McCully, and the Elders of Edisto Island.

Further: I wish to dedicate this collection of images to my daughter, Alexa Keefe, and to the Loving Memory of my dear friend, Eloise Robinson Tolbert, whose enthusiasm and wisdom provided me with the courage to bring this work to fruition.

INTRODUCTION

This book records two extended conversations that took place some 30 years ago. Both started with my asking, "What d'you think, the old days, weren't they better than the days and ways we see now?" It's an opener I learned from Tony Deas, who first goaded me into doing the work and reflects his view of the past, and is an invitation to nostalgia and romantic regret. It didn't work out that way. Brown and Gadsden and the other oldest neighbors I talked with praised both times, then and now.

An old friend, coal black and skinny he was, and lived on the sea side of the island, said, "Everything change up now. In the old day, money? Take him or leave him, be all right. Now? Must have him now. Everything change up now."

But another person, dear to us, for she guided our Whaley Field community for 50 years, "Ki? What you talking about? Here we all sit, now, each under we own vine and fig tree, take we peaceful rest. But in those days I have to do all the work for a boy and a girl, work for a boy and a girl. These days? Ninety times better! Ninety times better than those old days!" She was speaking of the time of her childhood, the 1890s.

PART I: THEN AND NOW

How many thens can a short essay stand? I count three already. In this 1999, we look back to the following: 1. My time of listening when I'm writing down what my old neighbors tell, men and women I've worked with and revere; 2. A "then" of 1890, their childhood when, as even Emily said, "This place was paradise," and they listened to what their great aunts and grandparents said; 3. A "then" of 1820, the time of grandfathers and slavery days.

Emily, Gussie, Tony—their childhood days were the childhood days of my own grandfather. Those days before the bridge when Edisto was an isolated, black, Gullah-speaking community living in its own, basically African, way, and the principal actors had their childhood either in West Africa or under the aegis of Carolina Sea Island slavery, which was itself in many ways an extension of West African society.

WEST AFRICAN SOCIETY

Ozuzu: West Africa (laughs) is not a peaceful place to live, and it was not peaceful in those years either. The Niger River delta, the towns Opobo, Port Harcourt, Bonny, you expect the powerful Igbo merchants of these places to be Christian by the late eighteenth century. The Christianizing movement came from these places. But Islamic traders were also coming down from the north, and they had a competition as to which of them would buy the gold, ivory, and slaves these peripheral Igbo merchants were selling. Whether they were Islamic or Christian, they still basically continued to tell the Sacred Story in the same way it had been told for thousands of years: one supreme creator deity, often a woman, our sacred mother, and under this deity, many lesser deities and ancestral spirits. Whether they considered themselves to be Muslim or Christian, this indigenous way of telling the Sacred Story was the foundation, this was the . . .

Lindsay: The same is true of European Christianity. The foundation is the Norse deities for the Germanic people, the Celtic deities for the Irish, the Scots, and . . .

Ozuzu: . . . their way of understanding. These ancient deities could only be appeased by blood sacrifice, preferably a human person. Our parents told us, "You'd better keep your eyes open, and don't go out alone or in the night. Some other group from a distant place may need someone to dedicate to their gods."

When you go to the river to fetch water, you don't go by yourself. No. It's not a good idea because there are a lot of things that could happen to you: attacks from animals, or abduction by slave-catchers. There was a busy trade in slaves during the 1940s going from West Africa to East Africa. So you go to the river in groups. The very early morning is for adult women, and then the later morning and the afternoon are for the younger people, both boys and girls. You must be attentive and observant at all times.

Lindsay: You mean, this was in the 1940s and 1950s, when you were growing up.

Ozuzu: That's what my mother told us.

The "then" of even earlier times, what of it? So much of what is considered to be at the heart of what it is to be American is from the West African community of the colonial days before 1700! There was by then already a cattle-raising industry in South Carolina based on the skills of the African pioneer immigrants who came here with those skills they had learned in their homeland—rounding up cattle from what was then the unfenced ranges of South Carolina, gathering them into cow pens, branding, and roping. These skilled men called themselves "cow boys" in distinction to "house boys" or field hands (see Peter Wood's *Black Majority*), and they used the Bambara word "dogie" to describe the smaller animals (see Philip Morgan's *Slave Counterpoint*). The cowboys and their dogies are still part of the American West. The "evil" harmonies of the blues, dance, white and black spirituals, gesture and idiom—their place at the center of what's called American has been remarked on at length elsewhere—are American society's inheritance from slavery days.

But could there be any good in those days if they are viewed from the point of view of those who endured them? Though my neighbors and many West Africans leave a glimmer of possibility, the historians don't seem to. Speaking from the basis of local laws and South Carolina State legislative acts, they describe a contest between terror and greed. Such words as compassion, tenderness, respect, benevolence, or the like don't seem to apply. Terror: "Send these strange Africans away who seem fearless in the face of death and who outnumber us ten to one and who would cut our throats in a minute. Don't let any more come!" And greed: "Get more, get more! They will make me richer than any king!" Slavery—abolished here in 1865, 14 years before Sam Gadsden was born, abolished in Sierra Leone in 1927, the same year I was born. The destructive power of ambition, coercion, cruelty, and "multiply yourself through others" was at work in Brazil, Haiti, South Carolina, as in the African kingdoms and chieftancies. The African writers of the 1960s, Leopold Senghor, Wole Soyinka, Chinua Achebe, Asukwo Udo, and others, were denouncing this exploitative strand in African village life even as my neighbors were speaking to me. Achebe says that the Europeans were not the cause, but just one symptom of the decay, like maggots in dead flesh. The society had fallen apart on its own.

"PERSONALITY" AND THE FEAR OF DEATH

Lindsay: Then what you mean, say, by the words "Sam Ozuzu" contrasts with what's called "self" in the psychology texts? This Igbo self is . . . What? A sort of collective . . .

Ozuzu: I have many names. The people in the village must tell me who I am. When I was a youth, 1945, 1955, during those years, I had a friend, an older man. He trusted me to cut his beard, even to shave him and not leave any cuts. Why did he trust me? He said I was reincarnated from an older friend of his. As an Igbo youth, I don't know who I am. They must tell me, and this is how I come to understand who I am.

Lindsay: If you have a "personality" only through village interaction, any fear of death, it's not individual, but . . .

Ozuzu: No, perhaps not. Who is this "I"? They must tell me. Then how can this "I" be afraid? The power of the individual does not emanate from him. The power, the voice you have is as a result of a verbal community and their support, and that of the deities. The European word "I" is equivalent to the Igbo word "chi," which is personal deity.

Isolated. How did Edisto stay so isolated that the principal language was a West African creole when most Edistonians of my grandfather's generation had worked in Charleston, Savannah, New York, or Philadelphia? It was an isolation by preference. People came back. They voted with their feet and way of speech and living. How did it get this way to start with? How did it happen that this overwhelming black majority of whom the mainland was so terrified had been left to govern itself on Edisto—to ". . . live in their own way and with a good report," as Sam Gadsden says?

There is an irony here, a sort of deadly joke. Along with their traditional basket-weaving skills and the secrets and technology of rice cultivation, the earlier African immigrants had brought with them both the malaria spirochete and their own high degree of immunity to it, which their people had developed in the mosquito-infested lowlands of West Africa. Evidently, this is not a racial immunity, since populations in other parts of the world have developed an identical immunity when they lived under similar circumstances, notable in Sicily and Greece (Wood's *Black Majority*). Whereas the Edisto black community suffered something like a 30 percent mortality from fever, and this mostly among infants and very young children, the Europeans risked some 90 percent if they stayed on the plantation or even visited during mosquito season. If the Sea Island masters left the black people to govern themselves and maintain their own ways at all, it seems seldom

to have been the result of benevolence, but rather from their own ecological weakness and the strength of the Africans. The mosquitoes, malaria, and yellow fever, at times, achieved what Denmark Vesey and the other revolutionaries could not: political and cultural independence for the African communities, even if it was only May through October.

They found themselves living under the same kind of community organization they had brought with them, and supervised by a leader from their own people, their "driver." If this leader was wise and merciful, as with Jane, Colonel Scott, or Charles Williams, according to Gadsden and his informants, the life could be tolerable or occasionally even good. When the leader was cruel and ambitious, as with April Frazier at Seaside, or Mule Head and York Scott at Jackdaw, or the unnamed driver employed by Binyard, then life was evidently both short and miserable.

If they were living "in their own way," this would have been with the women and children at work in the field with hoes, sacks, and baskets, after the men had cleared the land and laid out the rows or plant spacing. The men would be up on the hill, conferring, hunting, or fishing until harvest time. This has continued to be the economic organization in coastal sub-Saharan Africa until the present time (see Caldwell and Caldwell's article "High Fertility in Sub-Saharan Africa" in *Scientific American*, May 1990). This heavy reliance on her strength of back and her character might account for the way Emily described her labor: "I have to do all the work for a boy and a girl! These times now? Ninety times better!"

When these conversations started, the government census of 1960 had just been completed on Edisto; nine-tenths of us were black, eight-tenths were living in poverty, according to the Census Bureau's formula, though to ourselves we felt wealthy, living in paradise. Seven-tenths were Christian with 13 active churches for 2,500 people; three-tenths were dwellers in the kingdom of fear, witchcraft, and the decayed remnants of the various pre-Christian religions, African, European, and American Indian.

One way people were making money was the export of ingredients necessary for root magic. An old car would cross the drawbridge every week or two loaded down with "fu-fu dust" in 5-gallon buckets bound for Boston, New York, or Philadelphia. Washington, D.C. was the largest customer city during those years. In New York, each week or two, the *Amsterdam News* would have a classified advertisement, "Just up from the South with Everything You Need. Do you seek Love? Power? Vengeance? Come to ____. Complete materials and instructions." Some of these materials and this lore came from Edisto.

We had mostly dirt roads and footpaths to get about, with a mixture of ox carts, mule carts, and gasoline trucks for hauling things. Horseback and muleback were on a par with autos for visiting. The economic base was still garden-crop–diversified farming by black and white families, though this was being pushed aside by money-crop farming in large acreages producing cabbage and Maine potatoes for the New York market, the crops going out by barge and tugboat, since the drawbridge couldn't take heavy trucks.

Although in the "now" of the 1990s, work concerning African origins or agriculture is often framed in political abstractions and intangibles, it was a very real time back in 1965 to 1970, very tangible, with bruises, smells, cold air, neighbors intruding, children, and always the tides surrounding, guzzling in and out just outside the windows. While I was sitting in Rachel's house at Sam Gadsden's knee or at Bubberson's side in his house, the life they were describing intruded into the work of recording it, that present reality intruding into the story they told of their lives and that of their grandfathers' lives. The "now" that existed when these stories were told has changed to the "now" of 1999, and it's evident these stories are told from a new kind of "then" and tell things we didn't exactly notice then.

Whether we're talking about the time of grandfathers or the time when the stories were being told, common themes and elements emerge embracing the community and the place.

PART II. THE COMMUNITY: REALNESS, GUMPTION, MERCY

Realness

In the 1960s and 1970s, while I was gathering this testimony, we heated on wood. We had our four youngest children still at home and used fireplace heat. The Gadsdens and Browns used wood stoves. The storm of 1959 had left plenty of oak trash drying in the woods, so I went after it with a bucksaw and an axe. There were plenty of small stove-wood branches, so I didn't need a 6-foot saw nor splitting wedges. While I was cutting my own wood, I cut up trailer loads for Gadsden. He didn't need me to do this. He was just in his early nineties and usually cut all his own wood. Consider that when he was 92 years old, I went to see him one morning and couldn't talk to him just then: he was up on the roof repairing his chimney. He made the ladder himself. But those trailer loads of wood gave us some semblance of exchange. Bubberson Brown had grandchildren to cut his wood.

I will always treasure the words of Rachel Gadsden: "I don't know what to call you. I can't call you father, so I must call you son." I came day after day, listened, wrote down what they said, kept the tape recorder running, came back the next day or two and read it back to them. Sometimes she would say, "Well, you got that all wrong, you know." What has ended up in these pages is the final consensus between them, as spoken by Gadsden.

The same work went on at the Browns' house, with his wife commenting, rejecting, adding. She was so lively that I wanted to write portions as a dialog, or in her own narrative voice. She forbade this altogether. "Don't you put me in no book, d'you hear?" and she made herself scarce for some days, which was our loss.

All our houses smelled of woodsmoke, as we did ourselves. Our clothes. Our hair. Like hickory-cured ham. Only it was mostly oak with a little cedar and pine. And those were hungry times for us at my house, too, though they were good. I am a carpenter and exchange my hand work for wages. If I don't work, how will we eat? If I don't stop and listen and write, how will we get this testimony

15

recorded? We risked it for a few seasons. Some of the live oaks here in Whaley Field, our section of the island, have delicious acorns. They are as sweet, mild, and good as pecans, and more numerous and easier to shell. The taste of acorns, the permeation of wood smoke, the laughter of Sam and Rachel Gadsden, of Brown and his wife and visitors, this was the setting. The Gadsdens' house was quieter than the Browns' home, since Gadsden was more a scholar than a public person. Brown's house was a center of activity in the evenings. They were true inheritors of Bella's queenship—Bella, who came from Africa when she was 11 years old and was the daughter of the terrible April Frazier, who ran the Edings plantation. Bubberson Brown and his sons have always been fixers. If a pipe is broken, or if a house has termite-eaten sills, or a boat is leaking, "Get Bubberson, or Benjie, or James—them." He had a good hard-shell boat-launching bank in the yard, so boats could go into the creek there. The hot stove, the gang, the stories were not just some kind of research, but were all very real.

Being driven by the necessity for wages I have not been able to complete any more than the testimony of the two men. It's a poignant loss. That generation has gone by now. Our conversations and the setting were as real as death and as daybreak.

COERCED LABOR

Ozuzu: Slavery is a form of coerced labor: he has the gun and you do not: this is gun slavery. When you must turn aside from your true calling because some person has money and you do not: this is money slavery.

Lindsay: (Laughs) Maybe, yes. But this money slavery gives me a lot of leeway.

Gumption

When Wally (Woli?) and Kwibo (Qua Igbo) Tom immigrated to the Land of Opportunity, they knew of the risks and opportunities which faced them only from the conversation of European and Ibo travellers and traders. Yet still, like the California and Oregon pioneers, these men, according to Gadsden, felt they knew enough to make their westward exploration an informed and responsible undertaking—a pioneer destiny. Gadsden describes this sense of calling in them: "We are made for trading. We Ibo people know how to make a profitable trade along the roads of this African countryside; it is time now for us to try the salt roads of the broad Atlantic."

Did their wives want to go? It seems likely they didn't. Many of their European counterparts didn't. Why leave settled and productive farms in Nigeria, Cameroon, Gambia, Illinois, or Missouri for the deadly uncertainties of pioneering? The diaries of the Midwestern pioneer wives show many of them were dead set against it, but faced with the choice of "come with me or say good bye," they came. The risks of violence, hunger, disease, and accident faced by the westward pioneers who went to Missouri and then on to Oregon and California seem to have been similar to those anticipated by the people of Kwibo Tom and Wally. If this was true, the final experience of wholesale rational industrialized slavery was unambiguously and grossly worse than they ever imagined.

The men who blazed the Oregon Trail were friendly with the tribal people they met along the way—they were, in fact, guided by them. They were called "Injun Lovers" because they didn't shoot first but waited until they were fired upon. They never were. The brothers Kwibo Tom and Wally were, according to report, friendly with the people they met along their westward exploration and were guided by them. They entered into conversation and hired the services of a Dutch boat captain who took them to Wadmalaw Island. As Gadsden has said, "These were intelligent people doing the very best they knew." They were acting with gumption, that is, taking the initiative with foresight and courageous determination.

There are all kinds of gumptions on Edisto, big ones and little ones. For instance, Jane, the daughter of Kwibo Tom, showed political gumption. She waited all night long out on the porch of the big house at Jackdaw Plantation in order to pick just the right moment to speak to Maussa William Meggett Murray to redress the wrong done to her brother, Charles, by the driver York Scott. She spoke so well and so forcefully that Maussa made her driver and she became queen over on that

side. Anytime you can't get a nail, you use a black locust peg instead and it lasts a hundred years—that's wood-peg gumption. Or, you chop your leg and you know it will take you a half a day at the very least to get to a doctor and the wound will have got cold and won't knit so you sew it up yourself—that's needle-and-thread gumption. You load your pulpwood truck so heavy that the front wheels rise up off the ground and you can't steer so you pile sand bags on the front bumper to bring them back down—that's sandbag gumption.

When your old trawler, the *Cap'n John*, blows her head and leaves you adrift miles offshore, three Afro-American men, and not much food, and you rig a sail with mattresses and blankets out of the fo'csle and it takes three days, but you sail her home—that's a special kind of gumption called hungry gumption. When Miss Liddy Clark Murray and Kwibo Tom's Charles realized that the legislature was all wrong in forbidding anyone to teach the "colored people"—American Indian, African, or Caribbean—to read and write and she started her school over on that side of the island, quite a risky business for him and for her and for anyone associated with it, but it worked just as well as that black locust peg and it's been more than a hundred years—that was alphabet gumption. When April Frazier, the

new Ibo driver from St. Helena, saw the people at Seaside weren't going to make the place into an efficient money-making cotton farm and he beat so many to death trying to persuade them to join in achieving his ambitious vision, and in the tug-of-war between terror and greed that guides South Carolina history (greed was winning)—that was mean gumption. Their master, Marse Evan Edings, was gumption challenged not to have stopped or prevented it. When I spoke to my neighbor Maria Frazier, perhaps a granddaughter of April, after the storm of 1959 (with recorded winds of 150 miles per hour out of the northeast), I asked "How you come on, 'Riah? You have a happy hurricane?"

She answered, "Yes, yes. The Lord been good to me. Ain't lose nothing but me house." That was soul gumption. All kinds of gumption on Edisto. We hatch a new one every day.

Mercy

Bubberson Brown and Sam Gadsden have mercy for all comers. There seems to be nothing beyond its reach, nothing unforgivable. Sam describes "the time when peace been declared" after the Civil War. The masters came back and had to be simple residents. They were very poor and didn't have anything to eat. The ex-slaves who had made intelligent provision for that season and the next had to provide not only for themselves and the members of the black community who were not able to provide for themselves, but the masters as well. "And Oh! but those were hard times! For the white people especially," says Gadsden. Why were they especially hard for the white? Because they had to accept help from their former slaves. The paranoid style of thought would be to underline the hardship to the provident ex-slaves and express a justified resentment, because they were, in fact, working very hard against many difficulties and much heavy weariness. But here is this merciful judgement. Even though Gadsden has described how the masters regarded the black community as "cattle who had got loose somehow," and as "children with no sense of responsibility," still instead of condemnation and rebuttal for these unjustified scorns (after all, who was feeding whom?), here is this sympathy and mercy.

He describes Jim Hutchinson, one of the "Kings of Edisto," who helped the newly free black families to acquire land through the politics of Reconstruction. "And his work has endured." These families still owned their land in the 1960s. "Then one day they killed him. It was a man from Wadmalaw . . . There was some kind of ceremony at Jim's house. That man from Wadmalaw came up there and started some kind of talk with him. Jim was a short-patienced man and he ordered the man off the place and the man shot him dead. He was a white man, but he was from Wadmalaw. . . . It must be they followed mercy in this case instead of justice, for they never did anything with the murderer. The same politics that made Jim into a big man . . . was the thing that protected the killer." Though he doesn't approve, Gadsden accepts the killer's impunity as springing from the same source as the black community's new-found freedom. These men and women practiced responsible generosity and mercy, not resentment and redress.

> **VENGEANCE**
>
> *Ozuzu:* After killings in bitterness, reconciliation is going to be extremely difficult. Especially so for Igbos. Our way is to assign blame and seek vengeance in every case, even if the person just up and died. There is a saying in my town, in Naze, "No Igbo man dies of natural causes." It doesn't matter if he fell off a ladder or was smoking two packs of cigarettes a day for 40 years and died of it, or died of malaria, the idea is that some person has consulted a native practitioner and has killed him by means of witchcraft. Suppose it is you and I who are involved, it is our brother who has been killed. Now we must consult another practitioner and discover who the killer was. Vengeance and redress are our duty. "No Igbo man dies of natural causes."
>
> *Lindsay:* This is unlike Edisto. I am afraid we don't take our duty very seriously.
>
> *Ozuzu: (Laughs)* No. Not very seriously.

Bubberson Brown tells about the time the young people he was trying to work harvesting garden crops for the New York market nearly killed him with overwork. "I get to studying about all the trouble I been to my old man. If they bad, ain't I been bad too? So I was due to have mercy on them."

Brown tells how when the boll weevil came, the black community that had been well-off on Sea Island cotton had no more money. Their cotton gins quit ginning cotton and started grinding corn. "People were grinding corn all over this island. Ate a lot of corn bread. Boll weevil learn them to do that—been a good teacher. Show them they can feed themselves, don't need no cotton money. Get along without that money." Praise for the boll weevil! Mercy even on the boll weevil!

There is a Sea Island song collected on John's Island by the Carawans, and it has stanzas they haven't put in their book, *Ain't You Got a Right to the Tree of Life?* They appear here as follows:

> That's all right, that's all right,
> That's all right, gonna be all right:
> Since my soul got a seat up in the Kingdom,
> That's all right.

> Zekiel weep, Zekiel moan,
> Flesh come creeping off Zekiel bone:
>
> Since my soul got a seat up in the Kingdom
> That's all right.

My understanding of this stanza: If you, like Ezekiel, prophesy, denounce, and destroy evil, you will thrive in the same way he did. Your reward will be more suffering. But that's all right. As T.S. Eliot has written, your suffering is reconciled among the stars. Another such stanza is as follows:

> I got a gal, she's a long and tall,
> She move her body like a cannon ball.
> Since my soul got a seat up in the Kingdom,
> That's all right.

My understanding of this stanza: sexuality and the carnal creation is in tune with the sacred world of the Incarnation, and can be redeemed in the same way.

> If heaven was a thing money could buy,
> The rich would live and the poor would die:
> Since my soul got a seat up in the Kingdom,
> That's all right.

As I understand it, this is satirical reversal. Put as straightforward prose it might be, "I observe that rich people get better medical care, food, and political attention than do we who concern ourselves with spiritual things, and as a result, they live many more years after their poor contemporaries are dead. However, there is Heaven, and in that bright realm, we stand a better chance. These inequalities

must be all right; God made them. They are reconciled among the stars." The evening sermon at Allen African Methodist Episcopal Church on the third Sunday in January 1998 was "And I'm Glad." This is the chanted litany:

God made it all!	And I'm glad!
He made the white man	And I'm glad!
Hold back on my wages;	And I'm glad!
No food on the table!	And I'm glad!
Stab me in the back!	And I'm glad!
Scandalize my name!	And I'm glad!
For God made all!	And I'm glad!
Yes, God made all!	And I'm glad!
God made all!	And I'm glad!

That's all right, that's all right,
That's all right, gonna be all right;
Since my soul got a seat up in the Kingdom,
That's all right.

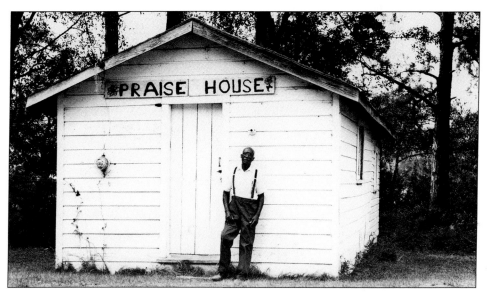

The testimony of Edisto, of these two old men, is especially valuable now at the end of the century in the dialog concerning race and history. It's been especially valuable to me personally in the times of my well-justified despair. Question: How can a person say, "You stab me in the back and I dare to be glad"? Answer: You yell it as a curse, as a challenge, a war cry, "And I'm Glad!" When people scorn you or point a finger at you, you say, "You lucky people, I am here." The testimony of these two old men is unusual. It shows realness instead of theory and documents the gumption, the active participation, and initiative of the African immigrant pioneers instead of portraying them as a passive cargo floated here on the tides of

history; these personal stories show mercy toward its antagonists, be they bug or man, instead of furious denunciation. Realness, gumption, and mercy, and the greatest of these is mercy.

PART III: THE PLACE AS PARADISE

Life on Edisto is tough, takes long hours and hard work, yet each of the six people who told me stories of the old days said early in their testimony, "This place is paradise."

Gadsden chose to say these words immediately after he had recalled his experience of the storm of 1893. "Cow, dead cow in the trees, dead mule. All the people on Whooping Island, Joe Island—all those—drowned, the whole place stink, gone salty and can't raise nothing."

I say, "Well, how did it come back from that bad place?"

He responded, "People come, come just like before. You can't keep them off with a stick. This place is paradise."

Evidently this paradise has some raggedy and painful elements, yes, and includes things we often call curses—hurricanes, pestilence, earthquake, tidal waves, slavery, and the money system. From the Old Testament, Job says, "Though He slay me, yet will I trust in Him."

Concerning the paradisal experience, Isaac Watts's poem from the eighteenth century says the following:

The sure provisions of my God
Attend me all my days;
O may Thy house be my abode,
And all my work be praise.
There would I find a settled rest,
While others go and come;
No more a stranger, nor a guest,
But like a child at home

When the cultural anthropologists, lawyers, and historians consider clan-organized and hoe-agriculture people, there seem to be parallels with this poem, especially the "child at home" element, the familial nature of the whole society whether the clans are Celtic, African, or American Indian.

Here's a quick history of the immigrant groups who came to Edisto. Those who came before 1900 mostly arrived under duress. The Scots, Macintosh, Murray, Bailey, Glen, and the rest were fleeing the English invasion of the highlands and islands of Scotland in the 1700s, and in the 1800s were escaping the coercive herding of as many as the English could catch and herd into the industrial centers in England and the lowlands, forcing them into what the reformers of the nineteenth century called industrial wage slavery. Among the early escapees from this English invasion and commercialization were the Scots of Edisto, who arrived from 1685 onward.

WAGE SLAVERY

Ozuzu: Wage slavery is a good term. It can be just as onerous as plantation slavery, and at times even more degrading. If I am not doing what my own skill and calling are, if I have been bought and have sold myself to the job, this is a grim servitude. This was my father's most important teaching: "Do not permit yourself to be bought."

Lindsay: On Edisto we don't say, "He works for me," but, "He works with me."

Ozuzu: You can help someone else. You can do things for others, but be sure that you don't allow them to buy you. If you help them, it must be by your own choice. This is the Igbo way that has come down to us from the beginning of time.

The Native American Cusabo people who got to the island in the 1500s were fleeing the aggressive and cannibalistic Westoes, who were coming in from the south and west. One persuasive reason for the welcome they extended to the Europeans seems to have been that they were glad for anyone with a gun who would keep off the Westoes. Many of the families in the black community of the 1990s have older members with grandparents from the Native American community, which was here until the middle of this century.

With the African immigrants, it has been a mixed bag. Two groups were not under duress. Some of them came from the Caribbean with pirate wealth seeking a quiet place to settle, much as the modern immigrants from Chicago,

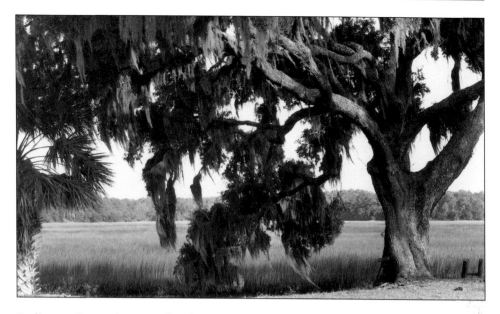

Indianapolis, and Louisville do, with the exception that the Caribbean families were of African background, and the modern tourist wealth comes from capitalist enterprise rather than piracy. Also the westward merchant explorers of African birth, the sons of Qua Igbo Tom, came following their vision of their own destiny, much as the land surveyor and hopeful real estate developer Daniel Boone did in the Appalachians during these same years. These people were not under duress.

The immigrant groups from Africa who had been caught up in the exploitative interaction between neighboring clans and had lost and been sold into the industrialized cotton agribusiness of the United State were under a double duress. They not only were fleeing a destructive enemy, as the Scots and Cusaboes had been, but, having been caught and sold by him, were under the bondage of military slavery, the logic of which goes as follows: "I could have killed you, but I didn't, so now your life is forfeit if you don't do the work I give you"—though this logic seems to have been followed in a rather lackadaisical fashion on Edisto. See, for instance, what Gadsden says about the 21-year holiday enjoyed by the community at Seaside, and the 24-hour work week described by Brown.

SLAVERY: A BENEVOLENT OPTION

Ozuzu: People who misbehaved, in many ways selling them to slave dealers was considered a more benevolent option than killing them and dumping them in the evil forest. This was still being done during my childhood and on up into the 1950s. They were sold both to get rid of them and with the idea that they could make a new start somewhere else.

Lindsay: The first Whaley to arrive on Edisto, he is called "the Regicide," came as a result of a similar plea bargain. He had participated in the beheading of King Charles I of England, and exile to Edisto was considered a benevolent option as compared to the execution he had earned.

Ozuzu: In my home, if you are an apprehended adulterer, or a murderer, slavery is a benevolent option.

The English and French refugees who fled to Edisto are important in our history, but they don't seem to have had clan structure governing their attitudes and exchanges before their arrival here.

Was ours a dark paradise? I attended a conference on linguistics and culture over on the mainland, and a young African-American woman, with a Ph.D. who came from around Columbia, South Carolina, was a speaker. I said, "Come see us on Edisto; we need your vision and competence."

She said, "No, no, not me! That place is too dark!" What then is our specialness? Our darkness?

Darkness—perhaps it has three elements which form a single substance: the idea that land belongs to itself and can't be owned; the idea that virtue is to be found in vulnerability, in unpainted wood, rusty tools, ragged clothes, nakedness; and third, the valuing of appropriateness of gesture over life itself.

Land Ownership

During the time when the first Biniards and Grimballs came to Edisto, the word "own" had a different meaning than it does in modern American language. In the now-archaic meaning, it has the force of "confess," as in "I own up to it," or "I own Jesus as my Lord." With reference to the idea of control, there is an almost complete reversal. "I own this car" means I have complete control over the car and can destroy it if I wish. "I own Jesus as Lord," means He has complete control over me. In this sense the salt tides own the moon.

The idea that land is not freely alienable is not limited to strictly clan and hoe-agriculture societies, but was the dominant view in England until the 1700s, and had strong support for 300 years thereafter (witness the Enclosure Riots of the nineteenth century).

In the African and Scottish Highland societies, as in the Native American that greeted them here, to possess land as chattel property was a new and alien idea. According to the older way of understanding, the land is like the air or the sea, which belong to themselves or to God, and can't be sold. The earth has always been our mother, and to plow, control, harm, or possess her can't be any person's right. Fences are ridiculous or an abomination. "I own this land," according to this older view, means, "I must act according to this land's needs and desires. She controls me, not I her." The modern Euro-American concept of land as property and the operations of real estate speculators are targeted in this Ghanaan bumper sticker: "Abomination Has No Remedy" (Gyinaye and Schreckenbach's *No Time to Die*).

A modern European or American arrives in a traditional non-European society. He approaches the leader of the village nearest the place he wants to settle, "I'll give you $500 for the patch of ground between the palm trees and the river."

The clan leader and the elders have studied this person for the weeks or months he has been among them. They respond, "Very well. You seem to be a good man, you may be our neighbor. We accept your gift."

But when the modern man mines, plows, or worse, fences off or sells this piece of land, the people are outraged. No man can treat the earth in this way: it is

immoral, according to their view. They understand that he gave them a neighbor gift and they welcomed him; they cannot believe that he has bought the land as though it were a sack of rice. A similar loss in sacredness (desecration) occurred in the giving of the bridal gift when it became "buying a woman and her children," that is, chattel slavery.

UMUEZUO

Ozuzu: Umuezuo Naze, our village, who owns this land? In the beginning there were six brothers and they came into our area of dense rain forest. They joined together to clear the forest sufficiently to plant yams, and oh! but this was hard work! Then these men and their sons were "Sons of the Land." This is their title. The land belongs to the whole village and it's shared. In those beginning times the elders got together and counted all the men that were of age and were ready to farm, to have their own families, and the land was equally divided among them. They were "Sons of the Land." The girls do not get land since our girls will marry away from the village. You will marry a girl from another town, so when she comes you will already have land and she will start farming with you. When your sons are ready to start families, you relinquish your control over that land. You become an elder and are valued for your wisdom and experience rather than your physical prowess with axe and hoe.

 If you come into our village but you answer to a strange name, you are a stranger. You may be permitted to come in as a wage laborer, people will hire you, but you will never be one of the "Sons of the Land." You cannot pay your way in, you cannot buy land. The elders may permit you to make use of some village land out of sympathy; you may be tolerated, but we know from your language that you come from afar. When it is time for you to marry, you will go back and get a girl from your own area. Then your children will probably speak your stranger's speech, and make their lives elsewhere.

When you give a gift to the Presbyterian Church on Edisto Island, asking for a grave plot, and are accepted by the elders to be buried in our cemetery, you have not "bought" the plot of land, you can't do as you wish with it, plow it nor sell it. You don't control it. We're glad for your money, glad for the limited fellowship of your ghost and bones, but the land belongs to God. Our concept is an archaic tribal hold-over like the "thee/thou" of some church language, but matches pretty closely the view of land "ownership" in at least a large proportion of the black community on Edisto well into the 1960s.

Both Gadsden and Brown speak of Bella, the daughter of April Frazier. She came here from Africa as an 11-year-old girl about 1855 and was the grandmother of Bubberson Brown. When her children accepted a gift from the visitors from Baltimore in the 1920s, they didn't fully realize that they had not only accepted the visitors as neighbors, but had also disassociated themselves forever from the land where the visitors stayed. Brown says, "It was a 99-year lease." The visitors could stay there for a while, that was okay, but the idea of their fencing and controlling, or, what's more impossible, selling off the land was not any part of the way Bella's children thought of this transaction.

When we came here, a family of eight in 1955, land wasn't a source of real estate wealth, but a place where neighbors stayed. The question of whether or not we would be permitted to get land depended not on how much we could pay, but who our mothers were and whether or not we seemed likely to be good for the

island. We paid $10 an acre for the land, the same price sometimes quoted for good cotton land in 1870. Bank money finally got to the island around 1965, and by now, 1999, good cotton land goes at $20,000 and more per acre, and it's up around $160,000 for creek land. Land taxes spiral upward, sometimes doubling in a single year, and as a result, those of us who measure our lives by other things than money will be run off pretty soon.

Gadsden found paradise here after the storm of 1893. Maybe when laws and dollar values are overthrown by storm, there remains a defenselessness which is victorious and we give the name "Paradise" to this difficult simplicity.

Defenselessness

The second element in the substance of Edisto paradise is the idea that virtue is to be found in vulnerability, and the Devil is mixed up in fine speech, slick paint, fancy clothes, straight lines, and good plumbing. At the time these stories were being told to me, there was seemingly a permanent shagginess here. Some windows were always cracked or out because the woodpeckers had been at them, birds would sometimes fly into the church on Sunday, then hastily out again, embarrassed by our unexpected presence. Sometimes they'd lose their way and someone had to deal with their panic during the service. In the fall, an occasional wasp would come in and add to the interest of the service. Where will he land? What will the preacher do about it when he finds the pulpit?

PROVOKING ENVY

Ozuzu: Provoking the envy of neighbors is not the way of a good or wise person.
Lindsay: We have a proverb on Edisto, "What the eye can't see, the heart can't grieve for."
Ozuzu: Exactly. Envy for your fine shoes or fancy house may provoke me to lawlessness: it is more generous to be less provocative.

House or church or general store are drafty in the winter, but there are wood stoves with their pipes stuck through the wall to keep off the chill despite the gaps in the buildings' outward armor. The men on the island have all shaved some time during the week, but haircuts? Well, that . . .

It's as though in changing our shaggy habits of dress, paint, and building maintenance we would be travelling into an alien and distant place. Why change? Why be evil? Why travel? We're already there. "This place is paradise."

Our young people and new preachers have always been irritated at this relaxed attitude toward progress. Of course they have. With few exceptions they leave the island to go to New York, Philadelphia, Boston—the big cities. As a teenager, Carolina Lafayette Seabrook, who received her name from the Marquis de La Fayette when he was on the island, enjoyed the bright society of Philadelphia of the 1840s and her husband had to build the mansion "Cassina Point" to entice her back home again. Brown's Auntie Christina, Bella's sixth child, went to New York around the turn of the century and by the 1920s owned an apartment house uptown. Bubberson went there and worked for her in those years, then returned to the island in his maturity. Now, at the turn of another century, all my living sons

have gone to New York to court young women and raise their families there. My daughters have mostly gone to more distant places. It seems paradise is not necessarily suitable for young people ever since "In the beginning, God . . ." when Adam and Eve went out in the world to seek their fortune and try for a new definition of paradise.

We used to feel wealthy to ourselves; though to visitors who judged by money and appearances, we seemed to be dwelling in poverty. Our houses were secure enough to keep out the storm and small animals, our clothing was patched and minimal but did the job, and our ox and mule carts (taxi) and later our cars were wobbly, unpainted, and had holes in them, but got there and carried their loads. Our roads, with one exception, were dirt, and many important houses were accessible only by footpath. A network of much-travelled footpaths criss-crossed the whole island. In warm weather snakes were a problem, as they still are. They grew old, large, and wise. An 8-foot diamond back seems to earn the name "serpent" rather than just "snake." He is called "demon" on the island. "How? You eat demon? Oh, oh!" We have several good recipes. The alligators were many, but personally recognized for the most part, their dwelling places known. All these elements seemed to work together pretty well and relied on our mercy toward one another and toward our tools and tasks and the idea that we were all children together.

FOOTPATHS

Ozuzu: Footpaths, yes. As I grew up there were no roads or highways as there are today. No. But you must know your way across hundreds of miles of footpaths. When the oracle communicated to the village that it was necessary to find somebody to dedicate to the gods, a sacrifice, certainly you will not go and catch somebody from our area. No. You can't do that with a kinsman. He must be just as strange as possible, from a far distant place. You catch him at night and blindfold him, so when you get him back to the village he will not know how to run away nor how to get back to his home. The pattern of footpaths was like a net. He was caught in a net.

My grandfather's name is called Ndundu. It means, "He who directs strangers to their right pathway." These Edisto footpaths are very much like my home during the time I was a child.

If I say "we" in this essay, I'm speaking of the whole island, and since nine out of every ten of us include African origins among our various ancestors, the reader should see what is often called a "black" community even though we come in many intermediate colors and minority groups—Anglo-Norman, Anglo-yeoman, Scottish-French, Brass Ankle, and Catawba Coosaw. Each of these tends to keep its own special versions of the rituals of dress, education, transportation, and worship.

Perhaps for us in the last decade of the century, the most poignant expression of the old paradisal vulnerability is the unabashed toplessness not only of men, but of women during hot weather. Edisto women didn't habitually cover their breasts until the 1970s. The young women would crab and fish in the creek, the old would hoe and do wash in the backyard, and in no way concern themselves with shirts. Of course, going to the store, to town, to church—these were a different matter. Wearing a covering for the upper part of her body has come in at

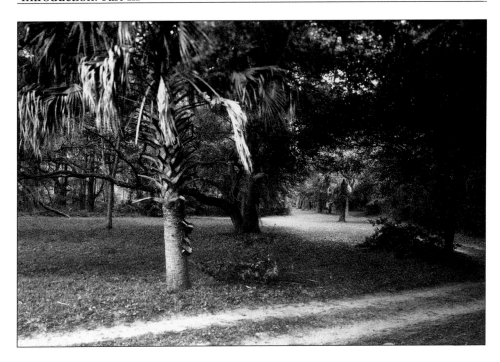

the same time as the idea that the earth can be fenced, controlled, bought, and sold as chattel property. It's tempting to knit together a theory that would link these changes into some sort of unity. Perhaps bare-breastedness on Edisto was one of the tangible indicators that African ways had persisted, that the island was isolated from European ways and "we own way" continued to be normative, and there was space for customs and views of reality not tolerated by the "one size fits all" society on the mainland.

Perhaps, according to the older way, her breasts were part of the general bounty of creation, a sign of the sacredness of the earth as the archaeologist Gimbutas says was true in the old European civilization that preceded plow technology (see Gimbutas's *The Civilization of the Goddess: The World of Old Europe*). Perhaps the earth and her sacredness are not to be fenced nor forbidden by any new European land scheme. "The earth is the Lord's, and the fullness thereof." This same concept may possibly lie behind the "pagan" nakedness of the men and women of the Celtic (Scotch Irish) clans that settled among the Native Americans during the seventeenth and eighteenth centuries in the then-wild territory around Camden, South Carolina, and which was was so much deplored by the Anglican missionary Woodmason in his memoir of that area in the 1760s (see Woodmason's *The Carolina Backcountry on the Eve of the Revolution*). In his Church-of-England way, Woodmason considered their Celtic Columban Christianity to be paganism itself. There are also fastidious critics who judge Edisto Christianity to have been pagan, but this is to judge native Edisto mores according to alien habits and attitudes.

During the late 1960s, while we were still eating acorns, I started gathering testimony about the phosphate mines at the town called Red Top, about half way

to Charleston from Edisto when you go by water. It was a wild place and had we got a tenth of the stories people had to tell, it would have been a regular encyclopedia of hilarious ferocity. Tony Deas introduced me to several people during this search. One day he told me we should visit A.B., a lady from the Baptist church who had personal experience of the Red Top Rock Mines.

We got to her house by footpath. Only foot and hoof traffic came there, which was not unusual. Sam and Rachel Gadsden's house was like that some years. It was mid-morning, a hot day in December.. She was doing the wash in the backyard, working over two large galvanized tubs, scrubbing, rinsing, hanging things on the line. She had a cotton skirt, bare breast and feet—a costume likely for such heat. She was probably in her mid-sixties. The two old people exchanged conversation about what was going on in the church, what crops were likely to provide some income over the coming season, topics of this sort. I did not yet exist, since I had not yet been properly introduced.

The black community on Edisto is formal, aristocratic, and hierarchical, more than the white. If you violate the propriety of formal grace, you're making a grave blunder. I must wait for a formal introduction, which came presently, "This is Mr. Lindsay. He is looking for stories about the Rock Mine."

She looked at me then for the first time, shook her hands dry, wiped them on her skirt, turned on her heel without a word, and went in the house. She came back out in a moment with a large knife, she pressed it forcefully into my forearm—a large, dull knife, yes. "D'you see this knife? He cut that white flesh just as easy as he cut this black!" Her eyes were furious. She was pressing her forearm tight against mine now and pressing the blade into her own, holding my eyes with hers. "And the blood run just as red from both." This was her first greeting to me that morning.

"Just as red as Jesus' blood that saved us both," says I. This is the way we began our conversation concerning the Rock Mine at Red Top.

Style and Stance Valued More Than Life Itself

The third element in this older substance of Edisto is the valuing of interaction with the whole community or action for the sake of the whole community over what's come to be called "personhood." To live in mankind is far more than to live in a name. If I ask a man, "Tell me about your personal life," he's likely to answer something like, "Well, in the beginning God . . ." Personality seems to be collective. Death is, perhaps, not significant as an extinguishing of "self," but as a first-rate form of utterance.

When the U.S. Army encountered the Philippine warriors in 1898, one of these heroes would often be shot so full of holes he was as good as dead, but since he refused to recognize the significance of this event, he would rush on and enthusiastically do away with the American soldier before he dropped. It wasn't the cutting-off of his "personhood" that was significant to him, but the style of his utterance.

The U.S. Army developed the .45-calibre automatic pistol to combat this fierce enthusiasm and what seemed to be a total fearlessness in the presence of death:

the huge, slow-moving slug would usually knock the hero over and before he could scramble to his feet again, he was dead.

On Edisto, back in the 1980s, our neighbor M.S. intervened between two quarreling nephews who had drawn pistols against one another. They refused to be diverted, pulled triggers, and blew the old man off his feet, and before he could jump up and give them a good chastising, he was dead. His death was counted a notable and hilarious achievement by all witnesses. None of them could speak of it without bursting into laughter. It wasn't the extinguishing of this personality that was significant, but the way the gestures all flowed so neatly together, one into the next, style and stance, and utterance.

Along with our dirt roads, oxcarts, and feeling of wealth in our poverty, then, were these three patterns woven into the fabric called Edisto: 1. Land is sacred and can't be sold; 2. Vulnerability is virtuous; and 3. To live in mankind is far more than to live in a name.

PERSON

Ozuzu: It is as though what Western education calls my "personality" has been inherited from someone in the earlier part of this century. It will not be buried with me when I die or if I should become incompetent, no. It will be passed along like the ownership of land is passed along. When Christian influence started to work its way into the thoughts of the people in our town, Naze, they talked not as though they were individuals. As Sam Gadsden has said about the political enterprise at Seaside, "No man can stand up and say, 'Me, I am boss here.' " This applies to the individual personality as well. It's as though it is a collective entity. Rather than each person speaking of his own private decision to become Christian, people spoke of our deity, the sacred force of the land, Ala Nkwo Naze, as though it were her decision. They spoke as though they had seen her and heard her speak, "I saw Ala and she said these words, 'I see that my children are going to church. They no longer come to see me at my shrine. I need to think about going to church too.' "

They speak what my Western training would say is "actually" going on, but they give it some transformation.

All three changed swiftly during the 1960s on Edisto just as family-based community values were overthrown world-wide during those years. The change has continued during the last 30 years and probably none of the three can any longer be found on all of Edisto Island.

Perhaps the three become one: as an island, we have lost control over our own life. An isolated, Gullah-speaking African Christian society which lived under its own control and according to its own way of understanding, and with a good report, and had the pioneer attitude that "anything worth doing, I can do" was overcome in one decade and made ashamed of its customs, architecture, artifacts, personal names, and language by the invasion of money, progress, and enlightenment. Whatever has to be done now, it's likely I can't do it; it probably takes a certified person, a college degree, lots of money, and a county inspector to do it. No more pioneering. The control of the island has shifted from here to where? New York? Washington, D.C.? Denver? More likely it has gone to wherever the concept and achievement of "resort property" comes from. The slogan spoken

most forcefully by our community leaders has changed from "Thank God for life" to "You got to get the Gullery out of the people." The changeover seems to have happened pretty thoroughly.

Is this to be regretted? Surely not. We are making much higher wages now; our longevity, our maternal and infant survival rates, and our literacy are better every year. And among us who keep the stories alive, the old tough paradise will surely endure.

PART IV: THE WORK OF TRANSCRIPTION

Here's how I started taking down these stories. One morning in the spring after the tremendous storm in the fall of 1959, I was repairing damage on Little Edisto Island. My work is a hammer and a saw, carpentry. My neighbor Tony Deas was there, too. He was cutting palmetto cabbage for the table of the old Edisto family who had employed us both. Cutting palmetto cabbage is an antique skill that is rapidly turning into a curiosity. My wage was $2.50, his was 50¢ an hour, may God have mercy on us in spite of our many sins. Walking in the squash of new grass bramble and chainy briar he said to me, "Ain't nobody care about the old days and the old ways no more. Children say, 'Them? Them old tale and story? Them old fogey ways.' But I tell you this: the old days and the old ways were better than the days and ways we see now." He had a treasure to give away but could find no takers.

I said, "I care, Tony. Tell me."

It was then, that very day in the spring of 1960, that we started gathering up these stories. He was an elder in the New First Baptist Church and had been a leader both in the Peter's Point community where we lived and in the whole island. He and his fathers before him were leaders and foremen for generations of masters at Peter's Point plantation. Together, we went to six more of the oldest people we could find, he'd introduce me, and then I'd come back to each one for weeks or months with a tape recorder and notebooks and make a word-for-word written transcription of each conversation.

In the case of Sam Gadsden's narrative, at his repeated insistence, I did a third step. I translated it into more or less standard American from his spoken form, which was strongly influenced by Gullah. Didn't I resist? Of course I did. The two languages often don't fully overlap and nuances which bring in a mature humor or compassionate satire or sympathy are lost. But Gadsden was determined that attention to his exotic language must not obscure the serious and careful history he was telling.

We began this work after the storm of 1959. Hurricane Gracie was severe on Edisto, the eye of the storm passed across the southern edge of the island, the wind instrument on the beach was carried away after registering winds of 145 miles per hour, and the whole place was torn up. You couldn't move around except on foot or horseback for a week afterward. The clean up was tough and while the working people worked, the insurance companies circled disconsolately

like buzzards balked of their carrion. They were concerned with small print, words, clauses, and dollars. But the craftsmen, their work was with hammer, nails, saw, the luck or Grace that brings them through the day ready for tomorrow's work unbroken and untorn no matter how high each man had to climb or how heavy the labor. Dollars aren't his language, but material things, the things God created with His hands and sweat, not paper ideas of money value, deeds of ownership, and abstractions like that.

It was a hard time for island craftsmen—70 hours a week all that winter, all that spring, and into the summer. Men came and went, and the ones who worked no more than 30 hours or who didn't work at all often increased their wealth and could care for their own better than we who worked long hours for short wages. Griefs of that time and place. All of it seemed to hint that there was some world other than this one but nearly within reach where large-spirited people dealt humanely and justly with one another and where we could all rejoice in our situation in the earth, a place of inexplicable radiance. Yes. We were susceptible to ideas of paradise, though it's certainly not what we were finding, travelling from task to task and going up and down across the sand and sweat and salt mud of Edisto.

Edisto is an 8-by-12–mile island which lies between the North and South Edisto River systems. As mentioned earlier, in 1960, nine-tenths of us were black, eight-tenths in poverty according to census equations, and seven-tenths Christian. By now in 1999, no more than two-thirds of us are black, and the beach resort is lily white. In 1960, the poverty and Christianity were pretty democratically distributed among the various divisions of society—man/woman, age/youth, white/black, property owner/worker with hands. A study of our population would show too many children and old people and too few of active years to have brought forth all these children. Travel across the island, you'd see house after house where people in their sixties or even seventies were changing diapers, getting children off on the schoolbus, hanging out a large wash. Shades of Abraham and Sarah! What is the magic of this place that extends the age of the pleasure and the toil and the delight of child rearing so far in the twilight of life?

Here's the simple secret of it. Most of the people of child-bearing age have gone North to get some of that Yankee money there where it is hot; they have left their children at home for grandparents, great aunts, and uncles to raise so that both parents can work in the North and the children can still get a good raising in the South. There are several advantages to this West African–Edisto arrangement. The most important is the one generation overlap; people really know their kin and family. Plus, the children experience both a tolerance and an implacability in the hand that wields the rod. The grandparents and kin can deal with them in a more professional way, being less on trial personally than the parents are.

In those years, the older people gained their livelihood from three sources: gardening and odd-jobbing, plus money from their children, plus a dole from the state welfare agencies, which paid by the head according to how many children you had in the house. Each child was a financial asset, doubly welcome.

The welfare agency, with the European two-parents-plus-their-biological-offspring family in mind, found this West African–Edisto pattern "non-normal" and wanted to change it. They found it to be evidence of the black-family-shattered-by-slavery syndrome, when it was just the opposite, for it was a continuity with millennia of West African tradition. Despite any forces the government brought to bear, this community found a way to strengthen its traditional family structure by means of the very agencies which elsewhere in the country had been held most to blame in shattering it. Their bonds of affection and nurture and common origins were augmented by support from their antagonist. Just as the songs says,

You go mock me, you go scorn,
You go scandalize my name:
Since my soul got a seat up in the Kingdom,
That's all right.

Are these reliable stories? They are the recollections of men who were 80 to 95 years old, near the grave and with little to fear from speaking the truth, their days and hours like the grass. As each man speaks, he usually distinguishes carefully between what he has seen with his own eyes and what he has just merely heard. If he has just heard it from the public at large, it is a hearso and must be regarded with caution. If it comes to him from a trustworthy witness, as Sam Gadsden cites Lena Williams or Charles, son of Tom, he usually gives the footnote. When he says, "This I saw with my own eyes," or "This came about in my time, after I had sense," then truthfulness is limited only by his own skill, the form of utterance, and his powers of memory. Charles was born around 1795. When he was 90 or so, he told his stories to Sam. Now, Sam is 90 and he tells it to me and I write it down. It's a short traverse—just two speakings and listenings—but a century and a half of time. It's likely some of the outlines have grown dim.

Some of Brown's accounts are yarns and he's a skilled yarn spinner. The yarn is a form which recognizes that the wholeness of truth often exceeds mere facts. When a man is described as "Pipe Shank Binyard, the stingiest man God ever let live" by both the white and the black communities on Edisto, it's likely this is truth but not fact. Probably an exaggeration of fact in order to get at the truth.

African slavery in the United States was an exaggerated condition and grew during an exaggerated time. Pirates buried their victims standing upright in the sands of Botany Beach on Edisto; Davy Crockett, famous U.S. senator and enemy of Andrew Jackson's Indian policies, warmed the world during the winter of the Big Freeze by squeezing bear grease from the heavenly constellation onto the axle bearings of the sun (see Rourke's *Davy Crockett*), and I am assured that the description of this second-generation Baynard of Edisto is exaggerated. The Baynard family of the latter half of the nineteenth century was compassionate and public-minded. The three men of that name who were living on Edisto in 1860 and who owned 710 slaves and 6 plantations among them did not spare themselves in labors to advance the level of law, peace, justice, and mercy. Such

titles as philanthropist, magistrate, church elder, justice of the peace, and justice of the quorum were not taken lightly by them or bestowed undeserved by their neighbors. The United States as a whole has benefited from the labors of these men and men like them (see Davidson's *The Last Foray*). Yet despite the good deeds of these subsequent generations, given that both communities on Edisto concur, it seems likely that Pipe Shank Binyard himself lacked in some of the essentials of human charity.

If he did, this is not so much a private failing, but serves as a sign of that time, which considered many people to be less than human. Not only people of African origin, but servants, the children of the poor, Scotchmen, Italians, women, American Indians, Asiatics—all these and many more were considered to be less than human by that society which then showed itself less than human in its treatment of them. The tough-minded of that age subscribed to a proto-Darwinism, which envisioned the multitudes of animate nature struggling to attain by frenetic breeding the pinnacle from which that mind regarded the world. The historian Taine lived during those years. His mind, which integrated the events over the sweep of human history, saw the Frenchman as the highest achievement of evolving Nature. Yes. You've guessed it: Taine was a Frenchman. The Scottish economist Adam Smith saw the successful mercantile gambler as the highest form of intelligent life, which, since it was able to, had the right to buy, sell, and exploit the labor and lives of the men, women, and children who put themselves on the labor market. If Pipe Shank Baynard was tough-minded and steadfast in this toughness even in the face of pain to himself and others, it was both the defect and the virtue of that rational age in which he lived.

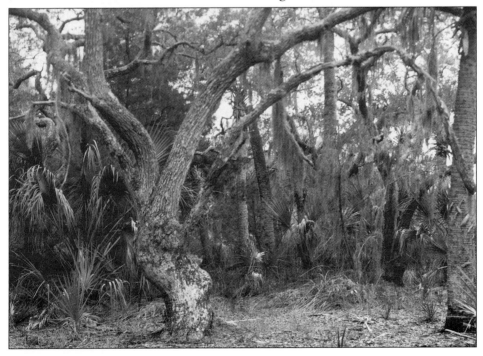

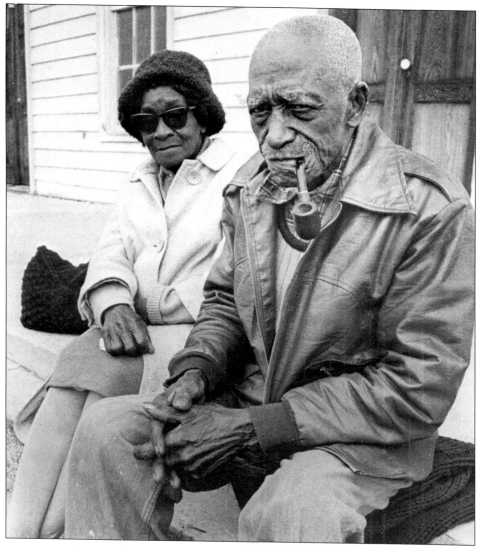

Sam and Rachel Gadsden. (Associated Press photograph.)

PART V: SAM GADSDEN, THE MAN

Sam Gadsden was an independent small farmer of Edisto Island. His whole income had come from farming since 1910. He was born in 1882 and during the 1960s was recognized on the island as one who knew more of its unwritten history than any other man. He was a trustee in Allen African Methodist Episcopal Church.

Gadsden laughed frequently while he was telling a story, a laughter for its own sake and not directed at the listener. It was the intense laugh of redeeming irony and often brought tears to his eyes, his teeth flashing, hands active, a true hilarity. Robert Frost was about eight when Sam Gadsden was born; they are men of the

37

same times. They both gave a listener the same feeling of the power not to see anger in their humor. The hugeness of the universal joke is part of the clarity of their comic vision. Frost's "Forgive O Lord my little jokes on Thee / And I'll forgive Thy great big one on me," was echoed in Gadsden's laughter as he told the tale of the murder of John McConkey.

Qua Igbo Tom, the Ibo chief, never left Nigeria, but his two sons—Wallie, with his wife and 4 children, and Kwibo Tom with his wife and 12 children—came as paying passengers aboard the ship of "that Dutchman, the pirate" and immigrated to the Land of Opportunity about the year 1820. When they reached Bohicket Creek on Wadmalaw Island, the women, children, and trade goods were sold. The people ended up under the ownership of Mr. Clark of Wadmalaw and Edisto. He gave the people of Kwibo Tom to his daughter, Liddy Clark, as a dowry when she married Major William Meggett Murray in 1825, and they came to live on the Murray plantation on Edisto. The story is told by Sam Gadsden, great-grandson of Kwibo Tom.

THE NAME "KWIBO TOM"

Ozuzu: Kwibo Tom. Kwa Igbo Tom, or perhaps even Aqua Ibom, the name of the region at the southeast corner of the country. The sound of the name leads us in several different directions. Since the name Kwa Igbo is a clear vocabulary item still in current use, perhaps it is of interest to see where these people are found today. The name would be more likely in the southern edge of the Niger Delta, where the towns of Opobo, Bori, Orron, and Calabar are situated. But certainly Bonny, Port Harcourt, all the trading towns of the peripheral Igbos are to be included. We are also informed that it is a powerful trading family. As such you expect it to be Christian by the late eighteenth century and certainly by the early nineteenth. The Christianizing movement came from the south, came in from the sea, from these very places. First came the Portuguese in their boats, then later the English in theirs, but the Muslims . . .

Lindsay: Ah! So when Sam Gadsden says, "These people been Christianized from the very start," he may have meant it was in their own home place and from the sixteenth century, or even . . .

Ozuzu: . . . but the Muslims came from the north, by land. This area is closer to the Negeb, to Egypt. The towns are Sokoto, Gusau, Katsina, Kano. The Muslim missionaries and traders occupied these.

Speculation seems necessary and difficult at this point. How to describe the events at Bohicket Creek upon the arrival of this clan of people? For there seems to be a puzzling element of good will, an idea that this is God's will and is all right, and also the fact that the two chieftains were never enslaved. And how is all this consistent with the experience of free immigrant pioneers? I'll try three approaches: the first is violence, the second is through Islamic custom as it had established itself in Africa of the early nineteenth century, and the third is through ancient African social patterns.

Clearly, violence could have changed "free" to "enslaved"; there could have been an act of violence by "the Dutchman, the pirate." He might have overpowered the two merchant chiefs and their young men, seized their goods and persons, and sold all at the illegal creekside market at Bohicket. The problem

with this explanation is that it leaves unanswered the question of why the two chiefs were never under bondage, as well as the atmosphere of good will, which may be spurious or an artifact of the retelling by Jane of her own story, or of Gadsden's telling of it to me. Or it may be no more than the result of gentle breeding on the part of both the Clark family and the pioneer brothers. These were of the upper class of Ibo merchant traders, almost surely Islamic, and aristocratic good manners would be an essential part of their training.

THIS ASSURANCE IS NOT SO SURE

Ozuzu: This assurance is doubtful. Though it is not impossible, since Muslims were very aggressive both as slave-catchers and as merchant traders. The light projected into the past gets so dim that . . .

Lindsay: "Almost surely." Yes, it's an exaggeration.

Ozuzu: This assurance is not so sure. That light is too dim. It is possible that they were Muslim and that they would not buy or sell those who have already converted to Islam. They would look for "heathens," which means Christians or native peoples who still told the Sacred Story in the ancestral way. Some of the women and children caught and sold in the slave trade come without husbands, perhaps those women had misbehaved . . . This Dutch pirate—the merchant traders Kwa Ibo Tom and Woli and their father could have struck a bargain with him. "We bring you so and so many slaves and you give us a free ride to the New World, to the Land of Opportunity."

Another possibility is that these women and their children were enticed. Many people were recruited and went willingly. They didn't know what awaited them.

Perhaps a good way into the second approach, Islamic custom, is through one of the stories retold in *The Arabian Nights* in its new, accurate translation:

> The Muslim chieftain of the city of Basra, Nur al-Din lost his inheritance. His wife, Anis al-Jalis, said, "Sell the furniture," and he did. Presently they were broke and hungry again.
>
> He turned to her! "What is there is there left to sell now?"
>
> She replied, "O my lord, it is my advice that you should rise at once and take me down to the market and sell me. You know that your father bought me for ten thousand dinars; perhaps the Exalted and Glorious God will help you get close to this amount for me, and if it is His will to reunite us, we will meet again."

Haddaway, the translator for the 1990 version, says in his introduction, "[These accounts] conform to the general life and customs of the Arab society . . . [and] reveal a basic homogeneity resulting from the process of dissemination and assimilation under Islamic hegemony, a homogeneity . . . that marks the cultural and artistic history of Islam."

Perhaps the two young Muslim chieftains, sons of Qua Igbo Tom, arrived at Bohicket and found that what they considered wealth was not regarded highly at this place and time. Like that other young Muslim chieftain of old, Nur al-Din of Basra, they were broke. The mixing of family relationships with slavery was

common in West Africa from the seventeenth century on into the twentieth. The suggestion, "Why not sell me?" was possible and could even provide a step up in the world. In Nigeria, if you couldn't accept any of your children to inherit your wealth (perhaps they'd all turned into hippies), you picked a good and virtuous household slave. He/she married into your family and became in every way a true son/daughter.

When abolition of slavery and its profits was finally accepted in 1927 by the community chiefs of Sierra Leone in the legislature of that country, the 400,000 people thus freed mostly married into their masters' families and there was relatively little social and economic disruption. A similar pioneer intermixing of family relationships with slavery without stigma or detriment during the 1600s in the Lowcountry and Midlands of Carolina and Virginia is documented by both historians Peter Wood and Philip Morgan (see Wood's *Black Majority* and Morgan's *Slave Counterpoint*). Certainly attitudes and laws changed drastically with the introduction of the hideous industrialized wholesale slavery of rice and cotton culture. Perhaps Wadmalaw and Edisto were a century behind the times. This may offer an explanation for the enigma of the experience of the children of Qua Igbo Tom at Bohicket. It would include the elements of good humor, sacred affirmation (". . . as God wills"), and the freedom to roam from village to village for Wally and Kwibo Tom.

Under the third approach, that of ancient West African custom, it could be that this clan of immigrants arrived in the same way many Celtic clan groups were arriving then, but Kwibo Tom and Wally's clan were not able to move West and

acquire land because of the problem of color. This scenario assumes that Gadsden's informants—the children who made the voyage, especially his great aunt Jane and his great uncle Charles—told him correctly in saying they were not victims of the slaving industry, but coming on their own, free pioneer immigrants. Perhaps they were able to communicate their situation to Clark and the other people of Wadmalaw Island where they landed since the African creole language Gullah was often spoken and understood to some extent by traders and farmers on both sides of the Atlantic. They might have worked out a way to farm and live in their own way as immigrant pioneers. As noted above, even within the limits of industrialized cotton slavery something like this was frequently the practice in the fever-drenched Carolina Sea Islands.

Immigrants. What did they import along with their physical persons? I count eight intellectual structures and one physical: it is the malaria parasite and an immunity to it. The eight intellectual include the following: 1. Marriage customs and the idea of the primacy of the lineage over the nuclear family; 2. Styles of clothing and nakedness; 3. Basket-weaving, fabrics, and furniture styles; 4. The technology of rice culture, seed, labor organization, and tool design; 5. Burial practices and the intimate immediacy of the ancestral presence; 6. Worship forms;

7. Songs, the now "typically American" blues modes; 8. Language, the most important of all. According to Turner, Gullah is the parent language for much of the black urban community throughout the United States. Many linguistic scholars of more recent years concur (e.g. Irma Aloyce Ewing Cunningham's *A Syntactic Analysis of Sea Island Creole*).

Gadsden says, and it is confirmed by Lorenzo Turner's *Africanisms in the Gullah Dialect* (1949), that Gullah and Edisto American are song languages and the meaning is often in the tune. This is traced by Turner to the West African languages in which tone is a determiner of meaning. Although some Edisto tone conventions contrast with the dominant language (rising tone used for direct description instead of interrogation, falling tone for interrogation instead of emphatic assertion), most of them correspond or at least don't conflict. The net result is American speech emphasized by tone which ranges over an octave or so, that includes all three gender pronouns in "he," and that has no tense and lives in the eternal or infinitive time. It is a clear and musical language. As Gadsden says, "You understand it when you listen to the song."

A more important distinction of Gullah is its timelessness. There are no tenses. There is a saying in East Africa, "In Kenya we have time: Americans have watches." To live without having every verb nailed fast to past, present, or future is to live in a different world. Suppose time does not exist? Now you are entering a world where personality and death are not significant in the modern European sense. According to the master-preacher of all of Edisto Island, Reverend Tony Daise, son of Old Man Tony Deas, who started me on this quest, this is a realm ruled by YHVH, Himself unpronounceable, our laughing, weeping, dancing God.

> If you are worshipping a God
> Where you can't laugh sometimes,
> Maybe you are worshipping
> The wrong God. (Now Tony is laughing in the pulpit. How fantastically comic!
> God? Who can't laugh? You poor people of the Glum God!)

> If you are worshipping a God
> Where you can't cry sometimes,
> Maybe you are worshipping,
> The wrong God. (Now he's weeping in the pulpit. Intolerable,
> heartbreaking! God? And you think he doesn't weep?!)

> If you are worshipping a God
> Where you can't dance sometimes,
> Maybe you are worshipping
> The wrong God. (Now he's dancing all over the dais. So glad! So glad that
> our God is a dancing God!)

(From the sermon "Go to the Ant, Thou Sluggard," delivered at New First Baptist Church in the mid-1970s.)

While these conversations were going on—Brown, Deas, Heyward, Watson—the world was making up its usual batches of history. The year is 1968 and the Black Presbyterian Church under the leadership of Aleen Woods and Reverend McKinley Washington goes looking for government money to help make a Head Start kindergarten and daycare center. The law requires them to prove they are fully integrated; they need white people. The White Presbyterian (established 1685) and the White Episcopal (established 1720), the only white churches on the island in these years, contribute their Sunday school teachers—an attorney, a bulldozer operator with bulldozer, an educational administrator with decades of experience in Columbia, a real estate dealer, a farmer, a carpenter, etc. We get the grants.

Later the same year, the white community is running shy of children and won't have a first grade in the public white grammar school. The Charleston County school administration plans to shut the school, but the black community provides enough students to keep the school afloat: "A school's a school, why lose it?"

These achievements aren't easy for anybody. Not for the white people who don't know exactly how to behave decently and gracefully under these new circumstances, but especially for McKinley Washington and his fellow pioneers in the black community. Anonymous death threats against you and your family aren't the sort of thing you just shrug off. But what else is there for us to do but tough it out? Amen.

The year is 1970 and the conversations with Sam Gadsden begin in July and continue into 1973. In 1970, the white grammar school finally closes; the Vietnamese involvement by the U.S. government is in full career; in the spring of 1969, there was a picnic in Indiana to celebrate the millionth bomb manufactured by the mostly female workers of a federal munitions plant and the picnic was picketed by peaceniks. The peace talks in Paris have for some time been a peculiar political ballet—hard for common folk to understand.

The temperature is usual for the time of year, in the mid-nineties. The approach to the house is grown high with grass for the last quarter mile. Few wheels have passed here this season. The midmorning heat has silenced the insect hum of an hour ago. The house is in a setting of live oaks at the edge of the woods. There is a lawn, a small flock of chickens, a barking dog. The house is at home in its surrounding, and inside it's cool. Radio and newspaper are part of the active scene here. Sam and Rachel Gadsden maintain a lively and humorous interest in the movement of state, national, and world events.

Sam Gadsden was on his death bed when I visited him and Rachel in the hot fall of 1980. He was lying restlessly in the bed in the house he and she had built, twiddling the edge of the covers and impatient to be gone. We said our farewells. What was my surprise to see him alive and chipper in the November line when we went to vote for Jimmy Carter's re-election!

Sam had noticed that it wasn't yet time to be gone until we did this and saw it through. He died around the time of Reagan's inauguration in his 99th year.

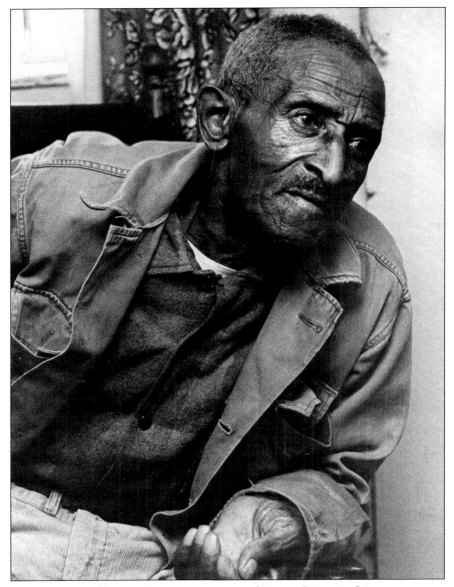

Bubberson Brown. (Associated Press photograph.)

PART VI: THE LIFE OF BUBBERSON BROWN

Bubberson Brown, his son Benjie, his grandson James—they are all skilled carpenters. They have all taught me carpentry techniques that I use every day. Being an Edisto carpenter has always had the usual disadvantages—the perils of climbing high, crawling low, falling off the roofs or into the septic tanks and cisterns, getting squashed between the boat and the dock pilings. And along with this, the risk of being slighted and scorned and led around by the servants'

entrance. A worker with hands, a mechanical craftsman will never be one of the upper class in the present social order. Yet these disadvantages are offset by certain advantages: you decide who you will work for, when and where you will work, and within limits, what your own wage will be. On Edisto this frequently amounts to rejecting the full amount of wage your employer has offered. "Yes," your neighbor says, "Come on, take it. The job's worth it, every bit."

"No. No, that's all right."

"How come you won't take it?"

"Well, you know. You've got to have the right feeling."

And if the fine front door of the aristocratic folk is to be maintained and repaired, the carpenter must have access to it at least while he's working on it. Necessity has established an illicit, brief equality between the master class and us servants. Bubberson in the captain's cabin of the *Brigantine*; me working on the fireplace in the parlor at Prospect Hill.

Bubberson and I worked for years on the same projects around the island, whether it was the boat *John Junior*, or whether we were working to placate the fury of Miss Nell Whaley, or whatever it was. We worked the same jobs, but we weren't acquainted all that while, except through seeing work the other man had

done, since we weren't ever there at the same time. "Well sir. It's easy to see it's been a good carpenter who has been at work here."

Then one day in July of 1970, Tony Deas led me around to Brown's house and we shook hands for the first time. I taped and transcribed what I could of his stories in that month and the next, but then because of delays, such as stopping to make a living, making the house ready for our last-born son, making ready and greeting our two first-born grandsons, the work wasn't completed until 1976.

The winter of 1976 was colder than any on record and in December, Brown broke his leg while he was out cutting wood. I would come to him day by day there where he was in bed, I would read the manuscript aloud. "Hey, no. That ain't quite happen in just that way," he'd say, even though I was reading to him exactly what he had said on the tape. This gave us our chance to get it right the next time.

His house is one among a group of houses Bella's children have built along a quarter mile of gently winding road. You can throw a rock into the creek from his doorstep and many people launch their boats here when the tide is right, both summer and winter. The creek bank is an easy slope of hard sand and shell. As the evening comes down, everybody stops by—preachers, merchants and farmers from the island, from Beaufort and Charleston, children and grandchildren from New York, Washington, all about. The house is the same house where his furious, ambitious great-grandfather, the deadly April Frazier, lived out the final decades of his life and died preaching a hero-sermon in 1905, when Bubberson Brown was eight years old. The house of a chief and leader. The people drop in to visit, stay for the evening. The conversation is full of laughter and the dignity of people who know they are in life's main stream.

Nick Lindsay
Edisto Island, South Carolina
July 1999

Chapter One

EARLY EDISTO

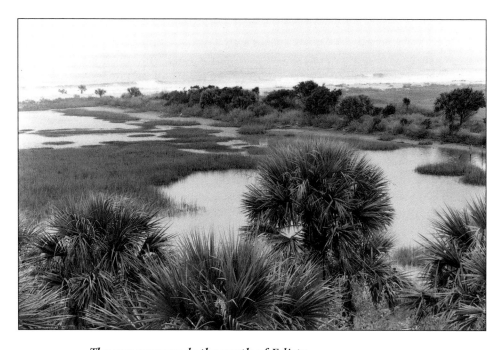

The sea surrounds the earth of Edisto,
Surrounds the salt mud and palmetto-praise
Sands of the island, the salt mud where ten thousand
Fiddler crabs pray to God each morning,
Pray to God who made us, pray with their tiny
Arms raised in unison, raised heavenward
In the morning of mud flats and rising tide. Surrounding
Us the always salt sea with sharks
Swimming and carnivorous money men circling
In. God made the ways sharks go within the sea,
And He made money men, and He made mud,
Made man and woman and the lovely salt embrace
Of tide and earth, of bramble and crop, of man
And Woman that makes children—a tough week's work
For Him. <u>And</u> He pronounced them good.
<div align="right">(Nick Lindsay, 1995)</div>

Kwibo Tom and His Brother Wallie

The world was full of pirates in those days. Nobody should admit to pirate blood, because the character of a pirate is so bad. It's worse than an animal's. They would take the goods and the ship and all, and haul them about, kill the people or sell them into slavery. If anybody resisted, they would kill them and throw them into the sea.

In the beginning, when my people immigrate to America, it was a Dutchman who brought them. He was a pirate. He had colored pirates with him. All of them been working in piracy on the high sea. He had the colored pirates go and get the Negroes from Africa and make a trade of them. They brought them back into America around this section where there were plenty of new plantations being built, plenty of work going on. That Dutchman was a salesman: he taught the settlers that these Negroes from Africa knew more about cleaning up land than any of the white people did no matter how they would try. The country was wild then and they needed help. He told them, "Let those Africans come; they will make good laboring people for you. I will bring them here; you can put them in slavery and let them do all the rough work."

Soon every man was in the race to see how many Africans he could get to bring over and sell. They sold them by the head, just like you sell cattle. Some of the white people who came over from Europe used these slaves with a good result. They were cleaning up America, and they were mostly good, only just the one thing: they treated them like slaves. They had guards and patrols and watched them all the time so they wouldn't run off.

The masters would buy these people from the slave trader by the dozen head. They didn't buy them at any auction sale; they bought them right off the boat at a place they call Bohicket Creek on Wadmalaw Island right up here. That is where the market was.

The boat would come in, then all the masters go there to buy. Maussa So and So would buy so much, then Maussa So and So would buy so much, and Maussa So and So would buy so much, and they would carry them on to their plantations. They would put them in a little cabin and make them work.

The people would clean up the land, dig ditches for rice fields and put up dams and learn off the kingdom. They treat the people as slaves, but they give them rations, give them meat and give them cloth. They don't give them clothes; just give them cloth so the poor fools couldn't hardly hold the neck closed. The women tear up the cloth and tie it around each other, tear off a big piece to tie around her waist and her neck. How should they know how to make clothes? They came straight from Africa.

Some of them live better and some of them live worse; it all depends on the master. Some masters treated their slaves well. They would let them do their own work in the evening and make their own little crop, and they could load it and sell it and make a little money. My grandmother told me these things.

That Dutchman kept bringing them in. He made a regular trade of them. He would come in here with a load, sell them, turn around and go out there and fool them niggers and round up and load his boat again. He fooled them with red cloth, beads, and promises. The Africans liked things like that.

They were easy to fool because they didn't have much education. The Dutchman was able to fool them because he did. He found out a way he could get rich off of them.

The old time Africans were not savages, not the Ibo people. They were a peaceful and industrious people. They studied how to clear and plant there in the jungle, how to harvest their crops and raise their children peacefully. They were no savages, but they had never yet run across clothes made out of cloth. This was the reason the things the Dutchman brought to them there pleased them so much.

ASUKWO UDO

Lindsay: Auskwo Udo. According to his book, *The Mbiabet Chieftancy* (1974), he's the son of a ruler of the Mbuti. He's the first person who alerted me to the history behind the name Kwibo Tom, and that according to his childhood training, there were a number of such chieftains who paid their own way to the Land of Opportunity in the period of 1750 to 1850.

Ozuzu: Yes, I know Asukwo. I remember.

Lindsay: When his oldest child was born, you were both going to Goshen College. I was teaching there then, 1970, 1972, along in there.

Ozuzu: His town, Mbiabet, is some 70 miles south east of my village through the footpaths of the forest. One must cross several rivers. He is from the Ibibio people, even though his language is close to Igbo, we could not understand one another. We must communicate in English.

My great grandfather was named Kwibo Tom. He was the main chief of a tribe in Nigeria, in Africa, a tribe of Ibo people. The Dutchman had been dealing regularly with the old man. Old Tom would lead the Dutchman in to find ivory, gold, diamonds, elephant tusks—whatever it was he wanted. In return for this, the Dutchman would bring the people clothes. This trade had been going on for years, for many years.

The chief's oldest son was named Kwibo Tom just like his daddy. One day he took a notion, "Why shouldn't I be going out there and trading? We could be trading out there on our own account."

This would have been a very profitable trade if he had managed to do it, for the Dutchman was getting rich off of those people even without selling them as slaves. Young Tom could have bought ten boats like the one the Dutchman was using after they made just one load of ivory, gold, and diamonds and sold them at market price. Tom got with his brother, Wallie, and they spoke to the Dutchman about it. That Dutchman answered, and told those two brothers, my great-grandfather Kwibo Tom and his brother, Wallie, that he would bring them here to the place where those trinkets came from; and if they would bring a cargo of trade goods and trade for themselves for these things, they could gather up a boat load and take them back to their tribe. Yes, he said he would bring them back, in his

own boat. And they could give him a proportion of their trade goods to pay him for his trouble and the use of his boat. Tom and Wallie could then bring that cloth and those trinkets back to their daddy and their tribe and they would receive a laurel. Their daddy was the main chief and this made Tom a young chief of the tribe there. Both he and his brother were married; Wallie had about four children, Tom had about twelve. They all agreed to that and Tom and Wallie went aboard with their trade goods and their families.

When they go to America, the Dutchman sold both the wives and all the children into slavery, right there at Bohicket, on Wadmalaw. Tom and Wallie never did work as slaves, but they came and went freely about these islands; there may have been some special arrangement about them. Among Tom's children was my grandmother, Rebecca.

They did not come in at the Customs House in Charleston. The Dutchman was a pirate and it was an illegal trade anyhow, so they came in at Bohicket. He told those two brothers how much better off they would be here, how they could go from place to place in these islands and have as many wives as they wanted—be a rich man here. Why would they want to go back to Africa?

What became of the ivory and trade goods I don't know. Maybe those brothers made a deal with the Dutchman, the pirate! But it might be he had them where he wanted them and they couldn't do anything but go along with what he said, once they were out at sea. Anyhow, after they got here and got settled in, the planters liked the kind of children they made, and they told them to make as many as they wished. Tom, he was the Big Chief.

The whole family—the two brothers, their wives and children—went to Mr. Clark over on Wadmalaw. Wallie's people were settled at a place they call Clark's, here on this island. Clark had all that then. My grandmother and her brothers and sisters and their father, Tom, came first to a place they call Legree's, over near Oak Island Plantation on this island, then from there they went to Murray's place, when her father gave all that family—Tom's family, not Wallie's—to his daughter, Liddy, as a wedding portion when she got married. That was in 1825.

Major William Murray, when he married for the first time, married Lydia Clark from Wadmalaw, and all that stock of colored people came to him along with her. They were not his property, but they came to stay on his place. They belonged to Miss Liddy. In those days the master had his own slaves and the missus had her own. Murray didn't rule them; Miss Liddy did. Only in this one thing Murray had the say so: he told Tom, "You go ahead: get as many wives as you want. We need the same kind of people as your children are." (*Sam Gadsden.*)

BAYNARD

That business called "slavery," it never did have force on this island. Oh no. Ain't been near this island. Slavery? What is that? If some men caught up some of the others and buy and sell them like cattle, that's just a joke. And if some of the men have their ears cut off and the women and children are hungry and cold, that is just some kind of accident. Slavery? Why, I never even heard of it. That is just some kind of name they make up to name three quarters of the people who live on this island.

But it seems like half of the island was free, even in slavery days. (*Nick Lindsay.*)

Yes, plenty of people been here free: the pirates were free. Sea robbers they call them. Like the D____ family. They were pirates. They came north from Jamaica and some of that family stopped here. They were free people, although they were colored. Some of them stayed on Edisto. The family is here to this day. A whole people came in behind that rush. They used to stay on the beach at the village called Edingsville, that place that washed away. In slavery times there was nothing smaller than two-story houses there, and they had two streets—one up and one down. That was a fine town. A whole lot of immigrants were in there. They say, "I am no slave: I come here with the pirates." The pirates, called "sea rovers," they would steal and they would kill and they murdered all about. They would pirate this coast on down into Mexico and the West Indies. They would steal your goods and bring them around to Charleston and down to Kingston in the West Indies, sell some and keep the other. They made a whole town down there, a pirate town, Port Royal.

If you say honest men were free, I don't know about that, but those pirates been here free. Some live on Edisto, and plenty live in Charleston. The biggest kind of people there, they say their ancestors were no slave, they were immigrants, come in with the pirates. They look kind of like a Spaniard, you know. Didn't pass for nigger no more. Some of them had slaves there in Charleston.

I'll tell you about a pirate. He has a bad heart. He'll kill you and burn you and do all kinds of cruel things just to get what you've got. There are people who boast about coming from pirate ancestors. If I knew my parents were that, I wouldn't tell anyone. It is either that they are ignorant and never read any history, or they themselves have a bad heart and boast about their badness.

Some were skillful men. The best carpenters came from the pirates. They made the ships the trade depended on. Some of the carpenters here on this island now are descended from a family of pirates. They have pirate blood in them, but that doesn't excuse them. They may think that makes people look up to them, but nobody pays any regard to them. They got a bad character way back yonder when America was young.

The pirates were free men. And the outlaws. And one of the landholders was just like the pirates. He was a skilled man just like the pirate carpenter; he was a pirate landholder. Slavery? Let me tell you what that was like. Under him, it was tough. He was a tough man on the people. They called him Binyard. He ain't no

Binyard at all; his proper name is Baynard, but the colored people, they have their own way of talking. They know his name is Baynard, but he didn't take care of his slaves. He treated them badly; then you call him Binyard.

He didn't have compassion. He had a lot more slaves than anybody around, but he didn't study his people. He didn't provide any feed for them, nor shelter, nor clothes. He taught his people to be thieves.

Emily Deas, that girl, her great-grandpeople were raised up around Rabbit Point Plantation. That was one of Baynard's places. She says they work them from seven in the morning until noon with nothing to eat. At noon they would break their fast, then at two o'clock go back to work until seven at night, then eat for the last time that day. They work right on through with no Sunday off, no time off at all. He didn't provide any houses for them. When you quit work, you stop, eat. Well, like you say, Amen! Sleep right where you stop.

That's the kind of man Baynard was. That's kind of a Mister Baynard. That's the way he treated his niggers.

Any place where Baynard owned land, that was a rougher place than the rest. He owned half the land in the Burrough and near about half of Sea Side. He owned Prospect Hill, he owned land on John's Island, he owned land all about. He was a man who raised up slaves to sell. He had cattle-breeding going on, he marketed them.

If you had the bad luck to belong to him, he would give you corn—that would be the shucked corn but you must go and get it ground up yourself—and he would give you potatoes, but he wouldn't give you any meat. The poor rascal that belongs to him must get his own meat. He would give him a knife and say, "Go get your own meat, but don't let me catch you, because if I do, I will give you hell." He taught them to steal that way—their neighbor's cow, their neighbor's hog, their neighbor's goat. They say all of Baynard's people could stand more hunger than any other people, but that's just because he didn't feed them; they stole their rations from the other poor people.

If a man of his stole a sheep and got caught, they would pinch up his ear and cut a slice out. If he were to steal a hog and get caught, he had to take up the hog in a big basket on his head and carry it back to the man he stole it from. That man then had the right to give him a hundred lashes. If he did it, the man who received those hundred lashes would never be of any use again, even if he didn't die. As he left that place, he couldn't wear his own clothes, he was so torn up, but they took and put his wife's clothes on him, a loose frock. That man would never be of any use any more after they massacre him that way. People tell that story with laughter, but that man was either dead or ruined for the rest of his life.

Binyard! Pipe Shank Binyard, the stingiest man God ever let live! He was so stingy he never gave them any clothes, but just pieces of cloth. He gave two yards of cloth for the man, two yards of cloth for the wife, and one apiece for each child. He told them, "Make your own clothes." But how was the poor devil going to make himself a pair of britches when he had no needle and no thread and didn't know the first thing about how to do it? Baynard was stingy with his own self. He

SONS OF THE LAND

Lindsay: This work, working in the virgin tropical forest, perhaps these people of Binyard felt, to some degree, at home? Because . . .

Ozuzu: In Owere these might correspond to the Sons of the Land. These men who agreed and banded together at the beginning to clear a place in the forests. It was tough, harsh work. Those are large trees with tenacious roots. No man could do it by himself. But so far as the women are concerned, it is customary for them not to bear the brunt of the first, almost terrible labor, and then to join in afterwards. So far as hunger is concerned, sometimes there was a hungry season before the first yam harvest.

Lindsay: But then, Binyard's people, these African immigrants whose suffering Gadsden sets forth here, according to Igbo custom, they could expect a reward and a permanent inheritance in return. And, what d'you know? Their descendants are living on that land right now, even as we speak, and there is not a single Binyard left in the whole of the Burrough.

Ozuzu: Too bad for them.

had a slave fisherman to catch fish for him. He told him, "Catch me two fish a day. Mind now, don't catch three, just two." If that man caught any more than two, look out. He would get a licking within an inch of his life, or Baynard would kill him.

Baynard was a rich man. He had a lot of money, but he had no wife. The way he got rich was this. Back in those days, just after the American Revolution, any time there was free land with no tax-paying owner, the state was anxious to have some person to start paying taxes on it. They would let anyone have it for fifty cents an acre. Baynard owned almost this whole island that way. He got it in the rough just if he would pay taxes on it, then he would bring in slaves by the hundreds and hundreds and have them clear up the land. They were cheap to him since he treated them so badly, gave them no rest, no clothes, no food, no house. By the time he got a parcel of land cleaned up so he could call it a plantation, he would sell it at something like ten dollars an acre. It didn't take him long to get rich like that. What did he care if he was wasting those niggers? He had plenty of money and could buy himself some more. Many of these plantations around here, maybe more than half, were bought from Baynard at the start. Sea Cloud? The Seabrooks had it from him. He was all around. He was a very rich man. He put silver doorknobs on the doors of his house at Prospect Hill, built 1790. (*Sam Gadsden.*)

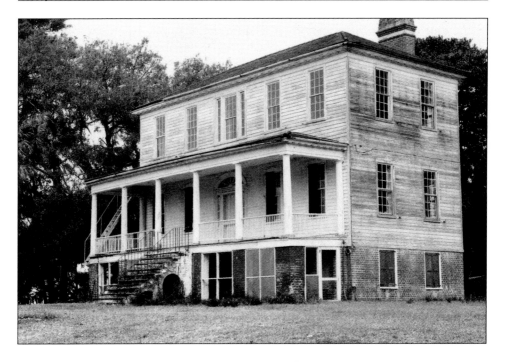

JANE BECOMES DRIVER

Major Murray was a nice man. He did not take advantage of the people, he treated them right. He let them live in their own way. He did not get rich off of them. The Murrays I have known never did have any great wealth. They're just as poor as me.

Major Murray had an agent to run the place for him. He didn't run it himself. The agent's name was Moosehead. He organized the colored people's work—my grandmother, Rebecca, her four or five sisters and her two brothers as well as the other families of slaves they had on the place. Some would mind the hogs and cows, and some of them worked in the yard with the Missus. Sister Jane and Brother Charles are in this story. Brother Charles had a regular job in the yard with Miss Liddy. Most of the people worked in the fields. The people didn't like Mr. Moosehead very well; they called him "Mule Head." Mule Head would give his orders to a man they call the driver, and the driver was the one who actually managed the people. The agent was white, the driver was colored. One day the driver died.

When the driver died, we had to get another driver, so the agent brought one in from his daddy's place up back of Georgetown. The new driver was named York Scott. The Negroes wouldn't listen to Scott, so Mule Head told him he must whip them. "If you give one of these niggers his day's task and he doesn't do it, tell him how many lashes you will give him next morning." The people didn't get on with this new driver. They grumbled back there by themselves because they saw that driver who came from Georgetown lick their friends and family.

The time came for Mister Murray to take his vacation. He went to the Mills Hotel in Charleston to stay for a week along with the other planters and farmers. While he was away, the new driver put Charles to work in the field. Now, Charles had skill in the garden and around the house with Miss Liddy, but not in the field. Naturally he didn't finish his task that day. The next day the driver got rough. He took his men and caught up with Charles; his men tied Brother Charles on to a barrel and they gave him fifty lashes, and Maussa wasn't even there. Maussa was off in Charleston. If a hundred lashes would kill a man, fifty was likely to leave him half dead.

That night Jane went to the yard to see Maussa about what had happened, but Maussa hadn't come home yet. She slept on the steps all that night. Late in the night Maussa came home, but she didn't bother him then. In the morning she went in and told him the whole story. She said, "Mister Murray, sir, I want to tell you, that Mister Moosehead have the driver to lick my brother, Charles. But I just want you to know, sir, that before you allow that driver to put any hand on my brother again, must make arrangements: there will sure be a funeral."

Maussa said, "How come will there be a funeral, Jane?"

"That driver will be dead. I kill him myself."

Maussa went out and told Mister Mule Head, "Don't lick those niggers no more. If you do, you are going to get killed. Jane will kill the driver her own self. If they don't do their tasks, go to Jane. Jane can make them work."

After that, Jane would bid them go, and they got along fine. Jane was a hero. From then on, Jane was the driver.

It would be fine if that had caught on across the whole island, but didn't. That couldn't catch on. It was just for that one family, the children of Kwibo Tom on Murray's place. It was a good way to work. When you get done with your task, you

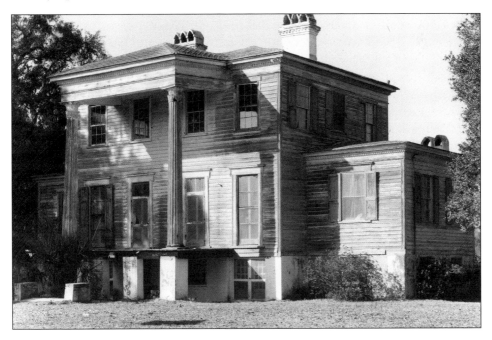

come to help me. When we two are done with mine, we both, go to help our sister. We all work together until each person's task is done for that day. Never the sun set on that plantation but all that family's tasks were done. But Mule Head nor Scott must not lick any of those people, or Jane would commit murder. She would have killed him the first time, only she just waited until Maussa came. If they had not known Maussa to be a good man, they would have killed that driver sure.

If Jane was driver, York Scott was not out of work. He stayed to carry out the agent's orders and give them their tasks and help them to get tools and things, but he had no more anything to do with whether they finished their tasks or not. They always did.

Mule Head would surely have tried to abuse those people and increase the tasks they had to do just because he saw they would always finish them. But he was afraid to, for he knew Jane would cry out. She would go to Maussa and he would welcome her. We had a chief. Jane was a chief of chiefs. She was queen of the whole works. That was one family and she protected them. It was lawless for her to threaten murder against York Scott, but those were lawless times. Lawlessness often worked for the benefit of the community.

They taught Charles to read and write. They gave him a Bible and after that he was always a carpenter and a teacher, and that was against the law. After the Vesey Insurrection in Charleston, the state passed a law against any person teaching a Negro to read and write, but on many plantations the Missus would do it anyhow. Each plantation was a little kingdom of its own. It would have its own laws and its own special punishments. Cut off their ears, shoot them, hang them. Each crime had its own special punishment. They used to split the ear of a sheep stealer.

Sheep were important then. The way they handled sheep was a sign of how the community was unified and worked together. They had no refrigeration, so the way to work it was this: I killed my sheep this week and shared it around to you and all the neighbors; next week you would kill yours and do the same way. That way everyone had fresh meat all year long. A sheep was an important animal and the sheep-stealer had his own special punishment. That was the law of a lawless time.

During the war the Black marauders came up from St. Helena's and savaged the place; they stole cows, pigs, sheep, goats—anything they could lay their hands on, and carried it away. After peace was declared, right there on the Townsends' Plantation, Bleak Hall, they would hunt them down just like wild animals, shoot them and leave them right there. The marauders were hunting the cows, and the Townsends were hunting the marauders. That was lawless on both sides. It was a lawless time.

Charles was so faithful that Miss Liddy taught him to read and write and gave him the task to teach all the people on that plantation. He went out among the cabins and taught them all. Miss Liddy's word was the law there, never mind about any state law or United States law. As long as she said he could do it, he could do it. Each plantation was a kingdom all its own.

Besides all that, it was before the Vesey Insurrection that Charles got his permission to teach.

Some people have traced their ancestors back to Africa, they go there and visit with all their old cousins and all the rest. The tribe Tom and Wallie came from was the Ibo tribe. If you went back to Africa, you wouldn't have any trouble finding that, but the particular village they left from would be very hard to find. Kwibo Tom and the rest of them left such a long time ago that there would be nothing of their inheritance left by now.

Originally, when those people came from Africa, Major Murray had a record of where they came from. But his son, when the Yankees came in during the war, his son set fire to the house so the Yankees couldn't get it, and the records burnt up too. Without a record, a man wouldn't know A from Z in Africa. (*Sam Gadsden.*)

The Place Called "Parson Lee"

In behind the big Presbyterian Church on the main road, the church up there past the whiskey store, was the place called Parson Lee. It had a plantation that went back all the way to the creek there. All the slaveholders gave Parson Lee two Negroes for slaves for the parsonage, for servants and to work the farm. There were a lot of slaves in there and two of them were Tom's daughters. Major Murray gave my grandmother's sisters, Alice and Grace, to be slaves on that plantation. I knew them both; they were my grand-aunts. Those two sisters married two brothers. Alice married James Gadsden and Grace married Joe Gadsden. They had plenty of children.

There never were any complaints about any rough times over at the place called Parson Lee. The people were practically free. They were slaves, but they were not treated as slaves. They didn't raise any cotton on that plantation, just food crops. Each family of colored people planted their own little farm. They raised corn, peas, beans, potatoes, rice, with some okra and pumpkins sometimes. Parson Lee's people and his own family had the full advantage of those crops; none of them were for the market.

The people who told me this came directly out of slavery. They had a hand in all of it. They said some of the masters were good, and I believe it's so. The people at the place called Parson Lee would plant for themselves and they planted enough over so they could give the master some, and maybe a little more beyond that so they could get a little money when they sold their stuff at the market that used to be where the Post Office is now. Although it's true they had to call him "master" and all that, and they had to give him all that he wanted, still, so long as they would

give the master his supply from their crops, master didn't worry them. They were slaves, but they didn't work like slaves. They worked more like free people.

There was one old man there, when peace was declared they told him, "You free—You free now! You can do as you choose! You better go and buy a farm."

THE LANDMARK MOVED

This post office has been moved. The old market for the plantation people is marked by the Old Post Office Restaurant and the craft shop at the place where Highway 174 crosses Store Creek.

He said, "I don't care if peace never been declare. I don't care if I never be free, cause I be get along so good in slavery times."

They depended on the master for many things besides just the house and the land. The overseer and the master planned the work, gave them tools, seed, and instruction. Did I say they raised their own crops? That would not be correct; no, for they had an overseer and they depended on the master for the important matters in the farming business.

Reverend William States Lee, the man the place was named for, was the preacher at that big Presbyterian Church on the main road there. The white people of his church and he himself—they all left during the war, and that left the colored people of that congregation without a minister until they appointed their own. They all kept on coming there. One Sunday after peace was declared and things had settled down a little, Reverend William States Lee marched in leading his white congregation, right to the front of the church, he gave the colored minister a paper which had the official government seals on it, "in the name of God, I repossess this church." The colored congregation went out singing. This story is told in several books and it sounds as though there were hard feelings in the colored people after that.

There were no hard feelings. How should there be? For do you know what that white congregation did? They gave the colored Presbyterians a church building of their own. They moved it from Edingsville and it stood until the last year or two when they tore it down and built that new brick church close to Miss Marichamp's store. There were no hard feelings; there were good feelings. (*Sam Gadsden.*)

THE CONFEDERATE WAR AND RECONSTRUCTION

When the war came, the masters all left their plantations, but their colored people stayed on. Some of them stayed home all during that while. They were farming, "We are a free nigger, yes sir, we are free." Boy, they thought they owned that man's place.

Then Peace was declared and the masters came back. They had to be simple residents then. They were very poor and didn't have anything to eat. All their money had gone to run that war and if there was any left, Jefferson Davis had it somewhere. None of the masters had any. And then, oh! but those were hard times! For the white people especially. When they got home they found the house full of "all the niggers," as they called them. It was like a house filled with children, from their point of view.

In some places out around North Charleston there were some fights when the masters came back and tried to enter the house. The colored people wouldn't accept them. Things like that didn't happen on Edisto Island. Around here they thought a lot of their masters.

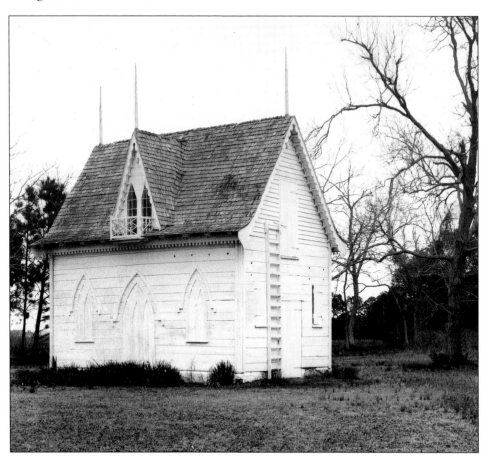

For those "children" welcomed the hungry master and took him in and fed him from their own gardens, and worked for him and helped him do his chores. They thought a lot of their master. When Maussa come home, everything is going to be all right now.

Some of the masters weren't able to come back; they were killed in the war or had some other trouble. The people on those plantations grieved, for if the master is there and any person wants for any thing, he can tell Maussa and Maussa will help him to it. They are glad to work for Master, feed Master and be his servant and care for him in every way.

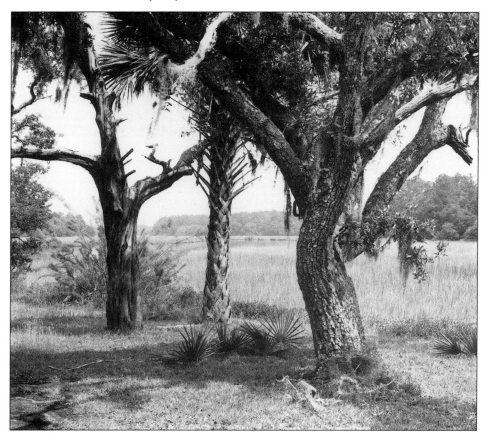

Commerce was cut off and there was nothing but what you could make with only your two hands. They used kindling wood to light with. That was still the way in my time. When I came along there was no gas, no electricity, but it was the kindling time. You want a light in your house? You go out into the woods and cut fat lightered pine, called lightwood because you light up the house with it. You split that up, put it in a bundle and have it there to light with. You make a flambeau with lightwood, carry that around the house, out in the yard. That was the dark age. After that, the times grew and grew until there came the time of a little tin lamp. That came in Reconstruction times, at the end of Reconstruction. A

little tin lamp with a cup and a spout and it had a wick in there. It was a little brass light. You could read pretty fair with it. It had no chimney, but it didn't smoke. The flame went straight up like a candle. The people in the big, ornamental houses used candles. The poor people were blessed to get a little lamp.

And at the time when the masters just came back, they all lived that way. It wasn't a bad way; they didn't suffer. All the people who were smart enough to make their own food ate well and they all made enough to feed the others that weren't—that's the masters and the ex-slaves that didn't have the gumption to care for themselves. All ate well. They carried the others along until times changed and Reconstruction set in.

Everything changed then, because they started getting money. Commerce started to flow through the island as it had before the war but with the difference that now the commerce and politics included the colored people. It is when they say the good times started. Everything flowed freely and they started to make money off of that long cotton. During slavery times they didn't allow any slave to plant cotton for himself, just vegetables. Some of the good masters would buy the garden truck from their slaves, though more often than not he would just take it. The good masters would allow the slaves to come up to the market at the head of Store Creek and they could sell it. There was a market there for the slaves to sell their pumpkins, potatoes, peas and so on. [In 1999, the Old Post Office is in this place.] Some of them made pretty good money even during slavery times. But they must always go back and work that cotton crop for Master, and work Master's corn, and peas for Master's cow. And no slave must plant cotton.

But Reconstruction began and they could make money off that long cotton for themselves. When they started in on the money crops again, the master didn't know anything about how to plant nor how to plow cotton, for he never did any work for himself, but his slaves did it all. Now they were free and they were planting that cotton to their own account instead of his. Master must wait for them to show him how to do it, or he must hire them to do it. In that one way the people held the upper hand in commerce for a brief time.

I was born right in that time, 1882. When Reconstruction first began, we got a dollar a pound for our long cotton and the white people made up to as much as two dollars. By 1890 we were down to forty, fifty, maybe some years seventy five cents. We could have been making a dollar a pound right through that whole time except the buyers and management cut us down to that. During those days short cotton was twelve and fourteen cents a pound. There wasn't anyone around here who fooled with short cotton very much. Short cotton, that is cotton with a short fiber length, is the crop they raise up country and all about the United States. You couldn't raise long cotton anywhere except in these islands along the coast. Can't raise it anywhere now since the boll weevil came.

In the time of masters it was all right so long as the Black people had a really white master. Some of the masters would starve their people and wouldn't give them anything. I'm not talking about them. In slavery times, as long as they had a good master, the Black people didn't worry about anything in their life—how to

do and how to get what they needed, what to hold on to or how to hold on. They didn't care so long as the master had it. "If Master has it, it is as good as though I had it for myself." He would say, "Maussa got him, Go for me." That is the way it started back in the slavery days. Some people picked it up and that's the way they do even to this day. This was the days of masters.

Maussa Got Um

Lindsay: On Edisto, if I provide hand tools for a man on my crew to do the day's job—wrecking bar, scraper, grooved roller, torch, whatever it may be—I can expect the tool to go home with him at quitting time. It usually comes back again with him whenever I have that same work again, in a couple of weeks, a month or so. "If Maussa has the work, has the tool, then I have it also." Too bad for me if the crew changes personnel. My question is this: If Ozuzu, your father, was working in the forest with saws, and one of his men knew that he, himself, needed a saw back at his own compound, would he feel justified in taking it? "Maussa go um, go for me." Now for ever after, when Ozuzu thinks of that saw, he will know it is dwelling at his man's house.

Ozuzu: Ozuzu would not accept this behavior. The community would call it stealing. . . . But if we are conceived to be one family, perhaps within the lineage there is an echo of this. When Joan and I came to America after the Biafran War, we thought to sell our auto to my cousin who was staying there. It was a good, usable American auto. She was offended: "Aren't we brother and sister? If brother has a car, it belongs to sister." Yes. That seems to have been her way of thinking. "Maussa go um, go for me."

Joan Ozuzu: And in Umo Ezuo Naze, our dishes and things!

Ozuzu: If this is the case, we are assuming two definitions: first, that the bonds of slavery, whether is is wage slavery or the traditional version, have become the bonds of familial exchange; and second, that the word "maussa" refers to anyone in the extended family lineage fortunate enough to own anything.

But after the war, and then after Peace was declared, then after Reconstruction set in, the Black people didn't have any master, good or bad. That meant they had to come together and work things out in some way so they could get along. The difficulty seemed to be within the white people. They didn't like to see the Black people be free. They set up rules and arrangements to keep the power and regard in their own hands.

"You want this, and you want that? Then go to Mister So and So. You work for him and he'll give you this and he'll give you that." They were against your staying free. It was not easy for them. It is as though you had raised some cattle and then the cattle all ran away and were gone. But then they didn't even stay gone, but came back and hung around the place you thought was your place and you couldn't control them any more. It's easy to see how you're going to feel. That's the way the white people felt who came back after the war and found the colored people living here all about the place, running free.

At first the white and Black worked together, but then commerce started to spread and all the usual, human feelings left from among them. The white people began to begrudge these niggers their running around and doing just as they chose. That's all there is to segregation, that caused the whole thing. The white people couldn't master these niggers any more so they took up the task of intimidating them. The best of the masters would have liked to keep that old

slavery idea alive, "Maussa got him? Go for you." Hang on to the master, believe in the master, just like God Almighty. If he's got it, it will come to you. If he hasn't got it, you don't need to worry.

ACKNOWLEDGING THE SLAVE AS FAMILY

Ozuzu: In Igbo Land this is solved by acknowledging that the slave has become part of the family. He marries whom he will and inherits his portion of his master's estate. This is what happened to my grandfather's slave. He was a trustworthy and good man.
Lindsay: If the Igbo people who emigrated to the Land of Opportunity expected this, I'm afraid they were rudely disappointed.
Ozuzu: Yeah. Racism. In Igbo Land, we discriminate because of language or you are an Osu, dedicated to a god, or if you are a stranger, but not on account of race.

Just as it was in slavery times, in the Reconstruction times, some of the masters were bad, they would starve you and wouldn't give you anything. They turned that saying around to read, "If you want anything, Master has to get most of it first and then give you a little bit. He gets the meat, leave you the bone; he gets two dollars for his cotton, gives you forty cents. Don't worry or cause a fuss." (*Sam Gadsden.*)

KINGS OF EDISTO: HUTCHINSON AND THORN

We had some Black kings around here in the old days, but it's not going to happen again. These younger politicians, they don't know anything; they're just wild cats. We did have some Black kings around here, and they really ruled the colored people.

Jim Hutchinson was one. His grandson used to work for Mr. Julian Mitchell sometimes during the 1950s; he stayed over at Green's Point. That grandson, young Henry, was a window-washer and high-climber around New York City during the depression of the 1930s, then he came back home after he got too old to climb regularly. Henry Hutchinson used to raise horses around here and he rode a fine one. Jim Hutchinson was his grandfather. He was Precinct Chairman for the Republican Party for this island. He had the Black people organized in the politics business here. He became the king of the bunch and what he said had to go. He ruled here in Reconstruction times. He got the people together and they put colored people in the legislature and had a colored magistrate here. He was

the head man here even over the politicians. He knew more about politics than anybody else.

Another thing he did was to get land for the poor people. After Peace was declared, he went around among the people and took up a little money here, a little money there and when he had gathered up enough, he would buy a plantation. Once the place was bought, he would divide it out to all the people who gave him money; the acreage each person got would be in proportion to how much money he had put in. Jim spread out and bought up all the land around Freedman's Village all the way down to The Neck, he got the colored people together and led them and helped them to get firm and clear title to their land. He was a good man for what he knew. He didn't know much, but he did all he could for anybody in need. He helped them get straightened out and get their own homes. And his work has endured. While he lived he had a voice in all the political law making.

Then one day they killed him. It was a man from Wadmalaw whose brother used to run the store by where the Post Office is now, at the head of Store Creek. He was killed the same year and month that I was born, in August of 1882. My mother told me that when she was going in to the house for me to be born, the people were passing by going to Jim Hutchinson's funeral. She couldn't go because of me.

He was leading the colored people too much. There was some kind of ceremony at Jim's house. That man from Wadmalaw came up there and started some kind of talk with him. Jim was a short-patienced man and he ordered the man off the place and the man shot him dead. He was a white man, but he came from Wadmalaw.

If the people were Christian people and if they recognized justice, there should have been some consequence from that, but there was none. It must be they followed mercy in this case instead of justice, for they never did anything with the murderer. The same politics that made Jim into a big man and helped him spread abroad so far was the thing that protected the killer. But the man couldn't take the land back. The people had clear title and Jim's work has endured.

After Reconstruction, every thing got ruined. Both the Republicans and the Democrats put the Black people out, and white people ruled all the offices in government, only them. The Republicans went along with that. Republican? Do they call them Republican? The Republicans threw the Negroes down! And they were down for years. Negroes couldn't be magistrates, couldn't be sheriff, couldn't be constable, couldn't hold any office whatsoever.

Finally the Negroes had enough. They formed an independent party called Democrats in South Carolina. They had to do that because the white Democrats didn't want any niggers in their private association. The combination of white Democrats and Black Democrats threw the Republicans out.

But lately things have gotten mixed up again. You have a backlash against the backlash. The real Democrats have put down the Democratic Party and have gone and joined with the Republican Party.

It is time to fight this straight. If the politicians don't run things straight, the Black people must fight them straight. The Negro has come up in power now until his voice must be listened to. He has more education and a better position in the

community altogether. The politicians have to come around to treating him ninety percent right.

COMMUNAL LAND DISTRIBUTION

Ozuzu: This procedure sounds familiar from the point of view of the six villages of Naze. In both cases, they recognize a communal land, then it is parceled out to different people according to how much each has contributed. In Igbo Land, the contribution would be in labor rather than in money. However, there are these two differences: in the first place, the distribution of our communal land is supposed to provide equally productive portions of land to each male who is ready to take a wife and raise a family; and in the second, the owner steps aside as soon as there is a new age group ready to farm. The village elders take back the land and redistribute it each generation. It is considered that the land is sacred, is a woman, a deity. She cannot be bought or sold.

Lindsay: This African concept has presented a severe problem across the whole area of the Southeast United States where African immigrants continue to pass along land ownership from generation to generation in the way you describe. In South Carolina it's called the legal problem of "Heir's Property." It has proved to be a way unscrupulous and greedy real estate operators have dispossessed many poor black families of their land. There are at this writing (1999) upwards of 6,000 pieces of such vulnerable heirs' property still left in Charleston County alone.

All those people in Charleston, they don't help us at all. If we want for anything which it is the business of government to provide, and if we go and complain to them, they disregard us. They laugh at us. They think you're a monkey. The nigger is a monkey. You can go in and tell them exactly what is wrong and what is needed, tell them again what they can see and know for themselves, because it stares you in the face. They lock the door.

We ought to get the gang together and put him out of office. He will find the heat quick enough. He will come down when that vote comes around. If you go and carry ten people with you, and I do the same, and each of those twenty does the same, twenty here, twenty there, two hundred, a thousand—he can't win.

When the man from Wadmalaw killed Jim Hutchinson, they told us that was white politics.

There was another man who came here from Charleston during Reconstruction. He was half Spanish, but he passed for a Black man. His name was Thorn. He ran a gin house and all the colored people took their cotton to him to gin it. He took their cotton and sold it and bought them land with the money. He bought several large plantations. He took that little money of the little people and put it together until they had raised enough to meet the asking price for a place, and he bought it. He organized a club and took bonds for the land, and the club paid for it. He took the bonds to a lawyer and got him to cut up the land into small tracts and gave a tract to each man according to how much he had paid. They had plenty of money. Whatever plantation they set out to buy, they bought it out spot cash.

He bought the land around Freedman's Village for the people. He took the first cut himself. He had his business there where Grant's store is now. The big house there is Johnny Thorn's house. That is John's barn there beside it, and John's gin house. John's other big barn burnt down. He cut up land that same way along the

road that runs toward the D.D. Dodge place, back in the middle of the island too. He used to own the land where the Berrys stay now.

He was a leader; he led the people well and did not abuse them, but still he wasn't shot by anyone. He didn't cheat them out of their money, but in spite of that he died of natural causes. He suffered and died right in that house there. His wife died there too. During his whole life he was a financial boss. He established himself as a money power around here. Many of the white people dealt with him in the cotton business.

He had something going there that the young people would like to see here to this day: he had the Barnum and Bailey Circus to come and stay on his land for their winter quarters. They would leave off from their touring and come down here to spend the winter.

John had some big things going on. We had a big man. And he was a good man too. Both he and Hutchinson were good men. They were two of the Black kings of Edisto Island.

My grandfather, Thomas Gadsden, thought he had bought some land in the same way from a white man named Lieutenant Stevens, who ran the Beach Store on Wharf Road for years. Stevens sold off the Wescott plantation in parcels just like Hutchinson and Thorn did. The Wescott plantation lies on both sides of the road which leads out to Point of Pines—Jabez Wescott on the left and John Wescott on the right. My father, Charles Gadsden, built a house on land from the John Wescott place in 1886. That gallant old man did that. I remember.

TRUST

Lindsay: There was a large trust! They trusted Jim Hutchinson and Johnny Thorn to do the right thing, and that trust was justified.

Ozuzu: Yes, and this is quite Igbo. In the village, our trust in one another was pretty complete.

Lindsay: Y'all were Christianized.

Ozuzu: No, not even the majority. There are the two seasons of trust: on the one hand, there are the times of trust, and then, the other times when it is good to be more cautious. (Laughs) Perhaps the Christians relied on forgiveness and mercy to such an extent that they sometimes turned out to be less trustworthy than the adherents of the traditional deities. Fear is a great motivator. Remember, "The gods are watching"; if you steal someone else's yams, "the gods are gonna *get* you."

In those days, when you wanted to build a house, all the neighbors would work together on the house for nothing. There was no question of pay, the people didn't take pay for work like that.

But you had to pay for the wood. There was a man from Cottageville by the name of Ackerman. Since back in slavery days he used to bring lumber in a raft down to the central part of the island. He would come up Store Creek and tie up at the head of it, right where the Post Office is now. That has always been the way that lumber reached this island. A sawmill man would make it up in to a raft, then float the raft a round to where the people needed the lumber, then take the raft apart—that was the lumber. You would pay him with money when you had it. He charged six

dollars a thousand board feet. That's less than a penny a board foot for the same lumber you pay two and three hundred dollars a thousand for now. My father bought nearly two thousand feet of lumber for ten dollars. He built a big house out of that. That house weathered the storm of '93. Lieutenant Stevens said he would sell the Wescott plantation off in ten-acre lots. There was some idea that we were buying that land, but we never paid any taxes. What it amounted to was that we rented that land—ten acres for twenty five dollars a year. Many people had the same idea about that land they spoke for to Stevens. They would run up an account with him—groceries, seed, fertilizer, and they would add on a ten-acre tract of land. It must be they didn't pay very well, and besides that, Stevens was a Yankee man from off somewhere. There was only one out of that whole bunch who paid the whole price at once, cash on the barrel head, and got a full set of papers from him, and that was Lena Williams, the grandmother of Isaac Bligen. When Stevens sold all that land off the second time to the law firm of Mitchell and Smith, only she was able to prove ownership and maintain title. The rest were run off. Many people thought that neither Stevens nor the firm of Mitchell and Smith treated them right, but they just don't understand about business. It looked like Stevens was doing the same thing that Thorn and Hutchinson had done, and the people were fooled into thinking it would work out the same way. Stevens took the land back and sold it to Mitchell and Smith. Mr. Mitchell and Mr. Smith married sisters. They wouldn't sell that land back again; they both gave it to their wives. Smith is the man who owned Middleton Gardens and his son runs that place right now.

Mr. Mitchell has always been a very free-minded man with Black people and it's too bad there has been so much misunderstanding concerning this land from the old Wescott plantation.

MIDDLETON GARDENS

A Charleston tourist attraction, Middleton Gardens is a large plantation with formal gardens, lakes, eighteenth-century farm establishment all intact and operating. It is still owned by the family that built it.

My grandfather died in 1898, the year of the Cuban war, died right there in the house my father had built. Then, just before the boll weevil came, about the year 1915, we were run off from that house and my father bought land over here. We moved into a big house which used to stand up north of the yard. My father died there and we weathered the 1940 storm in that house, but a couple of years later it burned and I built this one. There was a house which stood in the south of the yard for all those years, and we rented it out, but after the forty storm it got in such poor condition that I took it down. Some of that lumber went into the building of this house.

The people who came out of slavery, when they built a house or a barn, they didn't use nails. They put it together with pegs. Old Man Richard Bowles was such a carpenter. He used to live out Cowpens Road. I saw him build Towney Mikell's cow house at California and he did it that way.

The Baynard plantation house called Prospect Hill was built that way and even the sheathing boards were put on with wooden pegs. When I first heard that, I doubted it. But I went there and examined the house and it is true. Every board in that house has been fastened on with black cypress pegs. They would take a gimlet and bore a tapered hole in the board and in the framing behind it, then peg the board onto the house. They could take all the time in the world, time meant nothing here. A man's time wasn't valued at anything. In slavery days each plantation had its own carpenter that they had trained up on the place. Prospect Hill was built in 1790 under the orders of the ancient possessor of the island, Baynard, the same man they call Pipe Shank Binyard, the stingiest man God ever let live.

Percy Whaley owned Prospect Hill until he died about 1963. Percy was one of nine or ten children who was born to an Episcopal preacher who used to serve the white Episcopal Church on the island. You'll see the father's tombstone in the Presbyterian graveyard. He got mad with his congregation and put it in his will that he should be buried in the Presbyterian Church yard. Percy's sister Emily married a Baynard and was mistress at Prospect Hill up until her husband died along about the time of the Depression, about 1930. The Baynards were as poor as church mice by this time, just scraping by. When Baynard died, Percy Whaley got the place.

I remember the summer when he took possession. He came driving around the roads here in a little buggy, all about, along the beach, up to Cowpens Point. He had a little boy with him, and his wife. The boy must be an old man by now. He came from Washington to reorganize the place. He spent one or two summers here and always left a man in charge who could run the place. He used it for a week end or summer resort. He was a publisher in Washington and made a lot of money; Percy Whaley, a famous personality in Washington. When he died they printed it in the papers all around the world. When the news got to New York, they sent it on to London. When it got to London, they sent it on to Paris—all around the world.

That is the same as Mendel Rivers, our congressman who died now. His funeral is today, December 30, 1971. Although you could hardly say he lived here—he lived in Washington like all those big men—still they will bury him near Charleston somewhere. He grew up in Charleston and all the big people there will funeral Mendel Rivers—the big people like the cotton factors and all that kind of people that don't work for a living. Mendel Rivers was one too; he was in the government and he was a rich man.

He helped the people of South Carolina well. He brought many big businesses into Charleston. He was up in Washington when they passed the legislation which established that they were going to have a Navy Yard or an Atomic Plant, or a Submarine Base. He was right there and he pointed those projects toward South Carolina. He caught those for us. He keeps those places running over in government money. That has been a great help to this part of the country. Those things would have gone to Boston or Chicago or Seattle if it hadn't been for him. It is politicians who run those places, but most of the people that the politicians work are people from South Carolina or Georgia. They might hire a few people

from other places, but that doesn't compare with the poor people from around here that they hire on. Mendel Rivers helped the state up.

Those big men that don't work, they are just like the masters: some of them are good men. Hang on to the master, believe in the master, that's if he's a good man. And some of them are good men.

My sister-in-law's daughter is a servant in the house of another congressman, Senator Hollings. She has been with that family for many years. It is time for her to retire, but she wouldn't retire for anything. She went to Washington with him and goes with them all about. The Hollings, the Hollings, she's in love with the Hollings family. He is one of the leading senators. He came back to South Carolina and spoke at my sister-in-law's funeral. (*Sam Gadsden.*)

A HISTORY OF SEASIDE

Those people of the island who are superstitious accuse the plantation house at Seaside of being the home of ghosts. There were so many terrible things that happened in that house and around in the yard there that it gave them reason to name it so. A young woman buried in the doorway, her son a suicide in the attic, a woman burnt up in the yard, a man murdered and a village of people jailed for a year. These make it seem like a bad-luck house, though I have been in the house and I have seen people live there and get along just fine.

Back when the country was young there was a family of owners named Edings who came from Edinburgh in Scotland. They had a castle and large estates over there across the water and some of them came to Saint Helena Island and settled there. They had large plantations and owned many slaves. It happened that one of the sons of that family, Billy Edings, came of age and it was time for him to take a wife. He chose to marry a daughter of Jimmy Whaley from Edisto Island. Jimmy Whaley owned both Seaside and Crawfords and maybe some other places. He gave his daughter Seaside as her wedding portion and her husband brought slaves to people the place.

I know this story from two old ladies: Bella Brown and Lena Williams. Bella Brown was from Africa and Lena Williams was born and raised on Seaside, and was a servant in the house there. They were two of the slaves which belonged to the plantation and they positively knew, because they were there while all these things were happening.

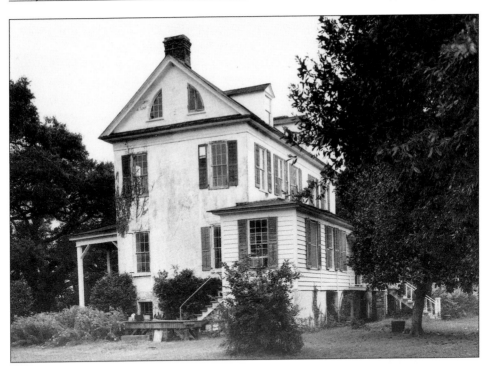

Bella Brown said the Edings bought her daddy, her granddaddy, her mother and twelve head of children. The record of that purchase is in the Fireproof Building in Charleston, the Customs House. The pirate who brought them here had to unload them at the Customs House to get them inspected. Mister Edings bought them in Charleston and brought them out to his main holdings on Saint Helena, down south here. When Bill Edings married, he brought Bella Brown along with a whole crowd of other slaves over here to Edisto to work the plantation where he and his new wife moved. The woman brought the slaves: that's how they settled about the property.

They settled his slaves into the slave quarters there, little houses set up by the big house where Maussa could keep his eye on them. He didn't want them out of his sight. They lived there and went to planting long staple cotton. The years went by, the seasons passed, and after a time Billy Edings' wife bore him a son, John Edings; then she died. Her son was a brand new baby then.

Old Lady Lena Williams told me this part of the story. She said she remembered like it was yesterday the day this happened. The driver, that was Charles Williams, he came to the quarters and roused everybody out to go to work and they were out in the field just ready to start. There must have been twenty families of people, all the able-bodied working hands were out there in the field, when somebody came out of the big house with a piece of paper. It was the will of Billy Edings' wife, and he read it out to them there in a loud voice. That paper told them that they were all knocked off for twenty-one years. They were not supposed to work until that baby, John Edings, came of age to work them. According to the state law

back then they were the property of that boy and neither his father nor anyone else could touch them. They were turned loose for twenty-one years.

They buried the mother there before the door. The grave is there to this day, right before the door. Billy Edings mounded it up and put up an arch over it and it soon had vines growing all up out of it. He took his son, John, back to his own people on Saint Helena's to raise, but Bella Brown and Lena Williams and all those people stayed right here. They were their own person. Although according to strict law they were still slaves, they were as good as free. The Black people came in possession of themselves on that plantation about the year 1835.

They went on living almost the way they lived in Africa. They lived happily that way for about twenty years. Charles Williams was their leader, the driver for their young master. They lived a peaceable life with one another. If I have something, it goes for you too. The people owned all things in common. They worked small garden-style farms, raised colts and cattle. They took their produce to the market which was established for the use of the Black people at the head of Store Creek. They sold cucumbers, cabbage, beans, potatoes, they even sold grass. That is, hay for horse feed. People bought those crops from them and they had a little money for themselves.

There was no marrying for twenty-five years among them there. Now understand, that word marrying was held for a joke among the Black people, for it came from the master. They took it for a joke, the way he used to give them in marriage. Imagine how it used to be. If I wanted to marry a certain girl, I must first ask permission from the driver to go and see Maussa. Only if the driver would let me could I even go to see Maussa and then ask him whether I might marry her. If he gave me his permission, he would also give me all the things he thought were necessary for me to keep house with—a pot, some blankets, and the mistress would give the girl all the things she thought she needed—plates, cooking pots, and other things. Then the order went out to build us a twelve-foot-by-ten-foot cabin in the quarters, a cabin with one door and two windows.

MARRIAGE AS A JOKE

Ozuzu: He says that marriage was held as a joke among the people at Seaside. Among the Igbo people, no. Marriage is *no joke*. Of course, well, I could see where it would seem a joke, perhaps, if the driver has to give permission, then you go to Maussa—all that plantation structure. But in the Igbo tradition, marriage is a very important part of the village. To start with, it is an expensive event. A large sum of money or other property will go to the bride's family. It is not just you falling in love with some woman. No. It is a large family undertaking for both families. If it is your daughter, you will send out a fact-finding committee, umm? You will find out who he is, what he does, who his family is, where they come from, are they good people—what is your daughter getting herself into? What are you getting yourself into? It's a very serious undertaking. Perhaps the plantation environment made them feel that this fabric had been torn beyond repair. Or they may have had their *own* marriage ceremony that was *not* a joke.

Lindsay: The money that goes to her family in Igbo Land is similar to the dowry that in England goes to the husband's family. I know since I have seven daughters and was emphatically warned to never attempt to marry them to English boys—"it would be financially ruinous!"

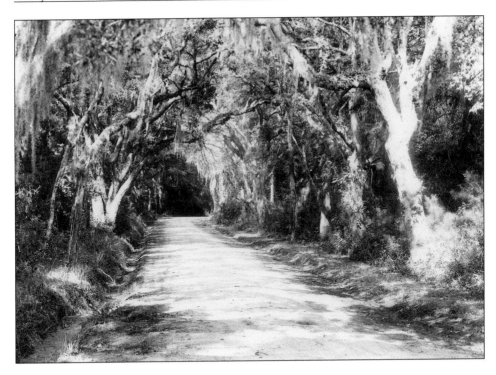

I asked Old Lady Bella Brown, "Why? How come they didn't put two doors in that house?" She said, "So the man can't run out the back door when the driver came to the front. At working time in the morning the driver would come to the window, knock, knock, knock, 'Jack in there?' 'Yes, he here.' 'Maussa say he want him down on the dam. Hurry up now Jack, time to go. Maussa done waiting.' They leave off that back door so Jack can't run out."

If a young man from this plantation took a notion to marry a girl from that other plantation over there, then before they could do it, Maussa had to strike a bargain with her master and send one of his slaves over there to replace the woman who was coming to be in the quarters over here. They made those arrangements pretty easily, swapped off that way. It was not as bad as it might have been, for the young men mostly could bring their wives where they were. Maussa mostly went along with it. But the people took all of it for a joke.

During those twenty-five years after the missus died they must have used some kind of tribal law there at Seaside, African customs which covered marriage and kept the people at peace and at work, but that didn't come down to us.

Right now today there might be a man who says he has more than one wife and that it is all right since he is following an African custom. No: those women he is running around with, their name can't be called. That way is not recognized anywhere here. That man is just an irresponsible, run-around man and those women are not joined to him in any true way. He can be put in jail.

The people at Seaside lived in their own way, a peaceable and orderly life, abiding by African law. In the evenings they often held an entertainment. All the

people gathered together, sang and danced. I would have five or six followers, you would have eight or nine, and we would gather together in the evening while our people were enjoying themselves and decide what we must do. What we would decide would be the law. At Seaside they had two leaders in those days: Colonel Scott and Charles Williams.

POLYGAMY

Ozuzu: My eldest brother despised our father, Ozuzu, because Ozuzu was nasty to our mother and took another wife. He was an adherent of the old way of telling the Sacred Story, whereas she was a Christian. I used to ask my brother, "How come our mother is so anti-polygamy that she lost respect for him? Since, as you know, her own father married more than one wife and yet she continued to respect him? Why was she so strongly opposed to it at Naze?"

My brother answered, "It is because she was a Christian before she even met Ozuzu."

Many women are strongly in favor of polygamy. A cousin of my mother's—they came from the same family compound. This woman, after she had two girls and a boy, decided that she had had enough. She didn't want to play the wife's role any longer. She didn't want to be tied down. She went and found three other young women for her husband, saved enough money to pay the bride prices for them, and made space for them in the family compound. These younger wives then all stayed busy making children, and all these children see her as their Big Mother. She and her husband worked together to govern the compound. She was a good manager and strategist. She found this a very advantageous arrangement.

Polygamy solves lots of problems that the West has not been able to solve. For instance, wars have frequently depleted the supply of men, leaving the excess of women without any male connection. Polygamy would assuage this un-balance. And also, the more extended your family, the more likely it is that it will survive. You gain many more people who can help one another. You cannot clear much rain forest single-handedly. You need your own people to clear enough land. The more children, the better the income. Of course, practically speaking, at the present when hoe crop agriculture is fading and you are on government salary or an industrial wage, it's become just the opposite. The more children, the worse your survival is. I don't suppose our children will think about polygamy very much. They can't afford to pay off their credit cards as it is.

Colonel Scott was Old Man Ned Scott's father. He instructed the people and helped them decide what to do. They gave him the name Colonel because he was a kind of smart leader. The leader would hold classes when the people met in the meeting house. He gave them instruction in how to live, what they must do, what they must not do, how to live properly. They called him leader. Charles Williams was the other leader. He was no kin to Lena Williams that I have ever heard, but he was also called leader. All the smaller heads of families would meet together under Colonel Scott and Charles Williams and what they decided was the law and the people lived by it. No man could do any thing wrong or they would deal with him. They didn't hesitate to lick him, to give him lashes, just as the masters were doing. The people were pretty well Christianized and they lived with a good report.

When John Edings finally grew up and got to be twenty-one years old, his daddy wouldn't turn the plantation over to him because he had become a drunkard. By that time John Edings was already married and he wanted to move over here with his wife and have control over his own property, but his father wouldn't permit it.

His wife went back to her own people after a short while since she couldn't go on staying with a drunkard. John Edings got disgusted with his life and one day he went upstairs in the house there and cut his throat.

After that happened, William Edings turned the estate over to Marse Evan Edings to manage. Up until that time the people at Seaside had lived in their own way, and lived with a good report. But when Marse Evan Edings took over, there came a bad change over the place. He sent his own driver—it was Bella Brown's own father, April Frazier—up from Saint Helena to take the place of Charles Williams. He said the people weren't working hard enough, but they didn't listen to him; they took orders just from Charles Williams. But Williams wouldn't listen to Frazier either; he had too hard a head. Frazier got tough with them. He whipped them, he killed out a whole lot—it was terrible. And still they wouldn't listen. He beat Charles Williams so bad he was ruined for life—came close to killing him. He dressed him in his wife's dress, and he was wearing it when the war broke out.

So Frazier became driver. The house got a bad name—a grave in front of the door, John Edings' blood upstairs on the floor, and then all those people April Frazier killed out when Marse Evan Edings took over—the people charged it with the name, "The Home of Ghosts." Frazier was driver, but he didn't last long: soon the war broke out.

At Hilton Head, General Burnside formed up a troop of colored soldiers to fight on the Yankee side. They used to say freedom came to Saint Helena's first of any place on the coast. General Burnside had a camp down there. When the war was over, he mustered that troop of men out at Hilton Head and they broke up the camp on Saint Helena's.

All these stories I am telling are short. They all could be longer. I know these things, they once were in the front of my mind, but the memory can't replace it.

After the war broke out, the Yankees took over Saint Helena Island and the white people left from all these islands around here. The master took his servants with him up country; some he left here. When the masters went, they left some scouts, Confederate scouts, to keep watch. Each time they made contact with the Yankees, they would escape into the woods and then they were gone. So after a short time, there were no white people left, just these slaves, and the cows, pigs, goats and things. They lost some of that stock to hungry marauders from Saint Helena.

According to the way the Yankees were running the war, they brought Black people from all the plantations along the coast, in to Beaufort and Saint Helena. They brought the people, but they didn't bring any of their food—burnt that up right on the plantation where they had it stored. Burnt up the Black people's food and then brought and put them off at Beaufort.

They were strangers there, thousands of them, they were starving, and sickness broke out amongst them—it was a shame! They die off and die off—die like rotten sheep.

They had to try to look out for themselves any way they could. During those years and even after the war, there were bands of Black people who went all up and down the coast and savaged the place for food. Savaged it! They came to

Seaside too. They killed goats, cows, sheep—anything they could get—and carried them back to Saint Helena.

Lena Williams said there were two boat loads with fourteen head of them that came up here around 1862 and a storm caught them out along Edingsville Beach, and those two boats just loaded down with Seaside cattle. It was no hurricane, just an ordinary storm. They drowned, all fourteen of them, and the people found them washed up on shore for days after that. They buried them all at a sapling that used to stand on the side of Jeremy Inlet. It was just two common bateaux they had, maybe twenty feet long, and they came along with sail and pole, didn't use oars. Not much of a boat for the ocean.

April Frazier was once a member at Allen church. He was strong minded—a strict boss over all his children. They split off and formed Bethlehem Church. The building stands behind the Post Office next to Hunter's property. April built that

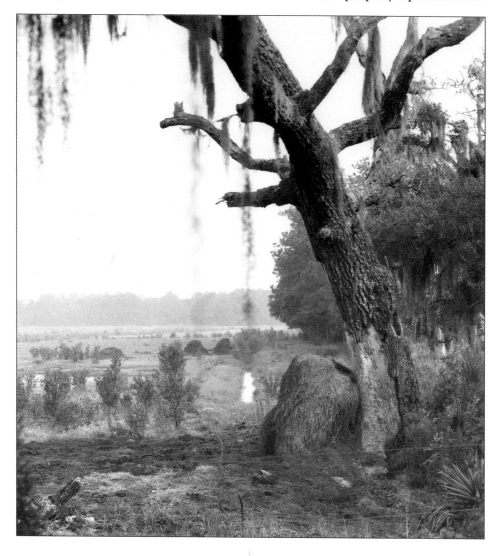

church. If you went there during the early years of that church, you better have been one of his children or else they would put you out. April died in 1905, along in there. They say he was 110 years old. Then Bethlehem split again between two of his sons—Will Williams and Peter Brown.

It might seem a surprise that two full-blood brothers have different names. In those days, no one had any title and if he did take one, like Williams or Brown or something, it was a joke. He took just whatever title he liked.

So then, Bubberson Brown's Grandpa, Peter Brown, started Bethel Church when he left his brother in charge at Bethlehem.

After the war broke out, the people at Seaside went into the big house and took possession there too. Colonel Scott died during those years, right there in the big house.

After Peace was declared, during Reconstruction, a man named Jack Wright came and bought the place from the Edings. The people lived well under him. He came from up north and planted up all the vacant land, reorganized and equipped the plantation, built sheds and a mill. He raised cotton and the whole place thrived. He built good new houses for the people to live in. They called that group of houses Wright's Street. He did away with a big graveyard there used to be all around the big house. There were a lot of people buried in that yard, but Wright sank all the tombstones down underground.

He did well, but after the storm of 1876, the same one that carried away Edingsville Beach, he left Edisto and never came back. All his sheds and equipment stood idle for ten or fifteen years. The people didn't take them over nor use them. The Edings place went to nothing then. When the place started back, it got the name McConkeys. It still goes by that name most of the time. There was a man named James McConkey who came from Canada and worked for William Bird, the paint and hardware firm in Charleston. He worked as a paint mixer there. About 1895, Bird bought the plantation for him for ten thousand dollars.

SEASIDE TODAY

Now, in 1999, a real estate venture called "Jeremy Cay" is what has become of this plantation. The house is still called "Seaside."

When John McConkey came, the people were still living in their houses there, Wright's houses, twelve decent houses, the best on the whole island. They were well satisfied.

McConkey tried to raise sheep there but they didn't thrive. He was not a good farmer. He died very soon and his two sisters came down from Canada to take the place over: Miss Rena and Miss Janie. Frank Hopkinson was their agent for some years, but he died some time before I came back home in 1906, and they got Mr. Mitchie Seabrook to be agent. He came from Central Mill over on Wadmalaw. And they brought his cousin, Mr. Washie Seabrook, over here too.

Miss Rena McConkey used to bake bread and bakery goods and I bought some of her bread to eat at our wedding when I got married in 1909. Then it was about

1910 that she died. In 1912 Miss Janie McConkey burnt up right in the yard there. She kept a stove in the shed and she was cooking something on it. Nobody knew how she caught fire, but she suddenly came running out of the shed all in flames. The people ran up to help her but they couldn't do any good. She fell dead in the yard all burnt up.

Mr. Mitchie and Mr. Washie kept running the place. Mr. Washie Seabrook was up early every day and working hard. Mr. Mitchie was the brains. The McConkeys had one more brother, John McConkey, and he came down from Canada and tried to take the place out of the hands of Mr. Mitchie. He tried, but he didn't do so well. The whole thing went with him like it did with the barrel of pennies.

Miss Janie McConkey had a barrel of pennies stored in the back of one of the sheds there. Brother John came into the shed one day and found them there, "Holy God!" he said. He sifted them in his hand; they were all green and corroded. "I'm going to dry you in the sunlight."

The children on the place, they listened. He spread the pennies out to dry; the children watched. When he went back and took them up, he saw the pennies didn't much more than half fill the barrel any more. "Now, how you shrink up so?!" he said. "The sun hit that copper and it shrank up."

That was the joke those children played on John McConkey; they had been gathering those pennies up by the handful. I saw that thing with my own eyes.

He had a gin house with a short staple cotton machine in it, but he was trying to raise the long. Even if it had been the right kind of gin, he couldn't have run it, not him. He was a funny man and had his own peculiar choice in everything. He would always do things the hard way. He carried his cotton over to Little Edisto to Swinton Whaley to gin.

He thought he would run the place by himself. Run it? He hadn't any idea how to run it. It was Mr. Washie who kept on running it, and Mr. Mitchie was the brains. John McConkey kept on for a couple of years, then after a while somebody killed him.

The place fell into the hands of Mr. Mitchie and Mr. Washie but they never solved that murder. It happened about 1915. At first they said it was a horse that had done it, but then it couldn't be kept hidden that he had been killed in the yard and only dragged into the stable afterwards. They held an inquest. The constable and the magistrate came out, and Marcellus Whaley was the lawyer there. Those men got together and locked up anyone who came out there the next few days. They put them in jail to find out what they knew about the case. The sheriff probably gave them orders about what to do, but he never came out there himself. He stayed in Charleston. They sent a whole wagon load of people off to jail for a year until the case played out, but they never fixed the blame on anyone.

All the people around Seaside had the idea Mr. Mitchie arranged that murder, he and Washie. They killed him or had him killed, then threw him in the stable to make it look like the horse did it, and when that didn't work, they tried to put it off on the niggers. That was foul. Just because they couldn't find the killer, or didn't want to fix the blame on their own, they locked up all the people who ever

came out to care for the old man or see about the place when they heard that he died. Marcellus Whaley had them loaded up into a wagon and hauled off to jail. Only me and my brother, Gus, didn't go, so they didn't lock us up. If I had been a better neighbor and gone over to speak to the people and see about the old man when he died, they would have locked me up too.

Among the Black people of the United States are a lot of sad stories. The literature people are blind to them. They say, "There was never any such thing in America," but there was. The people who experienced these things didn't know how to read and write, but they had good understanding. It is good to try and call these stories to the attention of the literature people.

It was money that settled that case. Mr. Mitchie stood in front of them all and waved that money and that fixed all their minds. He was a crafty minded man and did all those black-hand tricks to back up Washie. Washie was the working man and Mitchie was trying to help him get established as a farmer.

It was as plain as ABC that it was some kind of trick, and that made all the people look back on how Miss Julia died, burnt up in her own yard, and how her sister, Miss Rena, died in the house. They began to think it was all part of the same plan.

After all that settled down again, Mr. Washie took charge of the place and Mr. Mitchie kept on as agent and was the one who made the plans. After a time, Mr. Mitchie sold the place and took his money to Florida to turn into a millionaire.

They made half of that estate into the State Park, and the other half is still called Seaside Plantation. It was Washie Seabrook's half and it passed through the hands of Alonzo and George, his sons, to Admiral Murphy, who owns it today. (*Sam Gadsden.*)

The Edisto community has survived as a civilized people for three centuries, and though as an indication of how this has come about the Christian African settlement at Seaside is important, the murder of John McConkey is too. He is the only white person ever to be murdered for the sake of gain in the history of the island. There may have been one or two killed in duels or a woman or two murdered for love, but no one else for simple financial reasons.

It is true that the McConkeys were followed by misfortune. First Miss Rena committed suicide, then her sister, Miss Julia, caught afire and died of the burns, then the old man was killed.

John McConkey always dealt with a large amount of cash. He did a good bit of buying and selling of cattle and would go to and from Charleston quite frequently. In the evenings as he returned from town he would often stop by Cypress Trees, our home place, in order to rest, warm up if it was cold or cool off if it was hot.

On the evening before his murder it was cold and he stopped by to warm up. He had hardly got in the house when he ran back out and got a black bag from the wagon. My father greeted him and they sat and talked for some time. I was five years old then and remember these things. According to what his habit was and according to all report and likelihood, that bag was full of cash, probably several thousand dollars.

After the murder, an expert was brought out from Charleston to open the safe McConkey had at Seaside, and there was just five cents in it. This led to the idea that he had been forced to open the safe and had then been murdered. There never was any question as to motive, since it seemed so probable that he had brought back such a large sum of money the day before.

Mitchie and Washie were never implicated but another white man was. It would serve no purpose to name his name since no one was ever found guilty of the murder and it was never proven against him at the time. The matter might as well rest there. Mitchie and Washie didn't even enter the picture until 1915 at the auction sale after the murder. They bought the place then. I rode out with my father to the same sale and he bought some farm equipment there. So far as I know, James McConkey had no agent, but he ran the place himself. I never heard that he had any trouble business wise. *(J.G. Murray Jr.)*

THE CHURCHES AND THE WILD PLACES

It was John Wesley who started up a Methodist church right where the Calvary AME Church stands now, in the Burrough. When it started it had all white members, but it didn't flourish so well. After a while the white people gave the church to the colored people. It was the same story with the white Baptist Church. They started one up back in those days, but it didn't hold either. The people who built the church died and after a while the remaining congregation saw there weren't enough of them left, so they just gave the church, graveyard and all to the colored people, and they have it to this day.

What happened with the Episcopal Church and the Presbyterian Church was a little different. Both of those white congregations had two church buildings—one back on the island, and one on Edingsville Beach. All the white people used to go to live on the beach at Edingsville in the summertime in order to escape the malaria, and that was a fine town.

The hurricane of 1876 carried away that beach and it washed into the ocean. When they saw it was of no more use to try to keep a town there, the white people began to sell off the buildings for people to tear them down and carry them away. They gave their Episcopal Church building to the AME Church and the Presbyterian Church building to the colored Presbyterians. The white people gave each of those congregations a church and helped them to move it and put it back up again. They took them apart and rafted them around where they wanted them

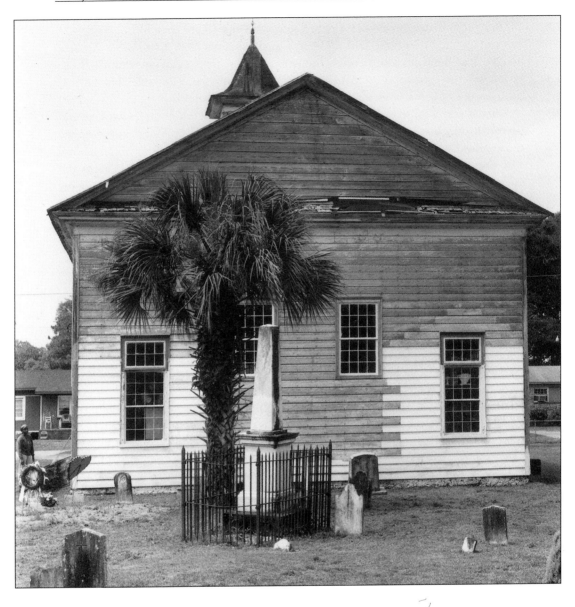

and then put them back up again. The Christian people on this island have worked together from the start. Way back in slavery times the people who came learned Christianity here and it made it a better place to live. That's why the people from over on the mainland and from the other islands have always wanted to come to stay here. There must be twelve big churches on this one little island right now. There is no chance for the island to be divided. It is made one by its churches.

On some islands and in some parts of the country there is a wild part and a tame part. In the wild part there are hobos and murderers and people the law wants, there are jailbreakers and gamblers. They go in to the closed places in the swamp and they hang around there hiding from the law. Where there are no churches?

All the bad people go there. But where the churches are, there is the place where there are civilized people. This island has always been as one, one Christian people, the white and the colored. There are two swamps over on the mainland where wild people live to this day: Four Post Hole Swamp reaches all the way up nearly to Columbia, near about a hundred miles, and then there's Caw Caw in around Hollywood and Summerville. The Indians used to live in there, and a people they call the Brass Ankle people. The Brass Ankle people are a mixture of British Revolutionary soldiers with Catawba Indians and then those people mixed with colored people who ran away from these plantations along the coast. The colored people went to live with the tribes in the swamp. Those British soldiers were called the Hessians; they were some kind of Germans. There is no plain record of the Brass Ankle people, since they are the only ones who know their own story and they are not telling it. They were a private people and pretty wild according to some of the stories.

The Catawba Indians used to rule in South Carolina. They traveled to Edisto to make their summer resort here. They would come to the point above Edingsville on John Jenkins' land and eat sea oysters every summer. When commercial oyster fishing began it destroyed all those sea oysters.

The old chief of the tribes who used to come here in the days when Kwibo Tom first came was called Edisto, Chief Edisto of the Catawba Indians. They had an Indian settlement here until quite late. There is one in York still, a couple of hundred miles up the country there by the North Carolina line.

When I was young, I worked in Florida for some years. There the Indians are not the Catawba, but the Seminole people. I went to visit them in the swamp. That was a place where it was hard to live! The mosquitoes would cloud against your face, a flock of them against each eye and enough to smother your breath against your nose and mouth. I can't see how those people were living there, but they were. Alligators there so thick in the water that it looked like a solid raft.

Both of those tribes, the Catawba and the Seminole, they have fine looking girls, fine looking! But they don't cooperate much. They don't marry outside the tribe. Some men have managed to marry an Indian wife anyhow. Henry Watson, he's nearly as old as me, his mother was an Indian. D_____ who lives here, he is half Catawba, and R_____ who lives over at Red Top is too. R_____ is a fine carpenter and he used to run an old sawmill. Since way back when I was a young man he was bringing lumber in a raft to sell it here on this island. These men are private and keep their own way. And the people in the swamps—some of them make their own laws even to this day. Some of those swamps have never seen a church.

The colored people, after Peace was declared, they covered the island with churches. They never stop building churches; they are building a church right now. There are four AME churches here: Calvary, which was started by John Wesley, then Bethlehem, which is on the land where the white Episcopal church from the beach was put, then Bethel, and Allen. Allen had a missionary bishop in Africa for years and years, Doctor William Beckett. He died in 1925. The AME Church has had missionaries in Africa since Reconstruction times.

Back in slavery days, Sunday was a special day. (Except for Baynard's people. When Jesus finally came to them, they could give real thanks for a day of rest and relief from their constant labor and oppression.) The people loved that church. Once they got inside the building, Master had to come and *make* them come home. If he didn't make them come home, they would stay there all day and all night. They would travel a long way. The people on the Edings plantation, Seaside, would go all the way to Calvary in the Burrough to wash their feet in Calvary Riverside—seven miles out and seven miles back.

Some of the church going was a joke to the colored people. They saw that the Masters' love didn't stretch quite so far as to include them as real Christian brothers and sisters, even during slavery times. And it got worse after that. Master liked to bring them down and ridicule them by getting them into Sunday school and church. He laughed at them, the way they got in their meetinghouse and hollered and kicked around. He was glad to get them to church, and sometimes he was making fun of them that way.

Some people have been writing books about Edisto Island. Chalmers Murray—his great-grandfather is Major Murray who was master to Kwibo Tom—he wrote a book. That book was too rough. It tells a true story, but it is not the complete story. There was no Christian in that book. It was all about some wild

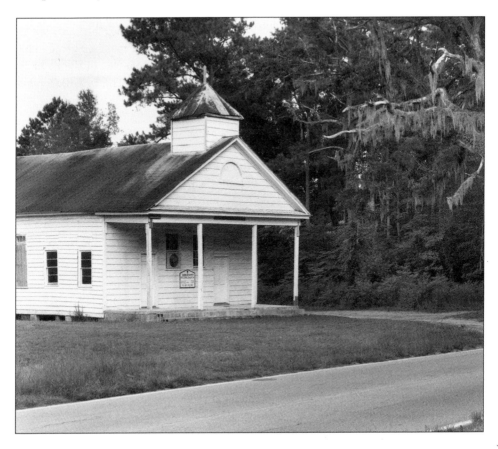

kind of thing, witch spells and violent people. It was an incomplete picture and it held the people up to ridicule.

Mrs. Graydon has written some books too, and they are the same. They are more natural, sort of like a riddle in some parts. Some parts are true, and some parts are just a joke. There are a whole lot of crooked places in those stories. Spooks, haunts, death roots, witch spells—that is not the truth about the island. Superstitious people tell her stories that they don't believe themselves, and then she writes them in a book, and that is not a responsible thing to do.

The old possessors of the island know all about those stories; they are a bunch of old jokey tales that people have been repeating since way back in the early days of slavery. But they know better than to believe in them. Nobody pays any attention to them because they know they are not true. It holds the people up to ridicule for her to repeat them and not include the way the people take them for a joke.

Everybody agrees that the Africans believed in witchcraft. Their religion was half witchcraft. When the white man came into Africa preaching against witchcraft, the Africans listened and believed what he said. But then, when the test came, it turned out that the white man's witchcraft was worse than any they had before then. He bought them and sold them and cheated them and beat the poor fools every way.

Witchcraft has power. Let no one deny that it has power, but there is a power which is far above any small power such as witchcraft can have. The power of the Good News. If a man knows the way of Jesus, there is no need for him to study any spells or any antidotes to spells, death charms or life charms. He is free. The only person who is subject to those spells is the one who believes in them, he is the one who thinks he needs to study them, and he is a fool. The only one who will believe in them is the one who doesn't know the truth.

THE SUPERNATURAL

Ozuzu: When I was raised, 1941 to 1960, we were steeped in the supernatural. It surrounds us. The native practitioners—they were called "witch doctors" by the Europeans—will concoct medicine, give it to your mother for you, and occasionally it would cure you. We had to depend on the native doctors. The difference between the Igbo doctor and the doctor from England is that the doctor trained in England would not claim he could cure *everything*. He would admit that some things are beyond him. But, you see, the native doctor is supposedly operating with "supernatural powers." It is not the herb, but the god that works the cure, so nothing is beyond his ability to treat or cure. The mask, the tricky voice, these don't really impose on the people, but they suspend disbelief. The reason for this suspension, among other things, is a valuable assertion of community solidarity.

Lindsay: As with those who involve themselves in Christian faith healing.

Ozuzu: Yeah. So behind the god is a human activity. And slavery was . . . How shall I say? . . . associated with this activity, since some people who were assumed to be taken by the gods were in fact taken away by the practitioner to be sold into slavery.

Lindsay: What, was the native practitioner implicated?

Ozuzu: Yeah! Yeah! And then nobody ever knew what had become of you, nor why the native practitioner had become so wealthy. The gods were good to him. And the disappeared ones? It was assumed that the gods had taken them. (Laughs) Yeah.

Witchcraft is a heavy charge to lay against any person. To some of the white people who write books, it is some kind of biological curiosity, they say, "Look what jigs these monkeys are playing now," but they all have witchcraft in their own people just a hundred or so years ago. The Salem Witchcraft trials were about people who practiced and believed in witchcraft. In Europe and in England, the thing was going on too. There is no way they can put on airs of superiority except just if they are ignorant of what their great-great-grandpeople were doing.

Some of the books about the island name the names of living people and say they are using witchcraft against one another when they were not. The charge of witchcraft is a bad slander against sensitive and intelligent people, the leaders of the older community here, people who have fought against it all their lives.

During the last sixty years, there has been a gradual change in the churches on the island. First of all, it has become accepted even by Christian people that money-seeking is the normal thing for people to do. From this the second change has followed: the churches have become the place of organization in a money-seeking politics instead of places of worship. Each person and church is pitted against the others in trying to get more for number one. The third change comes from this and the churches are no longer unified and they don't trust one another. And with good reason: the churches have many hypocrites in them. There always were many hypocrites in the world, but now hypocrisy is the usual thing inside the churches. The churches used to bring people together, but now they are a way to power, a way of fighting.

These changes have come about more easily because so many new people have come in from the mainland and from the other islands. Every twenty years there has been nearly a complete turnover in the population. These new people have not had the opportunity to learn the most important lesson of life.

The most important lesson of life is the relationship between the spiritual and the temporal powers and fruits. An education can be of great value to you if you can learn the spiritual arts from it. Most people waste their time on the temporal. They study and they study and after a long time they gain the temporal arts—how to steal, how to lie, how to gain power over the other people. Then, if they are lucky, they become dissatisfied with what they have learned and they go to work and learn the spiritual arts. It is then that they find they had no need of the temporal arts: all the power they ever could need comes to them through the spiritual arts, which put the temporal in the service of the Lord. (*Sam Gadsden.*)

Chapter Two

GONE TO GET WORK

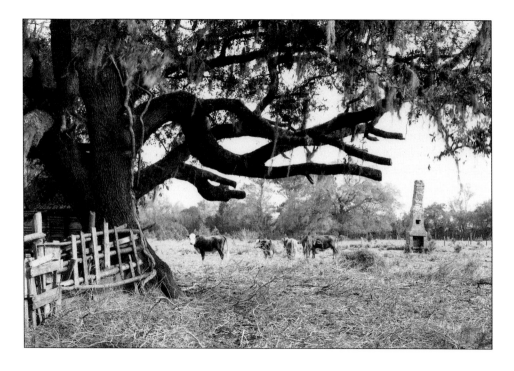

The praying mantis,
Two saffron butterflies in an upward gyre
Are kissing, kissing, kissing. Gum tree balls
Roll underfoot. You eat blackberries with blood-
And juice-stained hands. There is a lazy, deadly serpent:
His odor—musk and manure. You are watched.
Eat chainey briar, eat live oak acorns, sweet
As cashews, meat as substantial as a walnut.

(Nick Lindsay, 1995)

Down to Savannah

My father, he name William Brown same as me. First time he gone off this island it was after the storm of 1893, before he ever marry my mother. The whole place—torn up and can't make no crop. Didn't have nothing to make it with: no mule, no tool, no implement, and the land all mess up with salt. And factor can't help. Back then they have somp'n call factor. He give you food, give you seed and supplies. The first shot he take you from first of year up to June, that get the cotton high, then he give you the next shot up through harvest. You give him your cotton then and your credit will be good right on for another year. You can get credit from him, get lard, get grits, butts meat, flour—what you need to eat. But after that storm, can't make no crop no how, and my father leave out. A whole army of the young men left out from here.

He gone to work at the rock mine, the phosphate mine over at Red Top, call it Rock Field. He work there a while, make good money. Then the next year he come home again, help his old man. They make a good crop that year and the next. He farm and farm, and after a while, get married. Eighteen ninety six. Then he do just like I done later on, he plant that year's crop with his daddy, and as soon as that crop is up, he gone off to try to get some kind of wages for us.

My father gone off to get work before I could know him again. He get a job, work in Savannah, Georgia, a place they call Center Road, where they load and unload ships. He load lumber, cotton, rosin, steel, pig iron—anything that come through there—a king stevedore.

One day he send word to his father and tell him to bring my mother and the three children down to him in Savannah. That was me and two girls. I been about five years old. My youngest sister, Isabella, die in Georgia; only two of us come back. When Daddy send for us, my grandfather take us to a boat, name the *Islander*. We get aboard—middle of the night, right up here at Steamboat Landing. The *Islander* just make the trip between Charleston and Beaufort. That next morning she anchor at Beaufort until she could make connection with the boat they call the *Hilton Head* that run on down to Savannah. I ain't even know my daddy till I meet him there in Savannah.

In those days I like to watch a parade, any parade. I like to follow them. Day or night. One Sunday I been out in front of the house and here come one these big funeral. I see that parade, I say, "Awww shucks! I am going to follow this one." But I ain't know where in the Name Word was it going! I follow that parade all over Savannah, Georgia, in God's name! I ain't once think about turn back. If it had of gone from there to Charleston, I going to follow it. I ain't have sense enough to notice which streets I been walking on; I ain't even think about coming back. I was the big-eye bo, figure I would follow the people back like I follow them out. We live in Yamacraw and I follow them all the way to the Fort! They have a place there they call the Fort where they bury people. The place is just full up with gravestone, so many people bury there. I was just little, a two-bit boy, and I did respect those

graves! I wouldn't step over one, no sir! I walk around this one, walk around that one to get to where the parade went to. It take me a long walk. The first thing I know, before I even get there, everyone gone and left that place. I never see a funeral break up so quick! Leave me all alone there! Hah! Leave just every which a way, gone, gone! Ain't but me one left, me, jumping graves. Way God! What a time for me!

How could I know where in the name of heaven I come from? Ain't nobody live out there, none at all. A lonesome place. Trouble was on me then, for it start to get dark. I start to jump right square over all them grave. I come out of the graveyard all right, but which way must I go from there? I ain't know which road I come by. So I cry and I walk, I walk and I cry. That night I don't know where I didn't walk. It was a graveyard out there after night—black as midnight. Ain't been light one. Out of the city limit all together.

In the meanwhile, my old man go everywhere. He go to every police station, try to find out if I was lock up somewhere. He couldn't find any place where I had been.

I meet a cop and he ask me where I live. I tell him I live on President Street, number 12.

"Well, you a way off from there." So he start in and walk me home. Walk every step of the way, ain't take me in no cart and horse nor nothing. He bring me on in home about three o'clock the next morning. I had been gone since eleven

o'clock that day. I don't believe I had a dime in my pocket. That cop bring me home, knock on the door, and the old man come out.

He hadn't given up, but he just couldn't hunt no more. Then there I was. He say to the cop, "Well. I been hunting all night until I give up. I been hunting all over. I don't know what to say. I couldn't give you thanks enough." And the cop leave.

Now the old man get ready to give me a good chastising: "And why did you go and walk clear to Philadelphia?"

I tell him, "I just like a parade. I didn't know it was going that far."

He give me a good chapter and I been afraid he was going to lick me. He ain't hardly lick me any time at all. Once or twice maybe in my life. But when he do, then he would be mad; every lick he cut me, I spin around just like a top. Then I run, crawl up under the house, spend the day, hide up underneath there. But this time, didn't give me no licking. He say, "Well, I would lick you, but you already cry so much."

After that, I didn't bother with following parades much.

About nineteen o one Papa send for us to come to Georgia and after that I been in Georgia for eight years. Ever after that I like to go Savannah and work. I gone back and work there many a time since then. I know every spot there is in

Savannah almost, almost every place in the state of Georgia. They get me to lead two different Sunday excursion from my church back in the nineteen forties. We hire a bus and get down to Savannah; I show them the city. All that make money for the church, you see.

So then we were living in Savannah. The old man had tell me not to play out in the streets. He give me the devil about being out late: "When evening falls, you come home." But I couldn't listen.

One evening there was three of us up on the porch of a house just down the block, play with some girls there. One of the girls tell us to go home and she had some water with her there. "You don't play here no more," and she throw the water right at us. I jump back, didn't look where I was going, and I stumble all over a policeman. I mean, stepped all over both his feet.

He grab me, "Who the devil you? And where the devil you come from?"

"That my house, right up there."

"We'll go to see your father."

My father was just then back from work, hadn't eaten his supper, hadn't even got cleaned up. He come to the door, "Chief, what he done? What did these boys do?"

"Ain't do nothing, only just walk all over me. I don't like that. I'm going to lock him up."

"Best take him on in then. I got a lot to do still this evening." And he gone back in the house. The police have me by the collar; he gone to the call box. He start to call up, but before he could get an answer, he just turn me loose. And bubber, you better believe I beat it back home!

Oh, I was bad in those days. Hard headed. I was tough. I just didn't care. I did all kinds of things. Sometimes I went out across into some other streets from where we stay, roller skate in the night. President Street where we live is all round rocks, cobblestone. Ain't have no real pavement. I can't skate on a thing like that. I go get on out on the main road to skate in the night. I skate all night till the cops run me home. That is where the police had their job then, all the time run you off of those foreign street, chase you. There is one we call Sneaky. I don't care how fast you were, he would sneak up on you. He was a slim fella, not mean, but he was tall. And sneak? I don't mind how you did sneak, he would catch you.

One night I nearly give up on the skating. I gone out there to skate. As night come on I pick Saint Gaul Street to come back home on. That might have been all right, except for the studient. In the city of Savannah they had a certain month of the year, somewhere around in December, January, along in there, when they used to turn loose the studient. They let them catch people. For that one month, you stay in that house. You're not coming out of there. If you come out and that studient catch you, you no more see, no more hear. The studient, he was lord in that one month. That was back in nineteen ought five, nineteen ought seven. I don't think they do anything like that any more. But then, and in that month, you can't go out in any part of the town. They turn loose them studient—they were young doctors or something like that. They long to catch you; they catch you and they kill you. Those young doctors get their experience like that. The man allows

them one month out of the year to do that. He warn everybody, "Now don't you go out there. If you get caught out there, it will be your hard luck. Nobody will say anything at all: you have your warning."

That one night I skate, I skate, skate, and then I get on my way home along Saint Gaul Street. Many house and he been high there, big two and three story house, make the street dark along that side. I stay on the dark side of the street and sneak along. I get nearly home, maybe a block away when I look over on that light side of the street and I see a buggy there, one of them buggy got rubber wheel—can't never hear them when they move. I see a man jump out, and boy! When he make after me, I am gone! I mean dead! At the first thought I know I had no right out there because my daddy told me not to go out there. Oh no. I couldn't pay no attention to him. But when that man jump out, I remember clear enough. I start to run, and he to run after. I run, I run, I hear his feet behind me. "He go nab me sure!" Each step I jump up three feet above the ground. That man run me right on to my own house door. I get home, I slam that door in his face. Turn back? He gone. I stay home the balance of that month. I bet you I ain't gone out no more! No, no!

When I was little, I was troubled with a hard head. The old man would tell me, but I couldn't listen. This was the last time though. I didn't give him no more trouble.

My grandfather had a cotton gin on Edisto Island. About nineteen o nine age begin to come strong on him; he saw he must get help. He couldn't run that gin no more. He send word for us to come home. He want to turn the business over to Papa, for he was the oldest son. Papa saw it would be a permanent move: he send us all back home while he stay on for six months, get all the furniture, the house and all straighten up before he come on. My grandfather own the gin house in partnership with another man, William Fitlin, and he want to turn his share over to Papa. So, that is what bring us up from Georgia. (*Bubberson Brown.*)

THE MINES

My daddy and my wife's daddy worked at the Rock Mines, the Bulow Mines is where they worked. Daddy worked through the week, and came home on the weekends. The wages were very high, though only a little of the money paid to the men got home to Edisto. They were paid by the pit. Two men would pair off and work together and they would be paid according to how large a pit they dug and loaded onto the cars. The rock was put on tramcars which ran on a narrow-gauge track out of the mine. Many men came from John's Island, Charleston—all about. They came by row boat from Edisto, and on the weekends they rowed home to Steamboat Landing at the end of Wharf Road. The present generation of people

will still know what has happened after fifty or sixty years, they heed events: those people back then didn't care for anything but that one day, and no one remembers now what that day was. (*Solomon Brown.*)

There was three of them mines: Pon Pon, what they call Pon Pon, and horseshoe, and the third at Old Parkers Ferry, The Old Virginia Mine. The line of phosphate rock run right across the county, right through them three mines. I was eight years old and them mines was a-runnin. I wake up one day, I asked my daddy, "What's that racket and a-rumbling?" Twas the washer of the mine, washin' rock. Hit was the roughest kind of men come in to work there—Irishmen, Italians, Polacks and all—some kind of furriners hit was. Couldn't hardly understand em when they'd talk. They had what they'd call kittle. A big pail or somp'n, and they just cooked out in the woods. Camping out. They even eat buzzard. They catch and eat a buzzard just as soon as you er me'd eat a turkey. That's just the way they was. Knock down a buzzard with a shovel er a rock, set up three sticks into the ground to hang up their kittle, build a fire and cook him right there. Hit was a rough and mean crowd—most too bad for these Edisto colored to work with. It was men from them railroad crews looking for work after the railroad was finished.

The first man to start them mines died around nineteen ought seven. He come here before the Civil War. The place he come to—he showed hit me—hit weren't nothing there only a thick tangle of underbrush and some nails stuck in a tree where he used to tie his horse. Hit was up in the dimmest, most out of the way corner of the swamp up there near Parkers Ferry. The old man come down here in the eighteen fifties to see if there wasn't some way for him to make it better around here than upstate where he come from. He found him that little place and went and brought back his wife and all he owned down in a little old two-wheeled cart. When the Civil War come along, he was conscripted, but he sent his son in his place, and he sold whisky to the Yankees. Why, they was all hereabouts, don't y'know! Yankees all in this place in them years. He sold them whisky all through the war, got a good price too. The Yankees had a-plenty: if they couldn't pay with money, they could pay with something else. They would come and catch up a man's cow, take his corn and anything they wanted.

That old man got him a herd of cows off of them once. Our people come on them once when they had a great herd of six hundred some odd cows out in a field, which, they call hit Battle Field. Our boys went to shooting and run them Yankees off up through the county. There was just baskets and bags and boxes of groceries and things to eat laying all about. Old Man D____ took and rounded up them cattle and kept them over at his place. He kept right on a-selling whisky until, when twas over, he was rich. And the only man about who had any money at all. He bought up all that land around Parkers Ferry at twenty-five cents an acre, and then turnt right around and sold the phosphate rock offn it and made just piles and piles of money. Sold it by the pit, don't y'know. Old Virginia Rock Mine. (*Mr. Crosby, who used to run a crossroads store on the mainland.*)

Before he came home to farm, Daddy went to work at the rock mines, the Bulow Mines. That was in the 1890s. He worked in a supervisory capacity. It was a pretty rough crowd that worked there—Irish and Italians and Colored. Every Friday evening and Saturday they would spend drinking, gambling, and fighting. They had a killing over there every Saturday night. Didn't miss a one according to what Daddy said. The company had a rule: the men could get money on Monday morning, an advance on next Friday's pay, enough for food and tools for the week. They did that because most of the men would have gambled and drunk their wages all away. They got a good wage, but it would be gone by Monday. Invariably the ones that made the most wages and worked the hardest had the least left by Monday, and the ones that were laziest and hardly worked at all had the most. That was the professional gamblers that had ended up with the money—they didn't need to work. (*J.G. Murray Jr.*)

WORKING IN THE SWAMPS

I completed my education—the fifth grade at the school that stands now across from Grant's store. That was the top grade for us here in those years. I worked a little around the island, then about 1898 I left and went to follow construction work over on the mainland. I was in my teens and early twenties. We built all in the swamps in Georgia and Florida. I did all kinds of construction work. If I came to a place and liked it and could make a few dollars, I would stay. If I didn't like it, if it was a wild place, I wouldn't stay. I would go back to town and by the next Sunday I would be back home again. Sometimes the contractor would take us forty miles down a little railroad track, deep into those swamps and out of the way places. When the train stopped, I would look out, and if I didn't see a church anywhere, I might not even get off the train. Or if I did get off and couldn't find a church anywhere around there, I would not stay long.

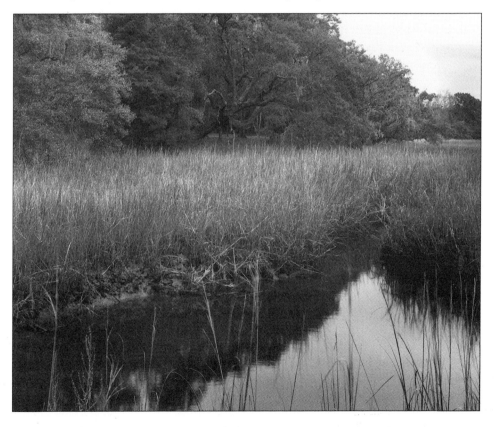

It's not just because of the way I was raised that I did this, although that had a lot to do with it. Yes, immediately when I would see a church, I would feel myself at home. But if there was none there, I knew I was off my beat. I would leave that place as soon as possible because that was a dangerous place.

It was dangerous because of the kind of people who lived there. They were the murderers, gamblers, pickpockets, men who just got out of the penitentiary, and everything low that wrecks people. They had come in there and they hung around just in order to get money and to hide from the law. There might be money there, and there might not be any, but money was their reason for being there. That was a money jungle where all those rogues and thieves hung out. Money was their only reason for going anywhere or doing anything. They are dangerous people.

But if a church comes into a place like that, those people aren't going to stay long. If they stayed, they would have to confess and turn away from their reckless way of living. So they get out as soon as a church comes in.

I quit that work in 1906. I had worked my way down to Fort Lauderdale, Florida, and one day I accidentally met some cousins of mine who were working on the railroad down there. They said, "You ain't heard the news?"

"No, what news?"

"The *Marion* gone down and drowned half the people of Edisto."

That sounded pretty bad. The *Marion* was a boat that used to carry passengers from Charleston to Beaufort and make stops at all the islands along the way. I went back to my room that night and wrote home to my mother to find out about what my cousins had told me. She wrote me a long letter and she could tell me a whole lot since she knew the people who drowned. I came home right after that and I have been here ever since. The sinking of the steamboat *Marion* just before I came home helps me keep track of that date. They built that boat back, gave her a new name, name her the *Islander*. (*Sam Gadsden*.)

LEAVING FOR SAVANNAH

I register for the draft in World War One, but they didn't take me. Then in nineteen seventeen was my first trip off the Island. That was my youngest traveling. I left from here in December of nineteen sixteen. That year they had a kind of depression, they call it the Panic of Seventeen. All the young men leave the Island. Here in this neighborhood, all my friends are going. I going too. I was eighteen years old. I tell the Old Man, "I will go down to work in Savannah. I know every corner of that place. Georgia is a good hiding place for me."

Old man say, "Go, maybe, but don't you run off."

It was night, dark outside, I say, "I ain't a run off, but I tell you I going and I will go."

Mama start in to cry. Papa, he start to cry. I gone through all that cry and I crying too. It was twelve o'clock at night when the boat leave and we gone, I and all them other boys, left out for Savannah.

Get there to Savannah and ain't but me one find work. Them other boys know panic for sure. Ain't nothing for them but to smoke cigarette and drink whisky; they can pick cigarette butt up off the ground but they can't buy no whisky.

I get a job the same night we land in Savannah, I do the same thing I been doing back home. Work for a gin house there. If you think you ever see a gin house, you ain't see this one. It stand out in the country at the edge of town, run day and night. Put him here, he take up the whole Shago. Lord, Lord, what a going in the night! Like a whole city under that roof, all belt, belt, belt and noise and dust. They got forty gin under that same roof. I gone right there and start in. Ain't got no boiler in that gin house. Got a big old six-foot-wide pipe run from down on the river up to the gin. Make the steam down there, run him up through that big pipe to the engine in the gin house.

I work regular, ain't lose no time. They run steady, night and day, seven days a week. One time I start in and work all day Saturday, all night Saturday night, and right through all day Sunday. By the end of Sunday I was like to be starved half to death. Man laugh at me there I so hungry. Ain't have nothing but peanuts, boy come around, sell them there. I eat peanuts for my meal that day.

I ain't there long before I have a good, solid job. Some of the men been there longer than me grudgeful that I got that job stead of them. I fix anything if it ain't right, I take sample from the conveyors every half hour, and I run the press. If something too bad, I call for the cooper and he will fix it. I was there a month, maybe more, work in the night, things going good when I like to have hit the end of the line. I was resting between task one night when all of a sudden a boy holler to me, and I look up to see the conveyor belt—must be sixteen inches wide—been throw off the pulley. Lint and trash and all been built up, built up until it ball up and throw the belt off the pulley. I climb up, I must walk on a kind of catwalk, stand on a platform. That the way I go to catch a sample each time. Platform about four foot wide, stand high above the floor. I climb up and throw that belt back on. But my hand catch between that belt and the wheel. Pull and pull, belt try to run, he got my hand and arm all suck up in there. Lucky for me he jam there. Belt and pulley stall. Hadn't been for that, he would have carry me up, over the top of that big pulley and down on to that concrete floor fifteen foot down there. Or tear the arm off. Lucky for me that night. I holler, I yell. Had of been some of my boys from home, they would have cut that belt. Man there was grudgeful of the job I have. They would like to have it, glad if I hurt. I have a big old knife; got a six-inch blade, and heavy. Most too heavy to tote. And sharp? I out that knife, open him with my teeth, cut that belt right slam in two. That arm mash just as flat as my hand, that belt and pulley mash him out like biscuit dough. The man tell me, go to doctor. I look at the hand: he ain't broke or nothing. I didn't go. Just work right on. That could have be the end of my journey right there. But boss and all—they were glad I came to get that job. I know that kind of work.

I change jobs, work for the Sea Island Cotton Press. That's a place where they re-press the cotton bale. Got to make it smaller. They press it down until it's no more than half the size of the bale you made at the gin house. They got to re-press it over again and make it that small to go on a ship. I was the press man, pack him at one shot. That press ran off a belt. By the time I had one bale out of the press, the next one was ready. It was fast work, and I liked that. But it was dusty. That whole place was fill up with dust. I have to wear a mask, but even so it got to me.

I never had any trouble keeping myself in a job. I had money even though in them days is what you call a recession and ain't no body got no money. Been a whole bunch of us down there in Savannah and only me one been working regular. That whole army of Edisto men in Savannah and out of work, and they want to get home. Along about March I was in a notion to come home too. I had money, I could pay my fare, sure. But what about them boys? I figure out a way. Carry a few, anyway.

I had been working down at the boatyard, work on the *Cleveland*—a big ship been up on the ways to fix, caulk, paint. She is the one that run regular from Savannah up to Beaufort. They must take a different boat, take the *Brigantine*, and make that run until the *Cleveland* is ready again. This one trip she would run all the way up to Charleston. The *Islander* been laid up too. That was for just that one trip and they need a crew in a hurry. Didn't have no deck hands. I tell four them Edisto boys, "I go as cook on that boat, and I get you on as deck hands," and in the meantime I tell the captain of the *Brigantine* that I could get him a crew that very evening. He agree to it just that way, them boys as deck hand and me as cook. I to prepare food and wash up the dish for both the crew and the captain and mate. "I will pay you all after we tie up in Charleston," he said. But we ain't study about that pay. We have it fix up among ourselves ahead of time that we wouldn't even see Charleston that trip. Besides, I was near about half sick with that gin house dust, had a fresh cold and a fever.

Gone to get aboard, three o'clock in the morning. Gone along the dock there—oh Lord, here he come, police! "Open that bag." I open, he search my suitcase, look for a gun. Ain't find none. Search and search but ain't find him. Search for whisky too, but I ain't had none right then. In that time you must write off for whisky. You send in your name and get two quart. I send in your name and get two quart for you and two quart for me. Well. But ain't had no whisky then. We get aboard and leave five o'clock that morning.

I didn't like that work very well. He had me to feed the deck hand first, feed them right there in the galley. Then, there was a little elevator, a dumb waiter, that ran from right over the stove to the cabin overhead. I must pull up the food, plate, knife, fork and things on that elevator, then run up to the cabin, set their table and serve their meal. The captain say, "Any scraps, you throw them overboard." But I didn't do it. All that good food? The boys in the crew, they all had family back on Edisto who have plenty of use for that food. Because, you see, our plan which we agreed on ahead of time was to leave the boat just as soon as she tie up at Steamboat Wharf.

We stop at Beaufort, then we leave on from there, come on and tie up at Steamboat Landing here by twelve o'clock noon. He ain't have no freight to unload nor load and tide still rising, so captain say we can eat there and then go on to Charleston after lunch. Go on? He did, but not with any Edisto man. I cook for deck hands, then put the things on the elevator, pull on rope and send them up, feed captain and them. While captain eat, them boys, one by one gone up the road. Walk slow, get out of sight, run home. Each man had his suitcase packed—all over the deck in that galley—suitcase, suitcase, bundle, box. I don't think them boys could tote that suitcase up that road that fast. Must be they run up on somebody have a cart there, put all them suitcase in that cart and then walk up there, them with they dry hand. When I gone to serve the meal in the cabin, all those boys took off on the blind side of the cabin. They long gone. And just as soon as I finish wash them dish, I take off myself. Take my suitcase and gone up the road. I knew the time was close, but I didn't want to leave no dirty dishes.

I jump off the boat and get to the turn in the causeway there on Wharf Road, and Whooooooo! Whoooooooo! The captain can blow till his arm get sore, none of us showed up yet. There was a fella going there with a mule and cart. I jump in and he carry me on home. I gone and left my wages that day Them boys ain't got none either. We figure he had a fair bargain, since he didn't have to pay a penny for his crew that trip.

I ain't had to take no cook job: I had my money I made in Savannah—I could have pay my way home. Ain't had to send no money home that trip and I live with my Auntie in Savannah. Ain't had to pay no rent. I only take that job as cook to help them boys get home. (*Bubberson Brown*.)

Working in New York City

I always feel like traveling, and after I was married, it was the same. I farm through the summer, soon as I make the crop, I pull out. I went to Florida, to New York, or to Savannah—all about. I would go out and hustle for about four months and then come back and farm another year.

In the fall of nineteen nineteen I was in Jacksonville, Florida. I worked for a soft rock plant, a cement plant there where they make portland cement. They roast rock there, turn it over and over in big drums, then it comes out and goes up on a conveyor overhead to where it dumps out in some big hoppers they have there.

Every half hour I had to catch a sample of that cement in a paper bag, go out in that hot dust and bring in a sample. It was easy work; that was all I had to do. Standing that thick dust was all. I got a dust mask so that dust wouldn't sicken me, I got that mask here about the house some place right now. By spring I was back on the Island.

I had an auntie, Christina Bailey, Bella's sixth child. She lived in New York and owned some property there. In nineteen and twenty-two she sent for me to come up there and help her for a while. I got ready and in March of that year I went. Went there by sea, the S.S. *Comanche*. She was the oldest ship on the line. She was known for always getting into a bad storm every trip. I had heard about it; I went on ahead and took that ship anyhow, and she did it again. Why did I ever take that boat? I knew better. As bad a storm short of a hurricane as you ever saw. The water flowed across the whole ship, from one end to the other. That was something for me, to wade in water up over my shoes so I could get from the cabin to my berth. After I got up to New York I was living with Joe and Christina Bailey.

I went first to the Pennsylvania Railroad, they have that big old station on Thirty-Fourth Street. I thought I would stevedore for them. I got the job right away. The first day or two a man says, "You got to work here a month before you get pay, you know. And after that they pay off just every two weeks."

"I didn't know that. Had of know that, wouldn't have start in here." I put in my time and I quit. Went to the Baltimore and Ohio Railroad: "Say, mister, ain't you got some space for a man to work here?"

"What you got in mind?"

"Stevedore."

"We are all filled up with freight handlers. Say, you work nights?"

"Yes sir. Day time or night time."

"You be back here at five o'clock this evening."

That's what I want to hear. I got on the underground train, the subway, and head home, One Hundred and Twenty-Fifth Street. I sat down, I drop off sound asleep. Wake up and that train was way out in the Bronx, high in the sky. They have an elevated portion of that track there, but I didn't know that. I ask a man, "How? What can I do? Can I get out and change back to downtown train?"

"No, you just stay on this same train. You already at the end of the line. Train going to turn round."

That's the last time I go to sleep on one of them. I got to my auntie's place, ain't no use to sleep. I just hang around there, play the piano all the evening till time to go to work.

I went back there, started in that night, and didn't miss a minute for near about two years. I was a header. I meant to be the best man they got. They got so they let me hire what men I wanted. I would go out and hire two, three men. Boss told me, "Yeah, go get many as you need, just so they work like you do." I could hire them but I couldn't fire them. Before you fire a man up there, you better be ready to pay him off. Near about all the men around here worked with me one time or another up there. We unload northbound in the night. As each box or crate comes

out of the car, I stamp it, which car it is supposed to go to, and check it off the way bills. Sometimes we work on through that way till day break, pull ten or twelve hours. More often we quit by three o'clock. I go on uptown and go to bed, sleep till near about noon, get up and get on back downtown in time to hit it again by five o'clock, load up those same cars with westbound freight in the evening.

In June, after I get things more or less settle, I sent for my wife to come. She bring one girl and leave the other with her mother. Nineteen twenty-five, and our first son was born up in New York at 55 East Hundred and Thirty-Third Street. I was just in the season to get my own place then. It was on One Hundred and Thirty-Fourth Street between Lennox and Fifth. I just was in trim to get that one. It was a furnished apartment. A fella had had him had run whisky there; he had him fix up very nice for a family to live. He quit with the whisky just then, that's how come he let me have the place. We were all lined up to move when bad news came.

A special delivery letter came to us there: the Old Man had got caught up in the belt and his arm was all mashed. That big old belt tore that right arm up. He couldn't work a lick. He told me to let my wife stay there in New York and come back and help him. The gin house was jammed full of cotton and couldn't nobody run the gin but me. I wasn't about to leave my wife. We are married and where I go, she goes. I straightened up for three or four days, packed up. I didn't have but

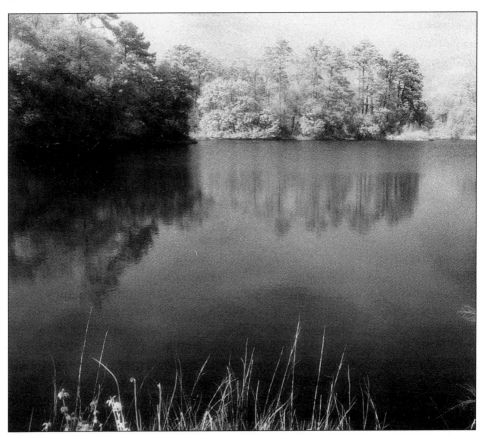

three children then and one of them was down home already, I said, "Maybe I can get us a pass, travel that railroad free."

If a man had worked three years for the Baltimore and Ohio Railroad, he could get a pass. I had worked just shy of two years—one year and ten months. I went to the man.

He said, "Well, William, I gotta hold on to this. We will have to look into it."

"Let me use your phone a minute." I called home, "I don't know if they are going to give me a pass or not."

He heard me make the call. He said, "Aw, let me check this record. Come back this evening and I'll tell you all about it."

I went back uptown. That evening I came back down there. "William, I have checked the record up and down and I see that here's a man who hasn't missed a minute in all the past two years." He let that sink in. "You can get the pass for you and your wife and just whosoever you want to carry with you."

"I ain't got but me and my wife. The other ones are small and won't be much bother."

He wrote me out the pass and I came on down, back here to Edisto. The Old Man was sick all that long year with that arm. He didn't have but the one son now, and I'm the one. That big old gin house was full of cotton; it would gin out twenty-five and thirty bags a day. And I had all the work that year; the Old Man couldn't do anything. I ginned all the cotton out of the gin house and the season was closed.

By the next season, Papa was strong again and didn't need me to run the gin any more. But I had prepared myself to stay home until I saw all my children pretty well grown.

Those years I would plant all kinds of things—sugar cane, corn, sweet potatoes, white potatoes—all things to eat. Besides I plant a money crop of cotton. It was just a little crop; my wife could tend it. I would get it into the ground and then leave out for New York. In New York I work for my sister and Matilda Bailey. Matilda Bailey—she daddy Joe Bailey used to cook for Mr. Connors Mikell. I care for them, do all their work. They own three building up there: the first they buy is on One Hundred Twenty-Fifth Street and Fifth Avenue, then they have one on Madison Avenue, and one out in New Rochelle. After they got the first one, the rent come in from it to help them get the other two. I could have work to employ me all the year if I want him, just keep up their property.

They have me fix up their New Rochelle house, remodel basement, move pipe and all. They want to make it into apartments there. I have a man to help me who was bad about wine. They put something in that cheap wine to make a man go crazy if he can't get it. We go to work: I got to give him some wine to get him started, or else he's too nervous to work. But as soon as he get that wine in him, he can't do nothing nohow. I just had to let him go. He was a cousin to us all too. If you can get him to drink whiskey it won't do him so much harm as that cheap wine. Had to finish that job by myself. Get it fix up for them.

We get together for the first time in nineteen seventeen, Matilda Bailey, my sister and me. They were together in Savannah when I was there. They leave from there

in nineteen eighteen, pull out for New York. I didn't get up to New York until nineteen twenty two when her mama, Christina, send for me.

Plenty of people from here have property up there. My uncle have a house in the Bronx. Clinton Avenue right by the Boston highway. They cut that highway through there, it cut a two-hundred-foot swath straight through all them houses. He end up beside the pike. House go halfway from here to my daddy's house, big old house! Have a iron rail round and round him. That man make some money now! Drive a truck, a van, three long distance trip a week, up to Albany and there. He make a good wage, but the most he get in tip. One year he ain't work a lick. Take the whole year off and it ain't hurt him at all. My wife, cousin, and her two daughter stay there now. (*Bubberson Brown.*)

Chapter Three
ISLAND LIVING

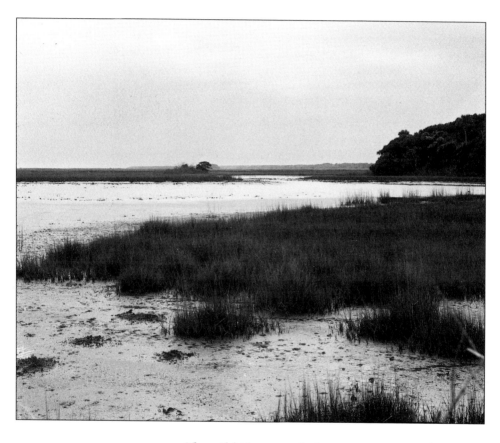

The wild place speaks its own mysterious language,
Place of panic, place of blessing.
Dive into the black swirl of the tide,
Touch bottom at the middle of the creek.
The small shrimp take small bites, and you catch nine
To eat. If there's a gator or a shark, he will
Return the compliment. Welcome home. Join
The wild place, the mystic food chain: Edingsville.
(Nick Lindsay, 1995)

GULLAH: A SONG LANGUAGE

The uneducated people here speak Gullah. The language of the people has changed according to their education. When they were not so educated they lived according to tribal law. They were ruled by a leader who had scarcely any language at all—just some kind of strange, funny talk—yet still they were ruled by that. If you were a leader, you would have a dozen or maybe twenty followers, and you would look out for them and care for them. The people here lived that way until they got a little bit of education.

After they got some education, they still tried to be nice, but they didn't pull together any more. They separated themselves according to education. An educated man will have very little to do with a person who speaks Gullah, a man who speaks some kind of strange, funny talk like I do. He laughs at a person like that and names him by all kinds of names. The English-speaking people and the Gullah-speaking people have separated themselves more and more. Though some of the young people even go to school for years now and don't speak good English.

If a child is raised in a home that speaks clear English, that child will speak clear English and he doesn't get it from any school. A child who speaks Gullah comes out of a home that speaks Gullah. That Gullery is in that child and he has trouble getting better; he just really can't do it. It's the home he has come out of, his environment. He comes from Gullery stock, just as the one who speaks clear, plain English comes from plain English stock.

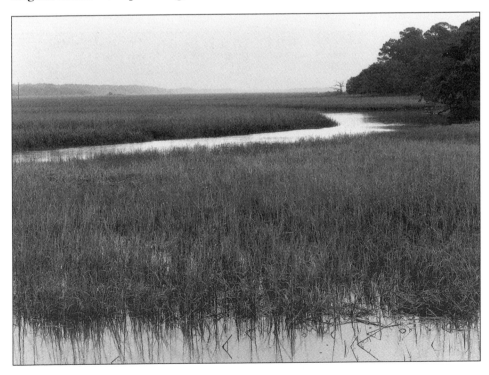

When I was young I didn't speak Gullah so much, but when I was about twenty years old I came back from working in Florida and caught whooping cough. I nearly died and when I came back to myself my larynx was weak. I couldn't talk straight sense; the only thing I could speak was Gullah. I was weak and couldn't make any long sounds, just short. I have been speaking with some Gullah ever since then.

If you get the full Gullah, it's a song language. That's the deep Gullah. It is a song language and not a deaf language like English. The speaker of a song language doesn't mean exactly just the words alone, but when he has once spoken them, he really couldn't have said it any better. If you catch the song, you can tell exactly what he means. (*Sam Gadsden.*)

DISCRIMINATION

Ozuzu: This discrimination against a person or against certain families because of speech patterns is very much the way we were conditioned when I was a child. It is very Igbo.
Lindsay: Gadsden implies a caste difference. These children might make it economically and even politically, except only it would never be as though they were really . . . ah . . .
Ozuzu: Native sons. Is it a caste thing, this discrimination because of language? Perhaps it is. This is one of the paradoxical things about the Igbo system. Even though we do not tolerate second-class citizenship, it is not uncommon for Igbos to discriminate on the basis of language, of vocabulary, of pronunciation. If you mispronounce words, they will laugh at you. People will say, "He is not really Igbo," even though you are from Owerre. His mother tongue has sunk his boat. God help him if she is Yoruba, or worse yet, as in our case, American. This is very Igbo.
Lindsay: It's also very Southern, as in the southern United States. "Well," people tell me, "You're not from around here, *mister*, that's easy to tell." I suppose what's called "Southern" in the United States is frequently of African origin.

CHILDHOOD MEMORIES

When I was little, I was troubled with a hard head. I was born right up here—Shago. Eighteen and ninety seven. Freedman's Village. We call it Shago. The Island—just coming back after the storm of ninety three, and my father—he gone off before I know him.

I did know him once, so they say. How I lose the memory of him is this: One time Mama put a pot of hot water on the table and I been big enough to pull that thing over on my self. It seem like just before I pull that boiling water down, the old man coming with a cart load of wood. That all I know by now: in the evening, a man coming with a cart load of wood. Can't see his face. I pull that pot over, burn my whole head, peel off the entire face, every bit of skin I born with. I might

have been two year old. All that skin grow back, but look like the memory of him had gone from my mind until we meet later on, down in Georgia.

Another time I run off. My mother and father work then, work so hard down at the Neck, go there all day every day, leave me at my Grandmother house. I like that all right; she feed me good. About dark Mama and Papa come, they get me, bring me home. Mama in the kitchen, mess around, fix supper. Papa sit down with me, drop off to sleep. After a while, Mama sit down, drop off too, both they been so tire out. I gone then, out in the dark, try to find my way back to Grandmother house. I believe my stomach guide me, gone to get somp'n to eat. After a while, Mama wake up, ain't find me no place, wake up Papa. About midnight they find me. Canal there, pond there, they been afraid I drown. I was out laying in a ditch, fell on my face and hollering. My grandmother hear me, gone to find out. That the first time I leave home, ain't gone far. (*Bubberson Brown.*)

SCHOOLING

Never had no schooling in Savannah. Just here on Edisto. About three years in a free school, but mostly it was Reverend James Johnson's house school. That was the first school I went to. He keep it in a big old house in Freedman's Village near

where Oyster Factory Road leave the beach road now. He have a good big piece of ground in there. His son, Buddy Johnson, build a house there after a while. There was a whole settlement along there then. A blacksmith shop set right by the school. Reverend Johnson was a Baptist preacher, and he was smart. He have a big church set in that curve by where they build Jane Edwards School, the new school, a church called New Jerusalem. He petition round and round up in New York, Philadelphia, and all for support. He had a school for grown people too, teach them to beg and go to get clothes and all. The government give him money to pay his two teachers. His wife a teacher too, that make three teacher work with us all the while. His wife—my cousin—come from Saint Helena. He get all these books and pencils and paper from the federal government or from the state somehow. He tell the government that he will keep a school and he make it a good thing for him. It might be the state or the church exercise some control on him, but I don't hear nothing about that. He was smart, talk it up, preach it up around in New York there. He bring back clothes, shoes and thing, give you some, sell some. Have a good outlook. You can't blame a man for being smart. (*Bubberson Brown.*)

THE BIG STORM

Papa and we came home and they farm one year before the nineteen eleven storm. We had a beautiful crop of long staple cotton, up by the pond at the head of my road here. Mostly you pick cotton from October onwards till January. We pick cotton in that year until March! I mean, we keep on picking in that same field by the pond there! He gone to all the trouble to cut a canal through that high hill all the way to this creek here, drain that field. Hard to do, but I don't think he lose nothing. That the best acre on the place. The cotton grow up shoulder high and it cover the whole alley. Everything cover under. Way up into the month of March it was just as white as it could be; ain't know alley from bed. Never could get done picking it. Gin house already close down for the year and us still picking.

Then in August of nineteen eleven we have a storm here. It hit on a Sunday. It catch me up at the Neck while I bring my grandmother home. By the time we start back, we couldn't travel on any of the roads, couldn't find no road, trees down too thick everywhere. While you look, every once in a while another one fall across the road. Tree fall, you can cut out in the field, go around him, then back in the road. I drive that little horse through woods, through fields, all through McKonkeys, on

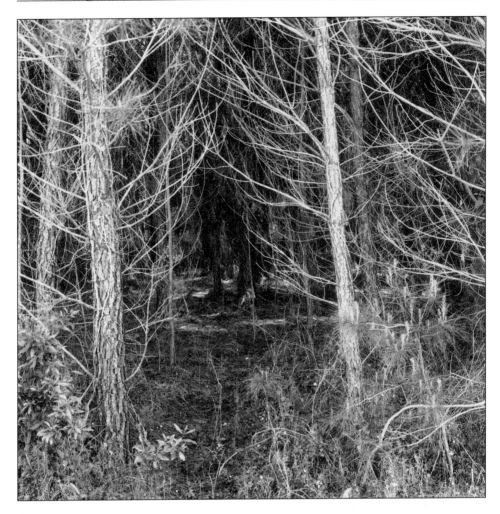

across through the Village. In them days you could cut across for ain't so much of woods like it is now. In that time they keep the land clear. Ain't have all that land to spare, plant up all that ground. Had of been like it is now, we never would get out. We fight, we fight until we finally fight it back to my father's house.

It ain't dark yet. I see an old lady go out of our house, gone to see how the house where she stay is taking the storm. That was Old Lady Ann Lucason. House where she stay is this one where I live now. She stay in the house alone with her little grandson. She had no place else to live then, and my grandfather always let somebody stay in this house when they have no place else to stay. If he can work, he do a little somp'n. If he can't work, he don't. That little grandson look exactly like me, so they say. Wind blow, blow. Old Lady Ann Lucason start to blow away. My grandmother tell me, "Follow her."

Good thing I did. That old lady start moving, she couldn't turn back. She gone to blowing, blow right on to that creek. Waves break here. Out here was just like a beach, just as rough as any spot in the ocean. I say, "Let's go back." If I hadn't

grab on to her, she would have blow straight on and drown just as easy as that. She couldn't turn round no way. I carry that old lady back where he came from. He spend the night there.

The worst of that storm strike later on, after dark. I don't know too much about the course he take. He blow all night, but I—asleep.

In the morning I get up and there are twice as many people in the house as before, people all over the floor. I gone out. Wind blow a little, not much, but tide rise up, rise up until it nearly to the top of the bluff. Ain't come into any of these houses though. All the marsh—covered over. You can't see nothing, neither grass nor creek bank. The tide everywhere. It just a ocean, that's all. (*Bubberson Brown*.)

I was born in 1882. One of my earliest memories is the earthquake of 1886. I was four years old when it came through and tore up Charleston and that whole section all around there.

It didn't shake down any houses on Edisto though. It just damaged some of the big ones a little. It came in the evening of the twentieth day of August and the people had all been out picking cotton all day. My father and my two brothers came home and it was hot. After a while my mother came home, she had been over there at Mr. Towney Mikell's plantation, California, picking his cotton. She got supper for us all and after we were done eating, she opened both of the doors of the house—it was a small house—and she put down quilts on the floor. We lay down there to try to get a nap and oh, it was hot!

Directly there came a rumbling, RRRRRRRRRR! People jumped out of their houses and started to holler, "Merceeee! Judgemennnnnt!" And they started to run back and forth to one another's houses.

I did it too. I was four years old; I went to the door and looked out; I enjoyed that kind of doings. The earth was going this way, that way, twisty, twisty, like something was underneath. Water was springing up out of the earth all about. I liked that kind of weather.

The thing went on, it didn't stop, so the people ran up and started a meeting at the meetinghouse, and they all went crazy with whooping and hollering. That earth didn't settle down at all for two days. People would just get to work in the fields when the ground would start to twist and hump and they would run inside again. They were about to run off, but they didn't know where to run to. I didn't have much sense. I didn't know and understand what I was looking at, so I took it for a rare pleasure.

The next insurrection we had here in this country was the storm of '93. I was a boy nearly twelve years old then. It was on a Sunday and the day was foggy. There was fog everywhere. I was hanging around the house while my father was getting ready to go to church. Allen AME Church it was, that same church on the corner where we go now.

My father gave my older brother the task to keep the crows out of the cornfield. They had been shucking and eating the corn as fast as they could go. I wasn't needed, so my father sent me to the next neighbor's; he had a boy my same age I

went to school with. I went there and my parents went to church. A fog and a stillness were on the whole creation.

The neighbor's boy said, "Let's go over to Mikells'," that was a couple of miles west. And the trees were so still! We played there a while then we went to play with my cousin two miles east of us. Then they each went about their business and I was alone there at my cousin's house. Then the fog began to get heavier and heavier, and it began to fog-rain. I was in the house looking out when it started to windstorm, Ohhhh! Ooooooooooh! Ooooooooooh! And it started to rain steadily.

There I was, all by myself. I looked out and I thought how I was far away from home and nobody knew where I was because nobody had sent me there. I jumped out of that house and ran flat out across the hill in the place they call Scott's. I got to the pond that is in the middle of that hill and all the pine trees that were around that pond were bending down to the ground. Their heads would touch ground, then they would jump back, touch down, jump back.

I was bound for the woods now. When I got to the woods, all the trees in the woods had their heads low, down to the ground. But the wind was behind me. I got through that place, I fled through that place. I wanted out. When I got out on the other side, the storm was there, the full storm, wind after wind. I went on until I got to the house of Old Man Peter Wright. He said, "Boy, you go on home."

But I said, "Let me stay here," so he opened the door and let me come in to the house. They were standing or sitting about the parlor, but I wouldn't go in there. I stayed on the stairs they had there going upstairs, sat right there on the one step.

I sat down and watched and the storm was real then. I looked down, and there those steps I was sitting on were starting to come apart one from the other. When I saw that, I leaped out of that house into the storm. The wind was behind me and drove me home so quick I didn't even know when I went right past it. I had to cut back, and that one thing was like to have cost me all.

The old man had a corn house on the far side of the yard and the house was on the near side. I got into that corn house and I looked out and that was a rain! I looked across to see the house but the rain was so thick I couldn't see across the yard. I looked back down, and in that short time that I was looking across the yard, the water had risen waist deep around me. Water had come on that last flow of wind. I made ready to strike out for the house. A flow of wind came, then went on by, and the storm ceased for one roll. I leaped out there, and the water was already almost up to my neck, salt water. I got to the house how ever I could, crawled up against it, "Knock, knock, knock."

My old man opened the door, "Where you come from?" and he shut it again as quick as he could, but the water was running through. I couldn't see anything; I was almost drowned. I went into the back of the house and pulled off my wet clothes, but then I couldn't get anybody to give me any room on the stairs. They were all on there. I went on up anyhow, climbed up on the underneath side of the stairs, like you climb the back side of a ladder when it's up against the house, hanging upside down like a squirrel. The back of the stairs wasn't closed in with boards. I got up to the top and lay right across the step there and fell fast asleep. I was out and done!

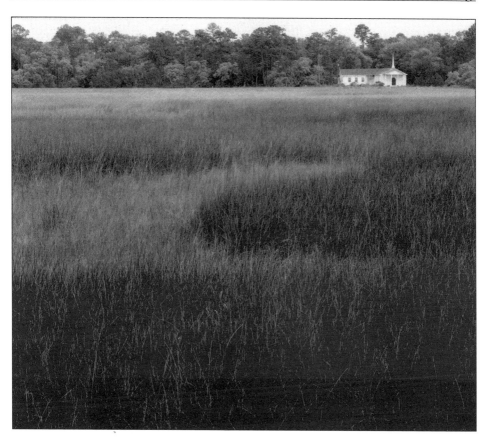

When I woke up next morning and looked out, everything was under water. The storm had abated. All the chickens and turkeys were drowned, all the goods—drowned, dead things everywhere. I thought I must be dreaming, I rubbed my eyes to try and wake up and I looked out again.

Across the face of the island—the Great Atlantic Ocean! Water was across the whole creation. You couldn't see anything but ocean all about, then two miles over there, Mr. Mikell's place still standing, one or two smaller houses, but most of them were down under the water. The tide from the northeast met the tide from the southwest and the whole place was covered.

That water started to run off then. That was a sight to see too. I thought I would die of astonishment. I never saw water run away so fast. The whole place turned into a swift-running river of tide water. You couldn't see anything but a brook here and a river there, a creek here and a run yonder. I dug out the oars to go with the boat and find out what water was.

Late that day the news came out, "Do you know, all the people on Joe Island drowned?" Joe Island, that's the northeast end of Edisto, the place they call Swallow's Bluff now. "They are all drowned, every soul. All the houses are gone."

Peter Wright, his boy, his wife, and James Wright and his daughter—all drowned. A lot of people lived there, and the whole island was drowned off, every soul. In

the years before the storm we used to go and pick oysters in the creek beside that settlement of people, and all were drowned. When the news reached us, I had to assimilate that.

Many people on Little Edisto were drowned, and all of them on Whooping Island. Many communities were completely wiped out. It was the worst disaster that ever came to Edisto Island.

The storm of '93 was the hardest time I ever experienced and it brought on the hardest times that anybody ever saw on this island. It didn't really start till sundown and the main body of it came after dark. It washed right in, came up into the houses and then the houses broke up. Many children were drowned. If it had come in the daytime, the people could have saved themselves better, but it came in the night. No one could see, they got up and ran out of the house as it began to break up, and ran out to their deaths. Many swam off and drowned just like the cattle. And almost all the cattle were drowned, the cows, the hogs, the goats.

It was a very hard time for the year after the storm. More people died after the storm than died in it. There was nothing to eat, the whole island stank with dead cattle. We had no time to bury them. The government sent some relief here: Missy Barton who was giving people some clothes and a few groceries. You could get maybe a peck of yellow corn meal every week, and two pounds of bacon, but it wasn't enough to stem the hardship. The storm came in August and all the crops for that year were wiped out and the land was too salty and wasn't fit to plant the next spring, 1894. I don't see how the people that had no wages to help them out managed to live through that year.

The next two years sickness broke out and killed almost all the old people. They were already starved, so they got sick easily. I had that sickness then too, and like to have gone. When God is ready for you, you go. He send me back. They called that sickness "malarial grippe." It was something like influenza.

Almost all the able-bodied men went away from here to try to get wages anywhere they could. Many men took work digging phosphate rock for fertilizer in the rock mine at Red Top. They called that the Cherokee Mine. They worked there to make a few pennies to help them beat the hard times for that one year.

After the storm passed, and then the pestilence passed, we started in on some good times. Everybody that had come through made sure that they would make themselves a crop to live on. They had corn, peas, rice, hogs and fowls and tater plenty. They all started up again, they went into good times that year and have never fallen back into anything like the misery of 1893, 1894, 1895.

After 1895, we were suddenly back on our own with that long cotton again, and pretty easy money. We were getting forty, fifty cents and sometimes as much as a dollar a pound. Since each man was raising all his own food, all the money he got from that cotton was clear and free, maybe one or two hundred dollars. Not only that, there was nothing out here he could spend money on. Each man had more money than he could spend; he was living like a prince. The people bought horses and buggies and they must have taken a million rides. Some unusual men actually did save some money and buy land with it. The majority didn't save any.

Egrets were in season then too, and you could get a lot of them before they passed the law against hunting them. A man could make a couple of hundred dollars a year on egret feathers; it was easy to catch them and it didn't take any investment.

The churches played a large part in the way the people knit themselves together and recovered from the storm. That is always the way it has been on this island: there is a group of people who guide the church and the church organizes the rest. There was no one man who stood up and said, "I am the boss. I want this, and I want that." A man like that would get killed. The people on this island work through the church.

That storm came at about the wind-up of Reconstruction times. The official Reconstruction was over when Wade Hampton came in as governor in 1877, but the time trickled on around here a little longer. First came the War, in 1861; then in 1865, in April, Peace was declared. That Peace time lasted until Reconstruction set in about 1867. (*Sam Gadsden.*)

PASSING ON

One year followed another until pretty soon my grandfather, that old man, he began to go down. He got lower and lower. He had got too old to be fooling with that hard work and the worry of running a gin house. He made out a will to distribute his goods among his children. He will this boy some horses, that one a house and the other one another thing. He and my grandmother Bella have the five girls and three boys. Papa was the third child but the oldest son. He choose Papa for the gin house, he will him his share in that and then, in nineteen twelve, he die. Eighty-eight years old. Peter Brown gone to meet his maker. Name Peter Brown: he name his own self. His daddy name: Jimmy Williams. Peter Brown and Yorky Williams daddy are brothers. But my granddaddy gone rebel, self-name Peter Brown.

Never will I forget that day. Day clean in the morning, before daylight. My granddaddy, lie in the bed and start in to preach. He been a preacher, mon. On he dyin bed, and start in to preach the longest sermon ever been preach in this corner of Charleston County, He, laughing and talking with Jehovah, there on his bed. "Ha ha ha ha ha ha! Look at the host! See them in the sky and they can't come down." He tell it loud and clear how he see the host that John see, see with his own eye right now the forty and four thousand. The New Jerusalem where there

will be no more tears and no more crying. Daddy hear him start in to preach so, and he know he going to die. I ain't know that yet, ain't had the experience. My old man hear that preaching, ain't do nothing but pull out, gone to get the coffin, know he must hurry to catch the boat, get to Charleston and get the coffin. If he miss that boat, won't be able to get him that day.

Some people make a coffin right here, get a carpenter to do it. We can't do that. Granddaddy been too upright of a man, have too many children to look out for him. Papa leave home about seven o'clock, catch the boat. That is the Stevens Line boat, and it would run at eight o'clock each morning, run straight to Yonges Island, and he can catch the railroad on to town. In that time don't embalm; most generally bury the next day.

Me and my granddaddy oldest daughter, Molly, we two the only one home. I don't know where my grandmother and them, gone field I reckon. I creep up stair case, listen. She stay there with him a while, then she run out in the yard. And cry? She make them know. Whooping, hollering. Been some crying then, mon. After that everyone know the old man going fast. That was a loving old man. All the people know. I never see him plow, never in me life. He all time fixing, fix shoe and things, have apple or orange for the children. Look just like me, so they say. I don't know did I cry that day or not; I big, supposed to be good-sized by then. All had see him do those things; everybody care for him. He preach more high and more clear till about eleven thirty that morning, he gone. Preach a six-hour sermon. Break the record.

Ben, my father youngest brother, gone with a cart to meet the boat in the evening, bring him back home with the coffin. I don't know where my daddy buy the coffin from. They put my granddaddy in him that evening; gone to the cemetery next day. (*Bubberson Brown.*)

DANCE HALL DAYS

Back in nineteen twenty-six and twenty-seven I work in New York for six or seven month each year, then come back to farm for five or six month. I come back for farm each season. I go up to New York in the fall and sometimes I be back home before winter come down cold.

In nineteen twenty-eight when my child Bennie was born, I was working for the county roads, off of that highway truck, work for Mr. Eldon Hunter. I was making sixteen dollars and fifty cents in every two weeks. That wasn't so bad. It went a long way. I needed it for I was helping Henry Eubanks get a start then too. Henry came back from New York a year or two after I did. He came in the winter, and so while I was doing other things, I was helping him get a start. I loaned him seed potatoes, helped him plow and plant and all. He had married Viola Gadsden, whose mother was sister to my daddy. Viola's mother was Miley, Bella's oldest daughter; she died about nineteen sixty-eight and she was a hundred and five years old.

I farm just the same as ever for myself while I work on that road crew, so I had to hire a boy to plow for me. When I pay out that boy and pay the grocery man, I still save a little out of that sixteen fifty. But do you think I was going to sit down and depend on just one thing? No, man. I was the very one who could organize things. We had a dance hall over here, the Knights of Pythias Hall, and in those years, there wasn't anybody besides me who would rent that hall. Along in nineteen twenty-five, twenty-six and twenty-seven, I first start to organize dances. I paid for it way in advance so nobody could come in ahead of me. I meant to make money somehow. Each holiday I rented that hall for two days at a time. I would go to Charleston and hire musicians and pay the deposit on them, twenty-five dollars down. I would bring them here and they were already half drunk. They came that way.

The Knights of Pythias. I joined in nineteen nineteen before the new hall was finished. There were eighteen men of us taken in that night, and seeing that the hall wasn't finished, we used James Jenkins' store. It had a big old stage up at one

end of it, old two-story store. They have people who come out from the city, bring us in to the lodge: there wasn't nobody on the Island qualified to do it. Lie on that hard stage all night long till day clean in the morning—I was glad to get up from there! I the last one gone through, day da clean 'fore I rise up from there! Hall got finish the next year. Sixty feet long, forty feet wide and three stories tall: what a building! Been up in behind the AME Church, there across in front of Dan Pope's place. Since I was one of the early members, I was on the inside and could get the use of the hall when I wanted it. Besides that, I pay the fee ahead of time each holiday. Every year I pay on him 'fore time come. Three fifty each time. Fourth of July, Labor Day, Thanksgiving and Christmas—all four them.

After a while they give me a policeman to help keep things orderly. He was Frank Wilkerson. He live up at Murray, and he was the first policeman this island ever had. He was fine! He was really cut out for the job: near about seven feet tall and a really nice man. Very seldom he talk. Just as quiet! He look like a policeman. If he knew the county police were coming by to make a raid or something like that, he would tell you to clean up or get out. He wasn't afraid of anybody, but he would treat you well, talk to you nicely and give you good advice. He treat you like a person ought to be treated.

I and Sam Gadsden and Steve Grant—we three have that dance hall together. I was the youngest one and the leadingest one. We ran those dances, but then, one Fourth of July dance, whooee! Didn't we have a time! A couple of men tried to kill one another that night. There was a gang came up from off the beach, the women were drunk and hanging through the windows, all through that high hall. There was an old man and his two sons and they went at one another. We broke it up for that night.

Frank Wilkerson appointed two men to help him, Isaac Stoney—he was three hundred pounds. And the other, Moses Mitchell, was a small man, but tough. With Old Man Wilkerson, that make the four of us to keep order. I had women to sell food and drink at counters all around the walls of that hall, they set up tables and I get a wagonload of stuff cook up and bring in there, get me three, four women and they take care of that. Later on, after my mother die, nineteen thirty-nine and in there, my daddy new wife, my stepmother, she be mostly the head one, do that selling and all. One Labor Day a big gang come out from Charleston. They come

here from all about that day. Big crowd, the things get upset. Some of them people come from off—they not satisfy until they have a fight or a shooting or somebody get cut or something.

The things get upset. I look across the hall, here come Dogger—he my close cousin, live out Whaley—I see he have some trouble. Walk toward him, then I see he got a pistol, point right at me. I keep on, walk to him right straight. Mosie been right behind me. Mosie ain't afraid nobody, that fo sho. A little piece of leather and he well put together. The women at the counter see that pistol about same time as me, they holler, some get under tables, one or two jump out the window—been six, seven foot to the ground. Mosie take the gun from Dogger, open it out, have a full load in him. That, my close cousin, and he pull a full load gun on me! Pull him just so, no reason at all. Just because he have him. Later that night Ben Randall hit James Wright and he most get kill. Bust his head open. A feller shoot out all the light that night. We have kerosene lantern hang up overhead, lamp, lamp, lamp hang on the wall. We broke that up, but after a while I said, "I am a church man: I better cut this thing out." So after a while, I didn't bother with that any more. We quit with that—the Second World War already on. (*Bubberson Brown.*)

Besides the Knights of Pythias there were two other lodges on the Island in those years: the Oddfellows Lodge up here in Seaside, and down in the Burrough the one they called the Good Samaritan Hall. At each one there would be a dance for a day or two on the four main holidays—Fourth of July, Labor Day, Thanksgiving, and Christmas. (*Sam Gadsden.*)

Chapter Four

IT TAKE ALL
TYPES OF WORK

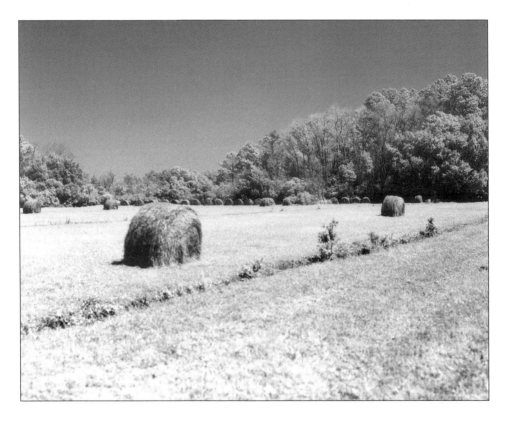

I'm going to build me
Just a cabin
In the corner of Glory Land
In the shade of
The tree of life
That it may ever stand.

(Traditional Gospel Song)

ISLAND WORKING

It take all kinds of work to make it on this Island. Some merchant work, some farm work, some secret running, like when we go get cotton at night, help other poor people who trying to make it. Trouble? Oh yeah, yeah, yeah, there's trouble. Plenty of trouble. Back before my time when my grandfather start with the gin house, times easier in some ways. Those were Reconstruction days and some things were more possible. Later on, by the time the trouble get going strong, he had already gone so far that they couldn't do him no harm. Besides, there were some more gin house that belong to colored men that built up since he and his partner, William Ficklin, start with that one. There was Jamsie Jenkins' over here at Freedman's. That ain't do much. And William Seabrook start up one, and the fourth one was over at Clark. It belong to Jeff Jones.

Papa and William Ficklin run the gin house for all those years, until at the last William Ficklin die. In those last years of age, the old man ain't run gin to a very good purpose. Let alone that, he charge many things against the gin house which ain't supposed to be to that account, make a heavy debt. The factor, Mr. Dill Ball from Charleston, he notify my father that debt been due on it, and that he will lift the mortgage if they can agree. My father gather up two other men and they go in together: Jamsie Jenkins and Yorky Williams. All three sign up the paper, Dill Ball lift the mortgage and advance them the operating money, take care of their expense while they get the business on the road.

In nineteen twenty-five we get a T model truck. With that truck we can go out farther to bring in cotton, or take a better load to Charleston. One night I gone out with that truck, me and my striker, Primus Legree, and got three bale of cotton a way over on the mainland, clear to White Point, maybe twenty miles. My uncle stay there. That the only way we could get his cotton. I load all three bales of cotton onto that one truck, three pile up! Had to work by lantern light and it was raining like a flood. By the time I stop by the gin house and we get out to unload, that rain done in the field and water up over the tire. We had to walk in water while we pull those bales up, twenty-five feet into the air, up into the top of that gin house.

You tell that bookkeeper, Yorky Williams, you tell him you are coming in with a load of cotton, it don't matter when, he will be there. You look for that lantern light coming closer, closer down the hill: that will be him. He keep the books, and all the cotton and seed pass through his hand. He want to know what come in. He was a highly educated man with a very good understanding; secretary to Allen church too. He was there that night, he make the third to pull. It wasn't too hard, three men and we had that big old wooden block and fall.

As we swing each bale in, up on to the third floor, we would stand it by one of the roof beams. There wasn't much up there—all the machinery was on the second floor mostly—only the big pulley and belts running through, and the five chutes that ran down to the gins. Two of those chutes we didn't use any more; the long cotton was out. We would have each man's name on one of those beams on

120

a piece of paper, stack his cotton there. The next day when I gin that cotton, I take his paper off of that beam. Then when we turn that bale out, by the time the bookkeeper had written it down, I had his name stamped on it. That's part of the way we kept track. We would turn that account in to Dill Ball, our factor in Charleston. He make out the amount due each man.

The boll weevil had come in about nineteen eighteen. He bite that long staple cotton—eat him, rot him right on down. Can't nobody nor nothing stop him. The thing get bad, then it get worse, and while I was up in New York, the long cotton run out entirely. The boll weevil came in force and he prevented that crop altogether. We did a little wise plan then. We gone to work and change gin house over to short cotton. My father did that. He find out about two short cotton gins—press, bins and all complete. Buy the one, get it in and was running with that, but he need more than just the one. The second one belong to Teddy Bailey, live in Blue House there. That was a good old fellow all right, Teddy Bailey! The trouble was he needed cash, he was set up so he couldn't let Papa work it out. I sent home a bunch of money from New York, but that wasn't enough; Papa had his two partners then, James Jenkins and Yorky Williams. They put up the money for the second short cotton gin. He had the two partners: it looks like the two of them together could have done something with the gin when he got hurt, but neither one of them could run it. If they had been able, there would have been no need for me to come back from New York. My daddy, that all he do is keep that gin running. We bought Teddy Bailey's gin. That left us with the three long gins

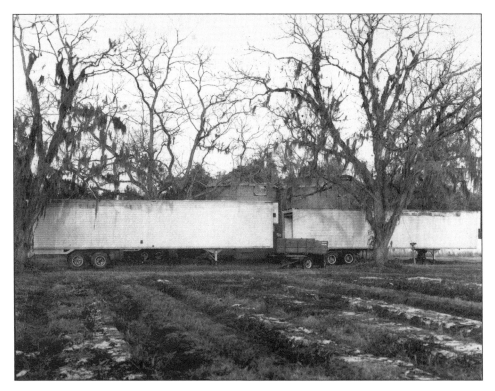

standing idle that used to turn out eight or nine bales a day; and the two short gins—one sixty saw and one seventy saw—that were turning out eighteen to twenty, twenty-five bales a day. Blew that cotton right out so fast! That is no joke now. By us making the switch, people were able to put out short cotton a long time after the boll weevil came.

With the long staple cotton, the gin use a roller to get the seed out. A lot of times you can see the seeds right in the cotton before you gin it. Not with short staple though: it come bunch up, thick as sheep wool. Couldn't see anything in there. You must not feed long cotton into the gin too fast either, no, no. Then when it come out, come slow, slow, and thin like a cloth. Women must be there, straighten and tend to it as it come out. Then the press man has his trouble. Must pack him carefully. Get about a hundred pound into the press, then bring the press down on it, settle it together, then take the press off, get another hundred pound there, press it again. He must pack each bale three times. When I work in Savannah, I learn about how quick short cotton is and I see how tedious and sickening slow that long cotton had been. The short gin could handle cotton as fast as we could throw it in the chute, and it pour out of there in a wide gush ten inches deep. (*Bubberson Brown.*)

THE MONEY GANG

I have been working only for myself from that time onwards. Sometimes I have made it pretty well and sometimes it's been pretty bad, but I have always made enough to stay off of public work; I have worked only for myself from that time onwards.

I have been a poor rich man. I have done as I chose and worked as I felt like it. Some days it would rain and I couldn't work. I was sorry I couldn't work, but not too sorry. I rested a little and then went back at it again.

I could make a little money. Some years I came out very well. I remember in 1915 I made seven bales of cotton, and that same year I bought up eighteen bales of cotton from these other farmers around here. I held them a little while and then when I went on through with it and marketed those twenty-five bales, I had three thousand dollars, spot cash. I was dealing there for a while in that long staple cotton. I made a nice pile of money just from buying and selling when my hand never touched the crop. I went to the factors who handled that cotton, went to

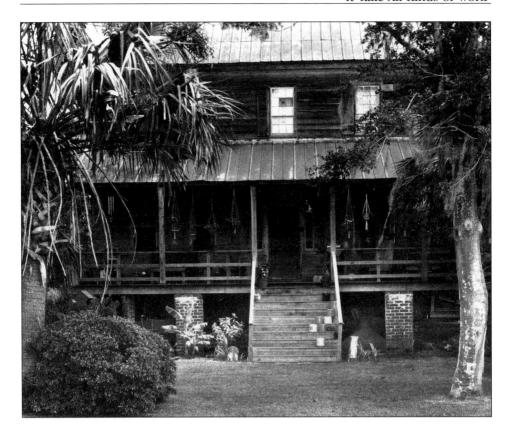

them one at a time—first to Mr. Ravenel, and he gave me a pile of money, then to Mr. Boyle, and he gave me a pile of money, then to Mr. Whaley and Rivers, and he gave me a pile of money. I couldn't take all the cotton to one place, I had to divide it out among those brokers, for if any one of them thought I was bringing in that big a load of cotton, he would cut me down. They had an allotment there for any colored farmer and if you brought in any more than that allotment, they would play a bad trick on you. They wouldn't sell your cotton, but put it back in the warehouse until it got old and rotten. We found out about that trick and the safe politics they were playing. When I divided the crop out that way, each one thought I had just an ordinary, little crop and he paid me for it. He didn't pay me but half of what he paid a white farmer, or even less, but still it was a lot better than no pay at all.

I was dealing in that cotton, and I could make enough garden crops to feed us here and I could always make a little money on vegetables. There was never any need for me to go to work for some other man for wages.

I planted long staple cotton until the boll weevil came along and wiped that all out after 1918. After that I tried to make some good crops of short staple cotton, but I never did understand how to manage that correctly. By the time I did understand, the state law came out and gave every man an allotment and it was so small it didn't pay to fool with it. That short cotton sold so cheap there wasn't much money in it for the small farmer at any time.

I raised Irish potatoes and beans, these two crops. I never did plant anything else. Some years those two crops kept me going along fine and I made good money off of them. Some years there wasn't anything to them except the work—no money at all.

During the last twenty years a radical change has come through the whole world. In these days a common man can do his work and get two dollars, three dollars an hour. Some common men get five! A skilled man who can lay concrete block and brick can get six and seven dollars an hour! Who ever dreamed that could happen?

I can lay block and brick and I can do the carpentry work, but in my time there was no wage at all, because there was no work. There was no was job to be found, no matter how you would come at it, not here on this island. The country wasn't developed and nothing was going on.

This island is getting into the main stream of things now. It's a necessary thing: get in the stream. Don't just lay there up in the grass, or the tide will leave you out on the marsh. You must kick and kick until you can get in the stream. That's the way the world runs.

In the 1880s, if you were lucky enough to get any job, it wouldn't pay you as much as five cents an hour. That is the top price for a skilled man. Some places you

would get fifty cents for a ten-hour day. Most places you wouldn't get but forty cents for a twelve-hour day. You worked from six in the morning till six at night just to make a little bread to eat. Those were very long hours, and no progress at all. That's because the only thing that was going on here was farming, one-crop farming, raising that long staple cotton. There was no job open here except farm labor.

After I came home in 1906 I never did any hourly wage work for anyone else, but I did do some work for Mr. Townsend Mikell at his plantation California in return for the use of some of his land. The rent he charged on his land was one work day a week during growing season for each three acres of land you used. You must give him Mondays from May to July, that's planting time to lay-by time, and then August through November, that's picking time. In July they left that crop alone for a month, they laid it by until August, when they started in to pick it. You helped to plant, hoe and pick his crop for that one day each week, and he let you use three acres of his land for the year. He gave you three tasks of land to be your day's work. Monday was the day. It was a mean Monday too. The way they measured a task of land was with a big wooden compass that stood higher than a man, and they would walk that compass across the field twenty-one times, twenty-one diameters of that compass was one task. Three tasks of land, either to plant it or to hoe it, that is a very heavy day's work. You would work that three tasks every week from May until the fourth of July. Then they lay by until the last of July. When the time came to pick, they gave you fifty pounds of cotton as your day's work, but you see, you came in better during that part of the year, because they would give you a little money too. They gave you fifteen dollars a month in cash when you gave that one day a week and picked your fifty pounds each week from August until November. Later on they raised it to eighteen dollars a month, but when I started it was fifteen.

I would give Mr. Mikell one day a week, then the rest of the week I could work my own crop which I had planted on his three acres of land and on my own.

On his land, which was good land, I would make better than a bale of that long staple cotton to the acre and I could sell my cotton, even when they low-priced me the way they did, and get three hundred dollars for each bale. When the white farmers brought their cotton to market, they got eighty cents to a dollar a pound, but the cotton brokers had their arrangement made and they wouldn't give a colored farmer but forty or fifty cents a pound in those years. My return on that three acres was three hundred dollars for the season.

Mr. Mikell's three tasks, that averaged an acre of land he had me to tend for him until it was time to pick, then to go ahead and pick it. And then I would get fifteen dollars for that. But I saw that if I had tended an acre of land for myself, I would have made three hundred dollars. It was plain to me that I had better try to make some of that cotton for myself, even though I had to sell it low.

It looks as though I could have been able to get the same price on the market for the same product, but that cotton was an organized game, and if you weren't in that organization, you couldn't get the price the organization got. It is just the same with truck crops today. You can plant four or five acres and make a good crop of fine vegetables, but if you are not in the marketing organization, it's a good

chance you can't even sell yours, and you absolutely are not going to get the market price. The buyer will take your crop and hold it and hold it, but the crop can't wait, not fresh vegetables. So he will give you whatever price he wants. He can completely take advantage of you. Some people say there could be a co-op. They are just for the big farmer. There is no co-op for the poor people. The poor people who want to plant those things, they go ahead and plant them, but they have to take them to market on their own.

We raise raise a lot of tomatoes here and there is a cannery for tomatoes over on Yonges Island. That canning factory buys on a reduction. They come in after the crop has been shipped and take all the ripe tomatoes you were going to throw away. They bring in their crew and pick those tomatoes, throw them in a truck and take them to the canning factory. At the end of the crop, when the whole field ripens at once, they come and take all. But they don't pay you more than twenty-five cents a bushel and they tell you, "That's a good price for them."

That might be right, because if it weren't for them, the farmer would have to plow them under, cover them over, because he can't afford to hire anyone to pick them and grade them and box them. The box costs as much as the canning factory is giving him.

The factory claims it is a big price they are giving him, because they say he has already made a lot of money on the tomatoes he has graded and shipped. He has already got plenty of money out of the crop, he ought to give the waste stuff to the factory, so they say.

It is better than plowing them under. Some years when the market price is low, even though the people in the cities are hungry, the farmer can't afford to pick any of his crop at all. The dollar rules, not common sense. There will be good tomatoes, the best you could ever see, and the farmer has to plow it all under. It is all a money gambling time that leaves the poor man in the cities hungry and the small farmer poor.

Things are plentiful out on a farm. I was down in Florida back before 1906. They raise grapefruit and oranges and all kinds of fruit along the east coast there. If you would go to any city there, say Miami, and you wanted a banana, you had to pay ten cents for it. But if you would go to where they were grading them, they would let you eat as much as you wanted. They had a pail of them there. A man would bring in a whole truck load and after he had graded out the best, the ones he could take out to the city and sell at twenty-five cents a bunch, he would let you have as much as you wanted. He would just give it to you.

It was the same with oranges. If you went in to the field where they were grading them, you could back a cart right up in there and load it up for nothing. They were glad for you to haul them away by the cart load. Those were the cull oranges, the ones they couldn't sell. But in some of the towns right around there you had to pay five cents and ten cents apiece. I have seen that myself.

Right here on this island, with the cabbage, if you go to the store for cabbage it will cost you ten cents a pound, but if you go out in the field the farmer will say, "You want some? Oh yeah. Take some and be welcome. We got plenty here."

Things are plentiful on a farm, but the farmers are all kicking about the price they have to pay for labor. The government has set the wage up to a dollar sixty-five, and as high as two dollars some times. No. A farm cannot pay that kind of wage for the labor and compete on the market. He must compete on his price, but if he sells at the price the marketing organizations give him, unless he is very large, he can't afford to pay the wages the government says he must.

They have thrown the little man out. It's only the big man who can make it, since he sells enough. He plants a big farm, and has a thousand acres of tomatoes. He has his crews pick those tomatoes as soon as they get ripe enough. He picks about three or four thousand lugs of tomatoes that first picking. A lug, that's one of those wooden boxes they use to bring the tomatoes in from the field. For that first picking he will get from five to nine dollars a lug. Some places he will get ten dollars a lug. Now he has made back every dime he spent on that crop. The next time he picks, he picks twice as much, and he gets three dollars a lug. And it's just like shoveling up money with a shovel. He is a big farmer; he has enough tomatoes to cover the market, and at that price too.

The price for the first picking is the highest, the second is lower, and after a while the price falls to a dollar and a half a lug. That's about the time the poor little farmer is just getting his crop to market. Poor scoundrel, he bucks himself off a dollar and a half, or a dollar a lug and that doesn't pay him to fool with. But it's all he's got.

The poor farmer doesn't have any thousand acres to work with, no, all he has is a little bit of a place and all he can do with his crop is to carry it in town to the co-op and they will give him whatever they want. No poor man can farm now. You just as well take your little money and dig a hole and bury it as to put it in a farm, because you never will get anything at all, not on any little farm.

The big farmer will be the first on the market every time, because he has money behind him. He can buy fertilizer and he can force his crop to get it to market early, and he has all his bulldozers and tractors to make the land ready so he can plant earlier too. There is no doubt about it, he is going to get that first crop out way ahead of you. And there he goes, that first crop has paid all his expenses; then he gets in there while the price is falling and he racks the second picking in there and puts that money in his pocket; then he gets the third drag—he don't want no more.

The whole business is gambling, right now just like it was all along. The gamblers get all the money and the working man is poor. All money business is gambling. The only sure thing is from God Almighty. Any thing that has to depend on man is gambling. If you are a plain working man and your boss pays you a good wage, you can depend on it that he is making ten times as much as you. He gets the wholesale business and you, the man who does the labor, you get only the retail part and the whole thing gone to the devil for you unless you can get into that organization, the money gang. If you can once get on the inside of that money gang, you will get rich quick.

There is no maybe about it, if you get into that association, you will be able to get all the money you want. You will get enough to fulfill your contract and leave you a good stake of clear profit. If you handle your business carefully, you'll have

twenty thousand dollars after the first few deals like that: ten thousand to put in the bank and ten to go back into the business.

A working man who just works and saves can never get any stake to start him in business. He will have to get inside that money gang or else he will just be working for a piece of bread and a roof. That will be the limit of what he will ever get.

For a rich man it comes out as nicely as it did with the bossman in slavery days. They thought these Africans could stand more rough living in new construction work than any white people could, so they treated them roughly. They bought them and raised their children and had them trained to clear land and work in the fields. The thing went on so nicely until the bossman, he didn't have to work at all, neither he nor any of his family. He went around wearing his white collar and his necktie and riding his horses and all, just like a Prince of Wales, and put all the rough work off onto the Black people.

Rich people. They! They don't do nothing. They just go from place to place, enjoy the scenery, enjoy the good things they have here or they own there. What, work for their food? Who, them? They have people to do that; they themselves don't do nothing. They just go around inside their houses in this city or visit that country place they own, or the other plantation. (*Sam Gadsden.*)

GINNING COTTON

That gin house had a history. Once my granddaddy and a bunch of men had rent a place which have a gin house on it. It was just a medium-sized gin, run with wood. Lot of work to that wood. They get people cut up the season supply of cord wood six months ahead, have him stack and dry right there. Must have a man to go in at four o'clock each morning from November onwards, have that boiler red hot by daybreak, ready for the day run. That wood gin need some wood, now. Later on, they buy some land in Freedman's Village, west of the beach highway where he run now. In nineteen thirteen, after my grandfather die, they set up a foundation, move the gin house and machinery over there and add on, add on until they had built up a really big gin house—a three story one. They get one of those big, one-cylinder International engines. Seven o'clock in the morning and Papa, swing that big old wheel around, kick him off for the day run. He turn, he turn, chah, chah, chah, chow, chow—turn him till he drive off. That engine stand six foot tall. He strike out in the morning and you could hear him from here to Steamboat Landing, five miles. He shoot four or five those cannonball before he

start up, then warm up and level out to run. The main belt run from the engine to the main pulley on the long shaft—near about twenty foot. That belt was fully twenty-four inches wide, drive the shaft that turn through that whole gin house, right on through. You could grind corn, press cotton, gin cotton—do it all. One cotton press, three long cotton gin and one corn mill. Later on we get two short cotton gin and add them on, after the boll weevil take the long cotton. All that machinery was there. You couldn't keep that engine down. Sometimes he look like he going to jump right out of the bed.

That engine so powerful, one day he split the belt right in half. Right splang through the middle. Belt two foot wide and a hundred some foot long—he run double you know, you got to run him double. Couldn't nobody go in there. Whole place smokey and that split belt whip around with every turn that engine make, whip through the whole place, cut you in two in a minute. For a while we ain't know what we going to do. Got to get him off the pulley some kind of how. We tear two board off the engine room, put a forty penny spike, prize against it, pull and pull—he inch, inch, inch across the pulley. Pull some more and he jump off of there. Then all the dangerousness gone. We split him and run with a twelve inch belt for a while.

My daddy, he keep the gins running. My job is to keep the engine running and keep up with the cotton seed, stack it and tag it for whoever it belong to. For a while, Mike Deas was press man. One day we went to running the cotton of Old

Man Glascow Whaley, have near about a bale and a half. Glascow ain't want that half bale of his mix up with no other man cotton, for he make a superior brand of cotton, want to keep all separate. He gone to Mike Deas while his cotton coming in the press, a kind of a hoarse whisper, "Mike, boy, get him all in one bale, go on, get him all in one. I give you something." Mike press and press. He leave the press down a long time each time, he press him twice for every once he mostly do it. End up and get it all in there. Six hundred and sixty some odd pound. Heaviest bale ever come out of there. Glascow Whaley give him a dollar.

In those years I would run gin all day, haul cotton all night. I get pay two ways and ain't sleep none at all. I get along without that. Once that work starts, you don't shut down for three or four months. You start in October and run on through until about February, gin cotton all that time. Sometimes we had to haul cotton five, eight, ten, even twenty miles in the night.

Why should we haul cotton in the night like that? Here is why: supposing a colored man live on a white man place and the white man has a gin house. Now, that man is supposed to gin his cotton there. But he won't get any money for it if he does. The white man says he is so badly in debt, all he will do is knock off some of that debt. If the poor man wants some money, he has got to get that cotton out from that man's place, go and gin it and sell it some place else, got to go in the night when the man is asleep. When I was still a little fella, fifteen or sixteen years old, I the one to go there and bring that man bale of cotton in to our gin house. When I done with loading up, it be about two, three-o'clock in the morning. Start home, and I drop asleep right on the wagon, couldn't keep my eye open. Get back to the gin, don't go home; gone to work, work right on through.

Sometimes we have to keep the cotton over for another year. If you don't have enough cotton, we can't run the gin house just for you. If you happen to run up on two or three hundred pounds of cotton, that's not enough. Gin house must run full. Then you can't gin it that year; you'll have to keep it for next year. We got plenty of place for keep him too. Gin house—three flight high and that whole top story wide open, just for store cotton. Stack your cotton by one beam up there. Plenty of beam for that cotton—sixty foot of beam. Next year you can put it together with two or three other people, stack it all together. We make a mixed bale, but we keep account of each man cotton. I start your cotton in the gin. As soon as I gin out your cotton, I holler to the press man and he tie it up. I remove your cotton seed from the gin, bag it, put your name on it and he weigh your lint before he stack it in the baling press. He tell me and I put it down on a slip, lay it in the tool box back there. I know exactly how much poundage each man has in the finished bale. I better know. We take that cotton to town and sell at the auction, call it the bidder sale. The man that buys that mixed bale makes out the deed in one name. All he really got to do is tell the ginhouse man the price it went at, it sold for forty cents, it sold for fifty cents, sixty cents. You come to me after the sale and I can give you just whatever your share of the money is, the next man his share, and the next man his, right along, based on however much poundage each man had. Gin house got the amount. We have secretary to keep track of that. Yorky Williams was secretary.

Sometimes we have a breakdown that we can't handle. Then a man name Winthrop Johnson, who was mechanic for Townsend out at Bleak Hall, he would come to us and help us fix up. He marry Townsend daughter after a while, stay out there and keep all the equipment at Bleak Hall going. He would set up that engine and work on him in the night. In the busy part of the season, if Papa come to a place where he got to stop, Winthrop Johnson would run the gin all night long sometimes, right on through to the morning. And any time if a bolt wrung off or something, he would fix it for us. He was a smart mechanic. Only one time did he have to go off the Island for parts. He had to go to Columbia one time, but that was one time only. He fix it himself every other time.

Jeff Jones run a gin too. Been three gin house side by side there in Clark's. One by Robertson, one by Henry Hutchinson—Henry Hutchinson wife is my mother first cousin—and one by Jeff Jones. Jeff Jones, he was a big operator. Worth sixty thousand dollars in cash when he die. Wife and all dead out first: ain't know what happen to that money. During those years back then, he gin a heap of that

midnight cotton, just like we do, only more of it. He have a big old store. I mean, big! Jones—he let people have credit against their cotton. Especially it's good if you start in to let the man have credit when cotton been half make. That way your money don't have to lay up long. When cotton done make, you will take your bill out of the bale of cotton when he bring it to the gin house.

The people bring him the cotton and he bite they head off. He take the cotton, pay them a little, not half maybe what it is worth. He rob his way through, that way he have a chance to make it fast ahead. They don't mind though. The way that work is this: the people who live on the white man place ain't got much judgement no how. They go from one day to the next. Go to the man's commissary, get anything they want, don't have to pay nothing, add on, add on to that account. In the fall they bring that bale of cotton to the man, say to John Townsend at his gin house, and he will collect his debt from them. More often than not they been spend more than that bale is worth. They know that much anyhow. They work all the season, know they ain't going to be no richer at this year's end than they were last year. By the time they get to the end of the journey, ain't got nuttin. But they get the idea they can beat that rap. Take that cotton out of their field in the night, bring him over Jeff Jones gin. If he don't pay them half what it is worth, that is still cash money, they are that much better off than they would be if they carry him to John Townsend. They supposed to let that cotton pass through Townsend hand, but when they go Jeff Jones way, they get a little somp'n; Townsend would have got him, he take all. One year they haul off all the cotton from over Townsend way, haul out across that sand in the night. Come straight on from Bleak Hall out by Sea Cloud, straight to Jeff Jones gin, sell him in the night. Jones have people to buy cotton too. He see somebody good in some good section of the Island, he get that man work for him, buy cotton for him to his gin. Jones buy up all the cotton out Peters Point sometimes.

After the long cotton gone out, Jeff Jones stop with the gin house. He still farm a little. Have a big, fine-looking mule, big and mean. He have a bunch of fee house, tenant house all on the place. He get me to fix them up, that is up in Roosevelt times, after I turn carpenter. I mostly check with him each day, or maybe a couple time a week—I know what to do. Once he done tell me, see him or not, I could go on working. One day I see him when he come from town, just when I knock off. We check out for tomorrow and I gone on. Next day I come to work. Bubber Whaley there, say, "Where you going?"

"Goin see Jeff Jones, go to work."

"You goin to undertaker shop then?"

"Huh?"

"Jeff Jones—dead."

"I talk to him last night when I knock off. How he dead?"

"Lady have that nice little colt up on the hill? Jeff Jones mule gone there, going to kill him. Jeff Jones see this, he gone out in the night, got so mad with that mule he drop dead on the spot."

I gone on to work anyhow. I had that to do.

I have a little shop here too. Papa give me a little shop for me to tend. Right out in front the house. I run him mostly in the night. I eat out of my shop in the day—big old case of milk crackers, you mash em in your hand, they crispy, condensed milk, slice of cheese. Make a good lunch. Run him in the night when people come to the gin house. I sell cash and carry. Rice, sugar, grits, meat, lard, flour, or cigarettes, chewing tobacco, candy, snuff—all that kind of stuff. You come in and buy ten, fifteen dollars worth of natural-born groceries. You pay me the money, I give you the change. I used to make out well on that business too. I remember when one man from the village lose twenty dollars there. It was my cousin Ezra Brown. I find that money, give back. That was one glad man. Lots of people from the village come here. Papa do a lot in that store, give credit to people. He even give credit to some that come from far off. He buy their cotton with credit from that store. When the crop come in, he gain double, cause he get the cotton and seed and all. Along with the seven, eight, nine bale he have of his own, he was well off. He sell that cotton to Dill Ball in town. As he gin him out, send him straight on to town. He don't know how much money he got till season end. After the gin house season he gone to Mr. Ball and check on his toll and his cotton. (*Bubberson Brown.*)

Ever since I can remember, there was my grandfather with the gin house. Now it was my father work there with him. I been just old enough to carry them something to eat—twelve and thirteen years old. I see them working when I went there to take them their dinner sometimes. They got these old, settled women, sit at a big, wide table, spread out the cotton and pick out all the trash, set there all day. For the short cotton, now, you get a blower, blow that trash out. Fast? Ain't no comparison. But there is more money in the long staple cotton for all that.

I saw my old grandmother work right there. Bella. Along with the other women. They would sort this cotton over here, over there—many task. Bella, she is my father's mother. She had another name. We all called her Beuw. Her sister Matilda that marry a man name Kelly, we call her Baw. That the oldest of those sister. My grandmother's full name is Isabella. She was a slave at the Edings plantation, Seaside, along in eighteen forty, eighteen fifty, before McKonkey came in. Her father was name April Frazier, and he was near about seven feet high. He was the driver on that same plantation in slavery times. They pay him a high wage for that work, pay him, man. Near about run Edings broke he pay him so much. Edings ain't never come back. When April Frazier get old, he live with he daughter, right down there in that same solid-built house where we weather the storm of nineteen eleven, my daddy's house right over there. He have a voice you could hear a mile, even when he was more than a hundred years old. Somebody come to the house, tell his daughter, "So and so done die," don't care how quiet they speak, the old man hear them. Then you can hear him all over the settlement, that big voice like a fog horn, "Hey, boy! Gie you grand pa a dose of physic salt." He want to show them he ain't dead yet. Every time he hear that word, he holler out and take a dose. Hooeee! If he had ever hear of three in one day, all that physic salt he call for would have kill him sure. He was a hundred and ten or fifteen years old when he finally do die. While we in Georgia, some time before nineteen o nine he die in that same house.

April Frazier, Nancy is his wife. They and all their children come from Africa, so they say. Born over there. My grandmother Bella is one of the children. She have two brothers know the arts of flying. Two of them got on top of the house at McKonkeys and fly, fly gone back there, out across that ocean, back to Africa where they come from. That what she said. Ain't got to believe it, but that what she said.

When Bella just a girl, work on that place where her father was driver, it been hard times some of the time. She would go out with two mules to plow, leave out at daybreak. She plow them two mules right on through the day with no dinner break at all. She take some ash cake from in the morning tie up in her apron, up around her waist, and then she would eat that a little now, a little later on. She got to carry water too. Wouldn't make but one furrow a day, a two mile furrow run all from McConkey house all the way up to near Grant store. They have a mule building there by the big house where they keep eighteen, twenty head of mules. You be a full-grown man, you ain't a make but two row a day no matter how many you hitch up. Down and back. Down, that's noonday, back, that's sundown. If your mules ain't fast, you ain't a make the two. Bella bring them two mules of hers back in at sundown, unhitch, turn them loose.

Bella, now. She give my daughter Carrie her name in nineteen and nineteen. She live on and live on until nineteen twenty seven or twenty eight. I go over there to spend the night with her sometime if she lonesome in the night. I be glad to do that too; she a loving woman and had been so good to me. When she die she was a hundred and five years old.

She used to work for Eddin Whaley and Rosa Whaley at their plantation, The Neck. It butt against McKonkey on the one side and run into the creek at the other. Old Man Jimmy Whaley who live at Crawfords by the Village here was his father and give Eddin Whaley the Neck. My grandmother, she cook for them on the weekends. She go there Saturday morning, spent the night, and come back home Sunday evening late. I—the one who take her—take her in a cart with a horse. My father have six or seven of the finest kind of horses back in those days. I hitch up Saturday morning and take her out there, and I must not bring that cart back dry, no sir. I bring him back every time fill up with wood. We ain't had much firewood around the place here and there been firewood a-plenty up at the Neck.

Each family had some connection with one or another of the plantations. The place name you. You related from there. "Who is that?" "That is Thomas Brown, he a Konkey," that mean his place is McKonkeys, or "That is So and So, he is a Murray," and so on like that. You born there, you work there and when you die, you would be bury there. In these days, now, you get bury in the church graveyard, but in times of my grandfather, you get bury in the plantation cemetery.

My auntie Molly Gadsden who marry Sam's uncle Carolina Gadsden, she live to be a hundred and five years old just like her mother, Bella. When Molly die along in nineteen sixty one, sixty two sometime along there, she wouldn't get bury at Allen Church, no, but she get bury in the old Murray graveyard at Jackdaw Plantation next to Seaside out there. I was out there just a month or two ago. They hire a man to cut off the weeds and clean out that graveyard—it's a shame how it is grown up! He couldn't have find his way in for nothing except I know the way.

If you needed wood back in those days, you better go where you have some connection, not just forage on some land where you don't have none. My grandmother work at The Neck, so they were glad for me to gather firewood there. They had more firewood there than any place on the Island.

Whenever I carry my grandmother there, Miss Rosa Whaley would give me a little bit of money. It ain't a matter of wondering would I get it or not; just as sure as I gone out there, I know I would get some little bit of change. She would never give it to me just flat out, so. For if Edin Whaley see her do it, he would stop her. So she would cut into an apple and then put the money in there, or in some tea, or some other little thing. When I eat the apple, I find the money and I would know she had give it to me. One Saturday she put fifty cents in an apple—now that was a lot of money back in nineteen ten—and then she stand at the window and watch me while I go back away, eat on that apple. They had a long lane led from the main house all along to the house of Elias Barron. He was foreman on the place, he did all their work, worked their people. She was watching me while I walked away along that lane, she saw I lost that fifty cent piece. I gone to looking all back and forth along that lane, back and forth. She call me back, "Didn't you lose that money?"

"Yes ma'am."

"Well, here," and she give me another fifty cents. Now I tell you, that was something! If we were real lucky, at Christmas time we might get as much as fifteen cents. And here she gave me fifty, the second fifty for the day. I was a rich bo. I held on to that one. Then as I went out, I saw the first fifty cents. I gone back to her, I tell her, "I find the first fifty cents. Here is the second one back."

"No, you go on and take them both. That's all right."

I gone away from there, I get my wood, I drive my cart on toward home: I was the richest man on all of Edisto Island. If her husband had know it, it would give him a fit. Three of them brothers and none of them don't want to see nobody have no money. One time a boy from here go around to one of them other brother house, Jimmy Whaley house, "Oh, look Maussa. I find a quarter, see?"

Jimmy Whaley, say, "Oh? Hand him here." He take the quarter, give the boy nothing. They ain't want nobody but them to have no money.

Miss Rosa was soft hearted. One time I been in the kitchen, eat a fish. Had a fish about a foot long and I was making good headway with it. My grandmother Bella tell me to hurry up go cut her some wood for the fire. Miss Rosa come up then, "Maum Bella, now, don't you bother that boy about cutting any wood. Bubberson is too small for that heavy work. We have men on the place for that. Elias will do it."

"Miss Rosa, you see him eat that fish? He ain't too small to eat that fish, is he?"
"No. . ."

"Well I ain't send for him into this kitchen, and if he can eat that fish, he can cut that wood."

I ain't cut none though. I get my own, but ain't never cut none for them. Miss Rosa is soft hearted that way.

While I go out the road from the Neck on back home, I gather wood and put in my cart. But I am looking out for Edin Whaley. Every day that man would walk to get his mail. Long walk! Three or four miles, from the Neck all the way up to Freedman's Village. He pick up his mail at Jamsie Jenkins' store there, then he walk back. Big tall man, big beard just like a Santa Claus, tall and slim—nothing but leg. And he walk, ain't never ride nothing. He got plenty of horse, cart, buggy and all, but he walk. And he walk quiet. In those days the land was more clear than now. Now it all grown up. In those days that man ain't have that much land to spare, he keep them fields clear. But he have woods patch along the road. Road dip down in there, he walk along, then he hear you cut wood on his place. He walk up quick onto the high clear land and holler, "Lias! Ohhh Lias! Lias, go there. They are eating up the No Knock." Each of them little creek or woods have a name like that—Matters Creek, Back Landing, No Knock.

Lias come, he see it's me, he go back to Mr. Edin Whaley, "Ain't nobody in there. I come there but it ain't nobody." If it hadn't been me, he would make them get out.

The way the mail get to Jamsie Jenkins' store is this: it used to be two colored men handle all the mail on the Island. The mail come by railroad boat there to Steamboat Landing. The two men meet that boat. One man come by boat, row there from Swinton Whaley's place on Little Edisto, get the mail, turn around and row back. If you live on that side and you want your mail, you must go to get it at Swinton Whaley's, it be to his commissary; keep commissary right in the yard. Over on this side it was Sam Simmons that carry it, go by horseback. Carry all the mail round and round this side of the Island every day. He drop it off at different places-Jamsie Jenkins' store, Baily's store, Murray's store-and you go get it there.

That was a plentiful time. More plentiful than any time we have since. Some year, in the winter, along in January, might come a snow. That is the day to hunt. I go out. Cold? Freezing—but I ain't care. Listen at the marsh. Look. Bird. He ain't fly that day, not just fly, but pop out! Pop up out of tree. Snow—pile up on the pine branch, dump off while you go by. Green. Branch thrash up to the sky. Rabbit pop out through the grass, pop, pop, pop . . . I kill more bird and rabbit! I couldn't get cold in those days.

A man could make something for himself. One year the old man haul in forty wagon load of corn, fill till the house can't hold no more. I would take and beat out rice, beat out ten quart at a time. I could stand up on a step and beat it with a beater in the mortar, put that rough rice in, take some corn shuck and beat up in him, beat, beat, beat—he whiten up. White as snow. When the preacher come, give him rice, whole plate full. All the men get that. For me, ain't but one scoop of rice over the grits. Nothing but pure hominy through and through. I wonder,

did it fool the preacher, think even child get solid rice at Bella table? I sit there, wish I was a big man. (*Bubberson Brown.*)

Bella Brown was born in Africa. She was brought over with her mother and father and nine head of brothers and sisters through the Customs House in Charleston to Saint Helena Island, the home place of the Edings family. During those years the United States government was trying to stop these pirates from taking people and bringing them across the ocean and selling them. They were trying to break up that trade. They made them come through the Customs House and they put a heavy tax on them there, fifty dollars a head. The slave traders said that was too severe, it would run them broke. One good thing: all those records are there now, the tribe and name of all that family of people is right there in the Customs House if anybody wants to read it. Bella Brown told me many times. (*Sam Gadsden.*)

The Flying Affiky Mans: this is an old and often repeated story. The old people would tell it by the fire and we children would take it as a joke, as a tale for amusement. You hear it about men from Wadmalaw, from Saint Helena—all about. The two men who had the reputation for flying on Edisto were not kin to Bella. They were Ceasar Knights and his brother, whose name I have forgotten. The grandson of Ceasar Knights is the same Mike Knights who is running a produce business in New York right now, the one who hired William to farm for him and who used to buy my potatoes back before the INCC came in and ruined that business for the small farmer. Here is the story:

Master Billy Edings had a slave named Ceasar Knights, had him and several of his brothers and their wives and children. It was Ceasar and one of his brothers who are in this story. That Affiky man and his brother had the master fooled: he said he could jump right across it. He told Maussa he must bring people to come from England, New York—all about to see him jump. It's a four-story house, that same big house at Seaside where McConkey took over. After they were all set to watch him, he would start in to run. He ran round, round, round that house, and after a while he would get such a speed on him they lost track, didn't know where he was. Just about then he would holler, "Here I am. I done fly across." And there he would be on the other side. Bella said he ran right through under the house that last time. Ceasar Knights did this many times and that is the way he fooled Maussa and all those people he brought in to watch, so the story says.

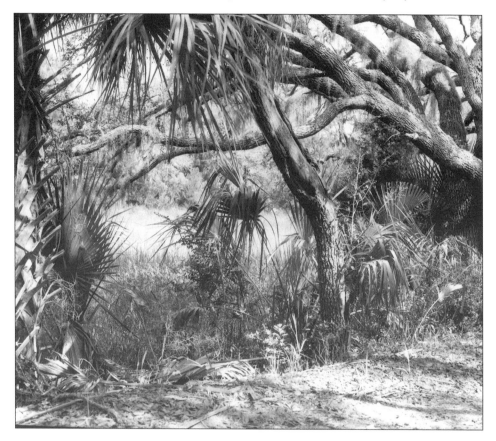

Ceasar Knights and his family that came to this country from Africa had several brothers and the master sent them into the field to work with their hoes. I am told they were good men to work with a hoe in the field. Ceasar went in the field with his brother but he didn't finish his task. Maussa sent to bring Ceasar and his brother in to whip them. The overseer sent the driver to get them, but when the driver came close by, Ceasar threw his hoe up into the air, climbed up and sat

cross-legged on the hoe, up high where the driver couldn't reach him. Neither him nor his brother got a whipping that day.

The next day Maussa sent them out in the field to work again, for they were good hoe hands and the crop was making. By quitting time, Ceasar hadn't done his task the second day. When the driver went to take hold of him to bring him and give an account of himself, Ceasar climbed up on his hoe and sat across-legged, grinning down on the driver from up in the air. Maussa got no account from Ceasar that second day either.

The third day Maussa went himself to see where Ceasar was working. He saw where Ceasar had a big fire and him and his brother and their wives and children were all dancing and making a celebration around the fire, kick up their heels and all. While Maussa watched, the fire began to make a smoke, make a big smoke. Smoke, smoke, smoke, and when the smoke was gone, come to find out, Ceasar and his whole family had gone up in that smoke. Fly out across the ocean, gone home to Africa. No more see, no more hear: two brothers, their wives and children—the whole tribe. (*Sam Gadsden.*)

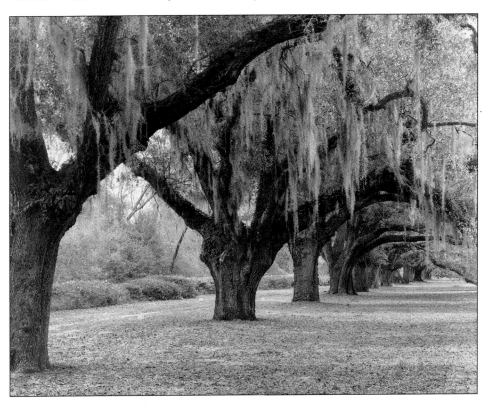

The slavery days had their hardships. The people worked hard, that's all they knew. If they had a hard master, their lives were painful. But most of the time the days weren't bad. If they had a good master, he would allow them to finish with their day's work in the morning and then work for themselves in the evening.

They made a good little crop. Then he would turn around and buy up every scrap of that crop himself; pay them good money too.

At Governor Middleton's plantation here on the Island they had one old man who made whisky. His master had him taught that skill and they had a still set up right in the yard by the quarters where he would run his mash. Then if some other master of the Island was going to have a party that night, he would send to Middleton's to get corn whisky. That same Major Murray who was master at Jackdaw Plantation where he treated Jane and Charles so well, he would send for it: "Go get some niggerhouse yard whisky." Maussa would say that.

It got to be a joke all over the whole Island. If the Black people were going to have a frolic, they would say, "We go be well supply: we got a brother over at Middleton's." He actually was a brother to all Jane, Charles, Dara and them, since their father, Kwibo Tom, had a wife there and it was her son—the whisky man. (*Sam Gadsden.*)

It was mostly white men who had charge of distributing the mail. The only colored man I know who had a hand in it was Freddy Seabrook. He lived down Steamboat Road. He built himself a big house down there, the place they now call Land's End. He was the star route carrier and took the mail from the boat to the post office. The postmaster took over then, sorted it and distributed it. It wouldn't go out until the next morning, for the boat didn't get in until five or five thirty in the afternoon. Everybody would go up there in the evening, get the mail and socialize. Old man King used to deliver it around the turn of the century. He is the father of the Kings who live on Yonges Island now. But that was before my time. The first I remember, William Bailey was the mail carrier. He carried it in a little two-wheel gig or sometimes on horseback. He must have had two horses so he could ride one today and the other one tomorrow—he had a long way to go on his route: all over this island. He would leave the mail in your box just as the mail carrier does today. Many of the people didn't have a box, so he would leave it at a store or central location where you could pick it up.

Then later on, about 1914, William Bailey got the first T Model there was on Edisto, and he used that to deliver the mail. That was a year or so before they started with the ferry from Whooping Island to the Main. They ran those early Model T's on naphtha: brought it over in fifty-five gallon drums on the steamboat. The first four T Models on Edisto belonged to William Bailey, then Dr. Jenks Pope, Old Man Mitchie Seabrook, and Old Man Towney Mikell—he had the first sedan. The rest were open touring cars. (*J.G. Murray Jr.*)

Things gone along so, and I was working at contract work, farming for myself, or working in the gin house. All that while, whatever the Old Man say, that is what I did. I work for him whenever he say work. I ran the gin house right along and I planted cotton too. The cotton would sell for fifty, sixty cents. In nineteen nineteen I had some that sold for ninety eight. That was the year I got married. That was a plentiful year.

141

My wife come of a good family of people: very industrious. I mean to keep her from trouble, take care of her. I know then she ain't got to do no hiring herself out. No sir. I will be the one.

I work that year, make the best cotton we ever gin. I get ninety-eight cent a pound. Ain't lack but two cent of a dollar. That was the highest price in the gin that year. Another boy make it too: Glascow Whaley. He used to live right by the gin house. It was hot work, a long season's work and hot as hot. I didn't mind. That was sport for me. I didn't think it could get too hot. Hot don't worry me. (*Bubberson Brown*.)

CONTRACT WORK

I was just starting out then. I wouldn't work for wages very often, didn't do much of that work, even though a lot of other people did. Sometimes I work for Robert Hills. He had a big place over here, Beckett Plantation. I liked to go and work some for Mr. Hills. That was forty or fifty cent a day. I didn't do much of it though; I had rather do contract work, plowing and all.

Me and my mother like sister and brother—she in her young age and I the oldest son. She tell me, "C'mon Bubber, let's we go work for Mr. Hills. Let's we go make a little horse cake." That was some little sweet cake you could get in the store. She know Papa ain't agree to that, but she like a little pocket money and she want to slip off, go work a little. The way we are and the upright man that my grandfather and father are, we hadn't no business in that field. But sometimes, I go with her any how. When you got me with a hoe, you ain't got nobody nohow. Before we half through our three task, I done give out. What make it so bad, everybody else done finish their task before the heat of the day come on, just me and Mama the only ones in the field who ain't done. Every time we go, Papa and the rest got to help us finish them three task. Three task, that is twenty-one bed and each one five foot wide. Each task, fifteen cent, that make forty five cent for half a day of work, two big people. If we had finish him. Daddy ain't going to leave us there to work it out by ourselves in the hot mid day. We was too well known. We ain't got no call to be there no how. Mama-afflicted anyhow, ever since before I was born. Got a weak back or something. Daddy ain't going to let her work in his own field: he got people to do that work for him, he hire them. How should he let her work for Robert Hills then? Ain't going to do it. I don't believe Mama could have pick forty pound of

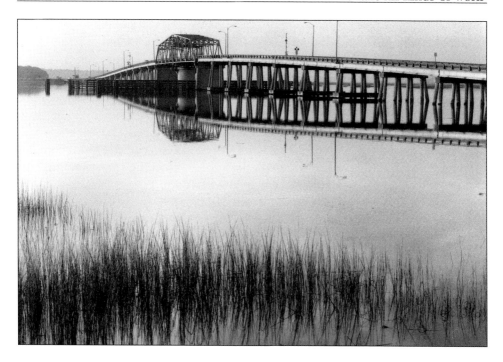

cotton in a day. And some people come out and pick a hundred! I ain't want no hoe and Mama ain't such a good hoe hand nohow: I wonder why she want to do it?

I am like my Daddy: give me a mule and plow. Hoe don't fit my hand at all. I like to plow. One time I been sick with a fever. I look out of the house, see Daddy plow. That was my work; I come across the field, tell him, "Let me plow now."

"Boy, you can't plow! You too sick."

"Let me plow." Fever on me and I been weakish, leg feel weak under me. But I done a day's work that day anyhow. He got a good plow man when he got me. I ain't want no better job.

One day Papa gone out to town. He have a seven and a half acre field over in Legree—plant rice, corn there. He say, "Take mule and plow, see what you can do with him. Finish him up tomorrow."

He come home, sun high still. He find me at the house: "How, you can't make it? You ain't plowing?"

"I done, sir."

"How? You can't be done and it high sun yet in the day!"

"Yes, sir."

He ain't done a thing but jump on his horse and gone over to look and see. Been a old lady live over there and I carry my little bit of lunch to her and she cook him. There is no rest for the mule with me. I can't get tired with that work. I ain't like no better sport. Plow that field out and leave the sun a-runnin.

Nineteen sixteen was a year when everybody was buying a mule. They would pay as much as three hundred dollars. I got me a fine little mule, Carrie. Paid two hundred and eighty five dollars for her. What a mule! Ain't too big, but Great

143

Jesus! What a mule! I get the cart that same year. You could load up two bale of cotton and she would pull it. She was strong. She would haul thirteen, fourteen hundred pounds of baled cotton and seeds in that cart all down those sandy roads, and in the night time, just her one. I think so much of that mule I name my oldest daughter by the same name, Carrie. She would haul any place—Bleak Hall, Peter's Point, Middleton's. I never go down in the Burrough nor over on Little Edisto. I don't believe I ever haul cotton no further than Dr. Pope's place, Middletons. Take one man with me, Primus Morrison Legree. Call him any time of the night. We work together through all these years. He's the right hand man in the gin house, never did married. Very smart—a workin boogie. That mule take the itch along in nineteen twenty and it killed her.

One day in nineteen eighteen Robert Hills gave me a contract: plow up four acres of land and he will pay me eight dollars. I said, "All right, we will do that." I knew that mule could do that, easy. The day I was to plow the Old Man gone to Charleston early that morning. Then I went on over to Mr. Hills' place. He stake out the four acres and I cut that mule in there. By eleven o'clock that morning I back home! Done that work and made my wages. Ain't no fifty cents in a day, but eight dollars in less than half a day. I went on that same day, on over to the creek,

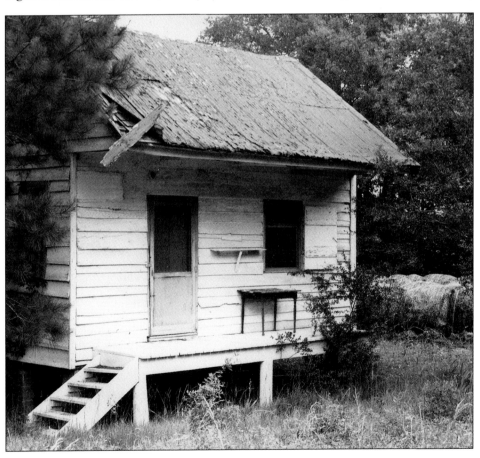

and cut me a load of marsh for horse feed and I haul it up here. Then I went out to the steamboat and picked up my daddy in the evening. All in one day!

I used to haul marsh, cut and haul out thirty, forty loads, put it out on shore in a big rick, let him dry out. Then you spread him in the horse lot. At first the horse would eat it. Then he would trample it down, mash it down, and it would get sour and rotten. Then along in March I would spread it in the field. Poor man, I ain't about to buy any fertilizer.

Some men would haul mud too, and they would spread that for fertilizer. Oh, but that was tough work! I didn't do it but once: that was in nineteen nineteen, the same year I married. Do it on my own land. After I try it, I don't see no sense in that, but them white farmers do it back then. They do it down at Peter's Point, there where Lee Mikell stay. They do it at California, where Townsend Mikell hold sway. They would give you day's work for haul mud. Forty cart loads would count for one day's work. You go in the creek, you cut that mud out and load in the cart. Cart hold about half a pick-up truck load, but ain't put but twenty or thirty shovels of mud at a load. You mostly get your work done early in the morning; you ain't going to fight that mud in the heat of the day. You haul him up and dump on the field. Look like a hog been through there—little hump here, little hump here, here. Line up in straight row. That cart would dump; ain't got to shovel him out. Put the mud there, that ain't the trouble. Trouble come when you go to cut that mud in. Shucks! That thing get hard out there? And all that string and grass root in him? Got to use a hoe and chop him in to the ground—that was tough, hot work. Do it in the cool before the day. Plenty of time you see the whole gang gone there and half done by day clean. There is a church meeting at my grandmother house Sunday night. Plenty of times they gone straight to chop after meeting. Moon shine bright: gone straight from there, chop mud in the night. By day clean—they done home. That mud—tough! With a long string on him. I try it that one year on my own land and then—no more. I believe some of them chunk mud lay out on the ground there to this very day-year.

You sign a contract for that day work. Give Monday every week, March through June, and the man pay you fifteen dollars a month for each task you work for one day. If you give him Monday and Tuesday, you get thirty dollars. According how much crowd you got you could take up six, eight, ten task of ground and whole family work at it. In June you sign a new contract. It was a sort of slavery way they would work you. Some of them treat you all right. Mr. Mikell out at Peter's Point treat you well and the people get on fine with him. I ain't never done that work, so I only know what I hear. Mr. Townsend Mikell, now, he a slavery driver. He have them two windows high up in the roof of his house, look out and see who is working and who ain't, who it is who stop the plow. He know when you stop that mule, he, way up in that cock loft. At that place you go at a dog trot, and you go from can to can't. And Dr. Pope, he's another one. If you get money from him, it will make you sick with work; he hang around you all the time. I tell you the plain truth: I don't want no man stand over me, drive me. I got my own interest, I know what I should do. (*Bubberson Brown*.)

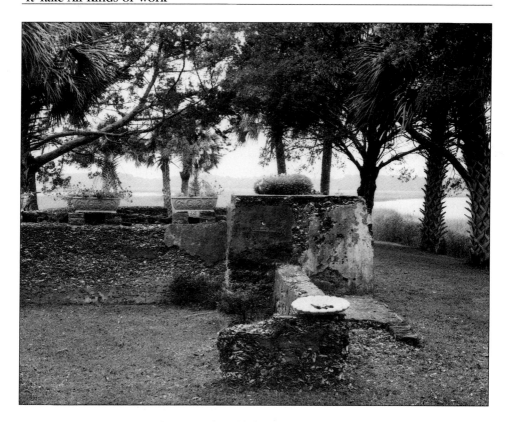

During Reconstruction days there was no such thing as commercial fertilizer. People used marsh; you call it marsh grass. And they used the marsh mud itself. You didn't have to use the mud, but it was better that way. You would take a lighter, a big, flat barge, you would go up in a small tidal gutter, cut marsh with a scythe and load up that lighter with it. When the tide was high, you would float that load around to a bank or bluff somewhere and throw the marsh off there. Then you would take it and lay it in the alleys between the cotton rows.

Many plantation farmers would mud their land, too. First they have you cut marsh and strew it in the field, then, later, during August, they have you to dig that mud and haul it on shore, let it dry out until January when you put it on the field. You might use a lighter for the mud, or if the marsh was close to the field, you lay boards across the marsh and use a wheelbarrow. That was in August and the temperature nearly a hundred degrees, and the air damp and heavy. It was hard, hot work, but the people didn't mind. In those days, that was all they knew. Mr. Townsend Mikell at California where my father and mother worked, he would mud his land every winter.

After about 1895 when they opened up the phosphate mines twenty miles north, there on the main, at Red Top, and the commercial fertilizer came in, they thought they would use that instead of mud. It was a lot easier to handle, but they found it wasn't sufficient for the long staple cotton. They gradually found out that what it lacked was salt, the salt from that marsh. They would add a salt they

brought from Germany, German Salt (potash). But poor people found they could gather up salt along the beach and it would do just as well. (*Sam Gadsden.*)

Many farmers used marsh mud for fertilizer for Sea Island cotton; my father did. It contained valuable mineral elements for the raising of that particular crop. In determining locations for digging the mud, he took samples. He would shake up in a test tube a certain proportion of mud and water and leave it to settle overnight. It was evident in the morning how much sand there was, and how much of fertile silt: it showed in a clear line on the tube. If it settled out with sufficient organic matter, he sent the sample off to Clemson to have them analyze it. If the analysis showed it to have sufficient phosphorus and potash, we could dig the mud in the area where he got the sample. If not, we would try again in some other area of the marsh. All the bulk potash we used in this country came from Germany in those days if we couldn't get it from the mud. Labor got short when wages went up during World War One and the farmers had to quit digging the mud. It became cheaper to import potash from Europe. Wages went up to two dollars and fifty cents a day, then to five dollars,and that just about stopped it; it took a lot of labor to handle that mud. First the imported fertilizer replaced the mud, then the boll weevil came in and ruined Sea Island cotton altogether. (*J.G. Murray Jr.*)

Nineteen twenty-nine, nineteen thirty—I was working on the road crew all this time. Dig out the ditch beside the road, clean out the culvert. But in nineteen thirty two I quit with it. I turned to working as a carpenter. I had a chance to work under Walter Brisborn at Nelly Whaley's place. The wage was eleven or twelve

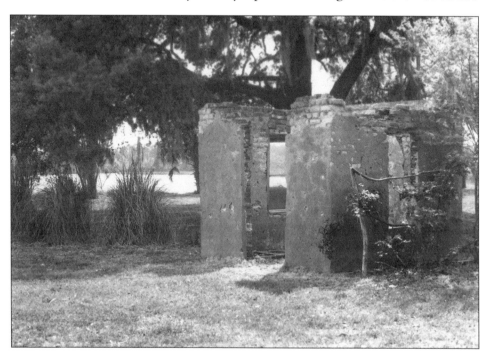

dollars a week. That would run me maybe twenty four dollars in two weeks; seven fifty more than the county was paying. I just dropped the road work.

We're cutting brush and pine off Hampton Hill one day, up Bleak Hall Road by Allen Church, eating our dinner there beside the road. I finish mine. I say, "Boys, good day. I gone from here. I finish with this thing: can't work for no fifteen, sixteen dollars no more." Then I'm gone and tell the bossman, gone and tell . I didn't care, because I knew there were people there who were going to tell him. They have people on a crew to look out for things like that, somebody will be bringing news to the bossman all the time.

That the way with _____. He try to catch up with you, swallow all the tellers bring him, then fire you some time when you can't get work no place else, have the hardest time you can. He keep up with things, with farm work and all, he know all that.

Swallow that news then puke him up all at once and fire you some time the worst for you. A_____ and B_____, they the meanest one to carry news. They slip out before work and carry tater to Mr._____ and all. He fire H_____ after all farm work out in the month of June. Ain't a thing for H_____ to do. Gone to work after so long a time for Steve Flowers, cut canal, dig mud and all. But _____ ain't a fire me no how. Won't fire a good man like me. I ain't never been fire off no job. I was a bird a-flying.

I first start in carpentry work with Walter Brisborn. He live the next road to mine. You turn off Oyster Factory road just before you get to me. He is my wife's first cousin and a first class carpenter. As soon as I had a chance, I jump in and work with him. I wanted to learn it. It ain't take long to learn him when you want to learn. We start in together and we get to working at Nelly Whaley's plantation. Under Nelly Whaley—Robert Hills; under Mr. Hills—Walter Brisborn, and under Walter there was me. Walter play me a bad trick there: he left me on that job. He got another job, good job, in the Village. Mr. Hills see him leave like that, ain't going to hire him back. Walter leave me, the man wouldn't take him back. That's the chance I get to get in there. Mr. Hills say to me, "Go get someone you know to help with the heavy work." I get Hanford Richards. The small job I could do myself, like level up house, jack him straight—I could fight them by myself. Have plenty of them big house jack and all. But then he get me to build that forty by twenty eight foot barn, I need Hanford Richards to help. He was a good carpenter, now. Lot better than me. Make a footing for that barn—the concrete form start big where he underground, come up, come up, get small to match the sill.

Very first thing Mr. Hills put me on, put an arch on that chimney, arch brick smoke cap, curve over the top. Worry? I ain't never see that done before. I ain't sleep that night, ain't get a sleep once. I study, study, I figure out something. Ain't sure till I try him in the morning. Take and get a tin and bend around in there. So I done it and it work just as slick . . . put that arch right on there.

I start working regular as a carpenter then, over in Whaley Field, for Nelly Whaley. It happened that I was still working under Robert Hills like my grandfather and my father had done. How Robert Hills came to be working for

Whaley and not run his own plantation is this: when my father was borrowing money to change over the gin house from long to short cotton, Robert Hills was borrowing money too. He borrow from Dr. Pope and then he couldn't get loose and couldn't pay, so in nineteen twenty eight they moved off that place. Dr. Pope sold it and Robert Hills went and rented land at Sunnyside Plantation on Peter's Point Road: Nelly Whaley's place right next door to that. He was her agent there at Whaley Field when I start in with carpenter work.

Nelly Whaley had me building up a place for chickens, and this and that—it was all carpentry work: that was good work. But after a while she put me up into the trees. I must saw off this limb here and that limb there and put creosote on the place where I cut it. I could see I was running out of carpenter work and she was trying to find other work for me. One day I went up in a tree and a big snake was there. This thing—I don't want. I said, "I'm going home for good now. I ain't a cut no more tree." It seem like every tree I look in after that, snake been there. Then after that me and her fell out.

We were in the flower garden working once, it was a Friday evening, and she said to me, "Ah, William, now, you know, I want you here tomorrow morning."

I said, "Sat'dy morning? I don't work Sat'dy."

"What are you going to do on Saturday? Why aren't you coming to work?"

I told her, "I go to Charleston, take me a load of cotton."

"For who?"

"For meself and the old man. We have a few bales."

That hit her like a stone. Come to find out, she didn't even know we had the gin house. I said, "I am going to take cotton to Charleston tomorrow; I can't work for nobody else."

She started in then, said, "Some of you people think you have got rich and aren't going to work on Saturday any more."

I said, "No, not that. It's work; got to work for myself tomorrow." I left out with six bales the next morning and hauled it in. Six bales from our own gin house. After that I saw me and her wasn't going to get along.

Travel that road, that long road. I have a lot of time on that road. Been on him before they had a bridge, a way back before that. Used to be a day's work to go to town and back, fall in the mud and ruts. Didn't have no hump bridge yet. You would go a way down in the Burrough to go off the Island by the road. Cut across at Doctor Shindledecker's and ford the creek on old pine log. We take some risk! Get on to Little Edisto that way, go across until you get on Whooping Island, you holler there and they will haul you across on the barge. Call it a ferry. Pull it by hands. If you got good luck you might make it to Charleston and back in a day. If you ain't got a good truck, you won't make it in a day. That's fifty miles by the road now.

Travel that road. Sometime I look back at myself and I wonder at myself. I was trying and trying and trying and trying. And in the worst of times. And the worst of time. Years and years I feed them children, keep them warm. Along in nineteen thirty and in there I turn around, get a bus. Make a living that way. My bus had fine leather seat round and round. Big, long old bus, a Ford T Model. Very nice bus I drive. We go winter and summer. Go every morning, back every evening. Along about nineteen thirty-two, motor give out. Had to put a new motor in him. Buy a new motor and put in there. It was a thirty-two motor, very nice. Have trouble some times to get home again the same day. That was a tough road. Have to be a T Model bus; nothing else could have stand it. One evening a lady was moving back to the Island; I have her load of furniture on the bus, and also a dead body. It was a little dead body; don't even know who it was by now. A child. I get back onto Little Edisto and bog down. Have to send for Daddy to pull me out with the truck. I give the little body to J____ to take care of. My old man meet me down by Calvary Church, tow me in. Sometimes the truck and the bus must go out together and this one pull that one till he bog, then turn around and that one pull this one out. Such a muddy road!

After nineteen thirty, the people gradually stopped farming. They gradually quit raising cotton, so there wasn't any use for all these gin houses. I quit raising cotton

and my daddy quit with the gin long before the rest did. Then one, then another, and after a little bit they all stopped. I quit first. I cut it out; I didn't bother with it any more. Since we didn't run the gin any more, Henry Eubanks and my first cousin, Viola, got a man, Old William, to set up a lumber mill at the gin house. They had a lot of timber in there on my cousin's land, so he got Old William to cut it up into lumber for him. William was all I ever knew, never knew his last name. He was a white man, had a wife and one girl child. Henry Eubanks got acquainted with him when Old William was grinding corn in the Burrough. Times weren't too good, it was nineteen thirty-six, nineteen thirty-seven, along in there. People were grinding corn all over this island—ate a lot of corn bread.

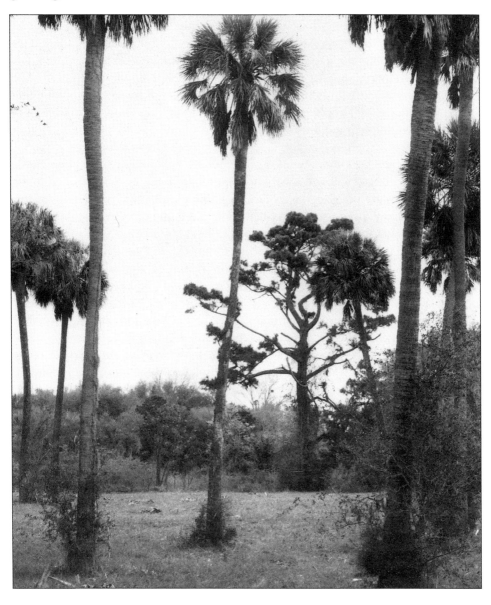

Boll weevil learn them to do that—been a good teacher. Show them they can feed themselves, don't need no cotton money—get along without that money. William grind corn in the Burrough, right in the Davidson's place. I carry corn around to him myself. He have a separator there, the first I ever see.

Henry found out that Old William know how to set up a lumber mill and saw boards. He hire him to come over to his land in Freedman's Village and cut boards. There was plenty of timber there. Old William was running a little mill in there for two or three years. Saw three-quarter board, just as pretty! That man do know something about run a saw mill. He have a sawmill carriage built, set that thing up right in the woods, where the logs are. Don't have to snake them out, just roll them on to the carriage right there. He run him with a tractor, a flat belt from power take off. He cut three quarter by eight inch board, four by four, six by six, two by four—everything you need, he cut him. He was much of a man. The first thing Henry did was to hire me to build him a store with some of those boards, that same store they call Grant's Store right now. Then he sold boards to everybody all around the Island. He was getting eighteen and twenty dollars a thousand for that lumber.

Old William didn't have any place else to stay, so we rented the gin house to him to stay in. One floor was pretty open and didn't have much in it. He moved in there. One day he set a fire and it got away from him. Or else, there was a construction crew had the use of a shed out back: it might have been them. Anyhow, a fire got in there and burn the damn place to the ground! Ah, Ah! Burnt it down smack smooth! That was in nineteen thirty nine. Two baling presses, five gins, all them long, old drive shaft, pulleys, and that engine! It was a single cylinder with fourteen inch side walls, a twelve-inch bore to the piston, have an old water jacket open on top to slop out around while it run, and all it little brass oil cup with each one a view glass in it—all. Everything burn down. We sold all the work things for junk and that was the end. Didn't gin no more: that's a patched-up plaster.

Now I tell you about the time I gone in with the government. About nineteen thirty seven they get up a plan that is supposed to give the poor people what they need to make a crop and make food for themselves. They give you money so you can get mule, plow, seed, fertilizer, food, clothes—everything you need to make that season's crop. They will also give you a pressure cooker and the jar and all the thing you need to preserve your crop. You get that cooker from Mrs. Frampton. She is very nice and she stay over on James Island. She give it to you outright, you don't got to pay for that at all. The mule and things, they only give you some of the money you need for them.

The man who administer that affair for the government here on Edisto was Robert Hills. He take care of you. He wants to help you get those things. I go to him, I sign up the papers—a mule, a cultivator, a plow. After a while the check come and he give it to me. I gone around and get cultivator and plow from a man named S____ at his store. My cart need a wheel; I get that from S_____ too. I get the mule down in the Burrough. Mule name Jamison cause man that raise him name Jamison. Laziest thing on earth, too. I get those things in March. I make a bale of cotton.

Next spring I was working in Palmettoville, do contract work for G_____ down by the Neck. See a man come toward me. S_____, he come and seize the mule, seize the cultivator and the plow, seize the cart, even though only one wheel is new. Let alone that, he try to seize my cow too. Nice little grown heifer calf that my daddy have give me. My daddy, he tell me, "Don't let him have it. That cow is your own. Ain't been no government money in that cow." S_____ check his list there, he see there ain't no cow on him, he leave me the cow. Cow break he neck anyhow. I leave him here, Papa and them to look out for: I gone to New York to work. He leave him too long a rope, he get to run and play, run out long, that rope jerk him up short, break he neck. S____, he seize these things and I let him take them. I ain't know no better. I think he is the government.

Not only he take the mule, plow and all, he tell me I must pay too. I done make a bale of cotton. I load him up, drive out by the gin house truck, carry him to town. I sell that cotton, gone to the government office where he been along the waterfront somewhere there—they take all. Take that whole bale of cotton ain't leave me a penny. It was S___ in the office. I tell him, "I been working all the year, make that one bale and the boll weevil all in here. You going to take the whole thing? Oh no! Don't treat me so. How I'm going to get home? Give me carfare for gas home anyhow."

"Brown, I don't care how you get home. You owe the government money and I am here to see you pay it."

They want the plow, they want the mule and they want the crop. Don't treat me that way. You got to give me a living part out that thing. That was a no good somp'n. Make out a no good plan and the man that make him—no good. The government have a plan—give help to the needy person, make a better life for himself. But the man they give that job to administer, he try to do other thing than the government want done. End up, he take away the little bit I do have. Clean wrongness. Whole pile of wrongness. That ain't the end of it though.

The next year S___ come back and try to get the same price again. He have the plan that I will keep on pay for that plow and mule the rest of my life, and the government already done pay for it. Now, how I going to do that thing? How can he get money out of me and he already took the mule and plow and all back? That ain't right. He worry me with government letter, letter, letter. I ain't know no better than to worry: I think he is the government. Come to find out, it ain't so. They wasn't doing things the government required; they doing things on their own. They got in power and then they wasn't merciful. The government ain't know nothing about it.

The next year a white man, Mr. Burns, he a white man stay over in the Burrough sometimes, he come from Washington where he work. He was an investigator like, come on this island to check up on this gang of thief here. He come home here on a trip, check on these things, come check on me. Day he come, I been in the house here and he come, sit right out under the tree there in the yard. I gone out to him, "Brown, I come to investigate you. I have heard about your case."

153

I tell him, "How can I keep on pay for these things and I already pay once? I don't see how I owe the Government anything."

Then he give me a good counsel. He is a very nice man. He help me to put a stop to that business. "Brown, that account is paid in full. You don't owe the Government a thing. I will send you a letter as soon as I get back to Washington." He done that too. I still have that letter somewhere about the house. I ain't have no more trouble with government letter.

That program bring trouble to the colored and the white alike. _____, he rule the land over by Little Edisto and into the Burrough. He was the administrator for this affair over there before Robert Hills. He rule from that big plantation house there just on to Little Edisto. He own all them people over that side. He do just how ever he want to do. Or he do so until I he meet up with Bubber Bailey. Bubber Bailey—his mother and my grandmother are two first cousin—he fill out one of them blanks, but when he went in to get his money, _____ wouldn't give it to him. He will just give him grits, butts meat, old dishpan and weevily wheat. might do like that, might fool the one on his own place, but not the man from off his place. Bubber Bailey blow the whistle on him: he complain against him to the government. That start the ball rolling and after a while, _____ take a pill and kill heself. After that, Robert Hills come in and administer that program—Edisto, Little Edisto, Parkers Ferry, Rantowles—all this part of the county. (*Bubberson Brown.*)

OYSTERS AND THE OYSTER FACTORY

That Doctor Greenway who bought Sea Cloud plantation and the Townsend Place, Bleak Hall, he has places in Connecticut, and a rubber farm in South America too. His son wouldn't even stay here. He came through here once on an airplane and landed on the beach, then he went away again and we will see him no more. He comes and goes between his farm in South America and his place in Connecticut. They have too much money. They don't know what to do with it. But they themselves don't do nothing; their money does all the work. The Greenways are all millionaires.

Doctor Greenway came in here during the Depression, around 1930, and bought up those places. He built his house on the Townsend place, Bleak Hall, after he tore down the old plantation house. The Townsends were dead broke and he bought the place pretty cheap. It was the Townsend daughter who ruled the Townsends then. They could have kept the place, paid taxes and all, but they

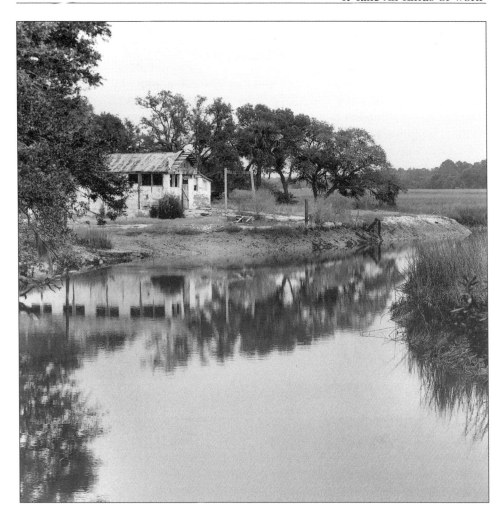

didn't want any fuss with their daughter, so they let the assessor come out and go over the place and they mortgaged it for thirty thousand dollars. During the Depression they couldn't find that kind of money, so they let the place go and Doctor Greenway got it.

It was all sold except one piece right next to the sea which still belongs to young John Townsend. He's a doctor in Charleston.

I remember his old granddaddy used to sail in a sailboat all up and down there where we would fish. The colored people used to fish plenty back then, but we didn't use boats for that. Each person had his own catch. He would use a cast net back in the creek. And there is an inlet over there where old Mr. Townsend used to be sailing called Jeremy Inlet, and another one further down called Frampton Inlet. In those inlets you could catch fish by the load at certain times. And if you went out on the beach there you could fish for sea bass in the ocean.

For sea bass you use a long line, swing it round your head two or three times, then let go, and it will sail out way beyond the breakers and you can catch those

bass out there. Maybe two or three in a day—that's a cart load. Big old bass! Red channel bass maybe five feet long.

I have caught him many times out there on Edingsville Beach. By now that's about the only place left where you can catch him, because a bass is a scary fish and the people have scared him away from the beaches further down. You can't catch him where the real estate people have developed the place, you must come further down this way where the people aren't mixing up the water.

I'll catch me one about three feet long, fry that fish up, peel him, put him in a cool place and you have a month of fish there. After I get one meal off him on the table with rice or grits or something like that, I don't want him on the table any more, but every time I come in I get a piece and eat it dry, just so. Get a little bread maybe. Presently I will eat that whole fish. That's the way I like to eat fish. (*Sam Gadsden.*)

During those years Papa had an independent life. He gin his own cotton, gin cotton for other people, everybody, white and colored. He farm some, did some horse trading and things. That's the kind of life he used to live: independent. He used to make the nicest kind of blackberry wine, or sometimes cherry or plum. Fifteen gallon a year. That cherry wine, you put him in a keg and you don't need to fool with him. The older he get, the better he is. They wouldn't go to the store like we do now. No. He raise a pile of cows, he raise a lot of hogs, six or seven head. If he feel like it, in the spring he kill a large steer. They put it in a barrel then and salt it down, and all through the summer we had salt-cured beef, corned beef. We have plenty of meat and a pile of lard besides. And they used to go into the creek every week, the last of the week, pick oysters, get clams and crabs.

I got oyster a-plenty all over my door yard here, but they are half brackish. Don't even have to put salt in them when you cook them. You better drain salt out of them. So the old people walk all the way to Jenkin Bank, over on Seaside, two mile for oysters. Big ones, and they aren't as salt as they are in here. Jenkin Bank, that is just done now. It used to be the biggest bank of oysters any place around here. And each oyster near big as your hand—have a lot of meat. They didn't bring them back in the hull either, no. They would take a knife along with them, shuck them right there, bring two, three gallon back here. It's a long walk, ain't going for no one gallon.

My old grandmother raise many a children on them oyster. People go in there on Saturday. They come from all about with mule and cart and get a load. That bank seem like was everlasting: the more oyster we take, the more come. But gone now. The ocean break in and spoil all that oyster bed. Two years ago I been in there, get oyster. I gone with a bunch from here. All I could do was stand and look. I walk about and just wonder. The others gone a way up, a mile up the gutter to find anything like fish or oyster. There at Jenkin Bank wasn't nothing but dead shell and sand. Jenkin Bank on House Bay, big bay in between Bleak Hall and McConkey beach. Each storm, ocean come in, come in, eat up beach, carry away land, house and all. Ain't be long before ocean be up in Murray. I got land up in

there, beyond Murray, up in Legree. Maybe I ought to worry—sea coming in. But what can I do? I ain't a worry about that.

A oyster is delicate. How you reckon they keep them all the week, all that three gallon of oyster? Maybe they fry them, or if you cook them and dry them maybe? Must be they open them and fry all up. That way they got oyster to eat through the week. You couldn't find no better oysters than we have. In those years, Papa keep us living well. (*Bubberson Brown.*)

My mother die in nineteen thirty-eight. Daddy marry again in nineteen thirty-nine. He marry a good wife. He had the ten children, and she had some. She had been married before but her husband die. I am glad to call her mother and all her children she had call me brother. My father was a good provider. He never was troubled with being out of work—a strong man. He work right on through until he was eighty-six years old and then he died. That was in nineteen and fifty-four. Even in his old age he would go out and pick oysters for us.

Oysters have been bringing money to this island. They pack them right there, that is the Oyster Factory right on our place, right there! Now! Ship them to Washington, Baltimore—all about. See him? Right over there. Do you want to know who built him? I was the one; I am the man built him. I built him the first time he ever built! Old John Flowers start with the oysters around here. The place where he got his start was over on Yonges Island. They were there for years at that factory over there. He did well enough so he got some money together and wanted to invest it somewhere, get out on his own. He sent to see about starting a factory here. He just came and hunted up a piece of land and built a factory where he could shuck full-grown shell-oysters, and not just deal in seed oysters. Those raw shell oysters are worth more than any seed oysters. Seed oysters are nothing, but for raw shell oysters you pay all of nine or ten dollars a gallon.

He hunt around, look around for land to put that factory, want to buy up the whole place! Peter's Point, all about: nobody won't sell none: they don't know him. Until finally Papa sell him some. Sell him that land on the creek. That was right before I went off to New York, nineteen and twenty one, twenty two, along in there, and we built the factory. We build him out of wood the first time. After a while the government health inspector have him to rebuild all in concrete, how he is now. When I say my old man sell him the land, he ain't out and out sell him. Give him a lease. Lease him ninety-nine years and one dog day. The land still in Boston Jenkins' name. Boston Jenkins wife kin to Peter Brown, my granddaddy. We keep it deed right on in Boston Jenkins name. Boston Jenkins have one son, come down from Baltimore years and years ago, look at the land: he don't want him, tell Papa to take him. We pay tax on him right on in Boston Jenkins' name. When John Flowers take over, he agree to pay tax in the same name. Not only that, they promise Daddy they give him two cent on the bushel for all the oyster they pick. Promise me too. Four cent on the bushel coming our way for a couple of years. Then that stop off. That just a dry mouth promise. Had been writing now, we could enforce it. But now, the way it is, their word is as good as ours.

The first man John Flowers get to open that thing was of the name of Eliot. He come here from Mount Pleasant with his sons and he was going to build up the oyster factory. It was a long time before I know the place wasn't Eliot's own. He was there while we build him. That first day, Eliot get down on his knee, ask God to bless the ground, crawl all around on this ground and pray God to bless this spot. Boys all da laugh at him. I been right there, see that with my own eye. Eliot, he come all around here, try to find oysters, and when he find them, try to find a place to sell them. But he couldn't make it pay. He and his son gone to build boat in Mount Pleasant after a while.

The second man come, a little short man from around Rantowles. Man name Schultz. He couldn't make it pay either.

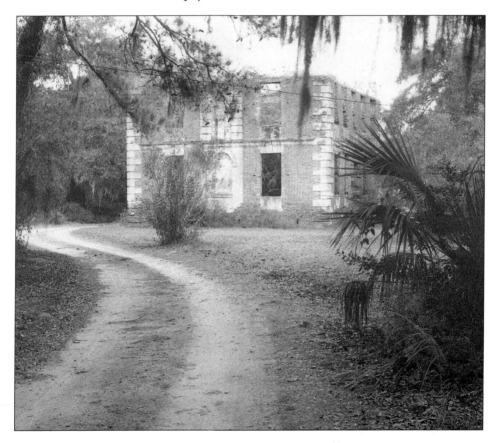

The third man was name Frank Donney. John Flowers get him out of Baltimore where he come from hisself. It was the same story with him. He try, he try, but when he have oyster, he ain't got the place to sell them; when he got the market, he ain't got the oyster. Me and my buddy, we pick oyster, pick oyster, get up a full-to-sinkin bateau full of oyster. Frank Donney come around in his truck. Been a gang of boat. He take up two, three boat load. Come to us, "Sorry boys, I ain't go no place to sell them," and he gone. Nothing for you to do but dump them out in

the creek somewhere where they stay fresh and pick them up again sometime, if someone else don't do it first. He don't pay nothing until he take them, then it's fifteen cent a bushel. Frank Donney ain't do no better than the others. He pawn the house, pawn two boats. After awhile, he gone.

Then John Flowers came himself, and things started to happen. There was an army of men he brought in—whole place crowded with men. From Beaufort, from Yonges Island, from Saint Helena—from all about. And he made it pay. There was forty-eight men in that crew. They will take all the oysters you can find, and they will sell them. He sell them to restaurant, hotel, store, and all. Besides that, he open up shop for himself, have that place on Folly Beach. That factory had been running strong five or six years already by nineteen and twenty eight. They worked women inside the factory. Each woman could shuck out about fourteen or fifteen gallons and she would make maybe seven or eight dollars in a day.

Old man John and his son Steve, they are the one! Old man John, he die nineteen fifty-four, along in there. It his son Steve run the factory the last twenty years, he—the boss. But back before, he used to go out in one of those big old rowboats, pick bunch oyster all along the creek just like anyone else—go to Yonges Island, Little Edisto and all. He get that gasoline boat, tow them other boat behind. He gone today, come back tomorrow—I mean he is going to get some oysters. Cold work too. He is a good boss man. I don't want no better man to work for.

I have been working for Steve and them right on. You see all these boats he has around the Island? All the crab and oyster bateaux? I built them. I am the man built them. I work for him right now. It's July now; I'll start in during August and overhaul all his boats—I work on my own. I don't have any boss nor no foreman, I go to work there, knock off when I'm ready, keep my own time. I just tell them what I did.

Have a big boat call the Westwind. Mrs. Flowers and all been live right in that boat. Keep it moor tight against the shore. Ain't a working boat, that boat just for live on. Have him fix up for living—bedrooms divided up and all. They cook on him. Have a light by the post: you could jump on him in the night, know he is right there.

They are out on the ocean right now with a big boat I repair for them, the *Lela Irene*. Steve gave her to his son and he can catch more with that boat than any of them. Man that was policeman here, live over on Little Edisto. Armstrong, he own that boat. The storm of fifty-nine come and put that boat up in the woods. Lay up in the woods two year after the storm. When he put him back in the water, decide to change the motor. Put a four-seventy-one diesel motor in there and it can pull just like a tugboat. Had to cut the pilot house all off him to get that motor in big old motor, get him new brand from Baltimore. I have a grandson of that same Walter Brisborn that teach me carpentry to help me. Every day we steam up plank on the dock there, have a twenty foot box, keep them board hot in there where we can bend them on the boat. Keep a fire under a fifty-gallon drum of water there, run the steam up into the box. I repair that boat from start to finish, put extra frames, replace plank, up one side and down the other.

He has another boat there he calls the *John Junior*. Nice boat! It float just like a duck! You see the waves twenty feet tall, other boats done run for it; that boat used to ride right through. Only he let it get bad: rotten all down one side. It is the best boat he's got: there is no sea can put that boat under. But it has gone down bad. There were some bad boards along the bottom and they hauled the boat up, had me to work this side. Then he was going to let the tide rise, turn the boat on the finished side and let me work the other side, only he never did do it. After a while they had to take it off the ways and pull it up high on the bank, left it there until it rotted. Now he says he's going to make a cement boat out of it. I keep telling him I don't know how to make no cement boat. "If you want to do that, you do it yourself, because I don't know how to." How is he going to do that? He has got to use a lot of steel rods and wire mesh. Double that wire in there and that cement will be stuck in between that wire, maybe form it up inside the boat he's got. Then after that cement sets up you could tear the boat off of there in pieces. But who is going to go to all that trouble?

My daddy and them get them big, single oysters. After oyster factory come here, it mess up those oyster, settle the oyster for good and all. They take and take and take and don't put back. It take six years to prove up an oyster if you plant the fresh shell back right when you shuck out the oyster. Every year the Government give them money to do that. That way would be oyster a-plenty to this day. But you ain't know how many of small oyster throw away in that place. Ain't keep but the big oyster, wash them small oyster away with the shell, let them go down that chute. Then they let the dead oyster and shell lay there day after day, then after six month or more they dry out, then they sell that shell. Some they plant back, yes. But they sell off a whole bunch. Bad business. You in business supposed to be a businessman.

I used to pick oysters too. Didn't get but fifteen cent a bushel. That was around nineteen thirty-nine, nineteen and forty. I used to come home a way in the night, and dog if I didn't come from some far places some nights! First I change clothes, then walk ten miles back home, let my boat stay a way down on a point somewhere back of the beach. Sea Cloud, Wilkerson's Landing, Murray. And I had to walk too, or row that boat back—didn't have a motor. Walk five, eight, ten miles out in the morning, start before day and don't come back till night. If I'm lucky I might make six dollars, or eight. But before I could get that, I had to take a boat load of oysters around to the factory and unload them too.

That was cold work. I remember three of us one day, and we had a boat at Bleak Hall, over beyond Murray, that's about four miles east from here. Big old boots—you couldn't wear them and walk all that way, so you tie them together and sling them over your shoulder. We leave from here in the dark, I and John Adams and his brother, Charlie. It was long before day. We get over there about daybreak and get out in the creek. A big old sculling boat—you would row it with two big oars. If we were lucky, each man might make five dollars. We got out there and it started in to rain. Got so bad, we pulled that boat out upside down against a tree, sat under there for the weather to change. Day pass. Get dark. We ain't pick

the first oyster. Wet. The clothes stick to us from head to foot. The boots, sling them on one shoulder—they fill up with rain. We pass Henry Eubanks' store; we get a jar of whiskey. Three men for one jar of whiskey. That was cold work.

One Christmas week Old John was in trouble. All them boys gone back to Saint Helena's, or Beaufort and all—gone back home for Christmas. Me and Lucas Morgan the only ones lief to help him then. He want them oyster bad. Order pile up, pile up and ain't but we two left to pick. Sunday night, I gone to church meeting, stay there until time to get to Lucas house along about day clean. I leave from the meeting it still black dark. I walk to find Lucas house. You go on down Fess Road. That road all crook up down there after you left the main road, get down in Murray, road twist, cut back on heself, cut back again. Black dark night. Directly, before I know it, I lost in the wood. Try this way, that way, move on steady. Crawl on my hands and knees at the end, come out by Lucas house. We gone out. What a early tide! Four o'clock in the morning. We could pick already in them gutter on that side, been a plenty around there. We go from Townsend beach a way down to Jenkin beach. We get him load and load again of oysters. He pay us good, raise us up to fifty cent a bushel. But ain't give us no gift. Ain't give us nothing but a praise and turn us off with that.

You pick oyster, and the night is trouble. One time me and Primus been out in one the old boat. They make with big hole six inches down on the stem you could put your hand through—for tie the rope. We pick oyster, pick oyster, pretty soon, boat most full up. I be sculling the boat, Primus get the oyster. In the darkness he throw the oyster forward, he throw, throw. Boat been low in the water anyhow and he want to level him out some—old boat and ain't been much of it stick up above water nohow. I know all that, so I keep him close to the bank all the time, close as I can go. But we ain't think about that hole up in the bow. Water start to pour in there; we ain't know it—dark: can't see. We get along all right until up near Cornish, and all of a sudden I feel the water rise around my feet. Ain't think two time. Jump for shore. We wade for shore. Lucky for us it nice there: hard, sandy beach. We can't do nothing about our boat and oyster there in the night. Come back next day and see: boat float upside down. Bog hole there in the creek. Can't touch bottom—all our oyster gone, gone. All dump in that hole. Lucky for us, we ain't drown.

I didn't have to do those things. I just got to be myself. I just got to be a man. But I could see very well that I couldn't make any money at it, not enough to raise any family on. So I didn't bother with that much: I made my living as a carpenter. (*Bubberson Brown*.)

STARS IN MY CROWN

Forty head of children. One time I try to work forty head of children, and they like to worry the life from me. Forty people? Better say savages. Them children—savages. Baddest kind, sinfullest kind. I work, I have so many to try to work, and they worry me so! I try to turn them to do right, watch over them, chastise them.

In nineteen forty-five, forty-six, Mike Knight got me to farm for him, got me to run his crew for him. I work for him on Nelly Whaley place. He rent all that land. Both sides, round and round, clear on to Clarkson, and part of Shellhouse Plantation. The only place I skip is Mack Hutchinson house and yard. Make melon on the east—that the only thing I could plant on that side. Make green, all kind of winter crop on the rest of the land. Mike Knight—a man from New York, my cousin. I used to haul cow for him too. Mike Knight daddy, that all he do is buy cow for the Jew. Mike ain't never do any of this farm work his own self. Come down and watch us work sometimes, go off, hunt squirrel, fish and all, and then go back up north. He send his trucks down when we have the crop ready, carry to New York. That where you make the winter money at. Vanload after vanload. Just get em

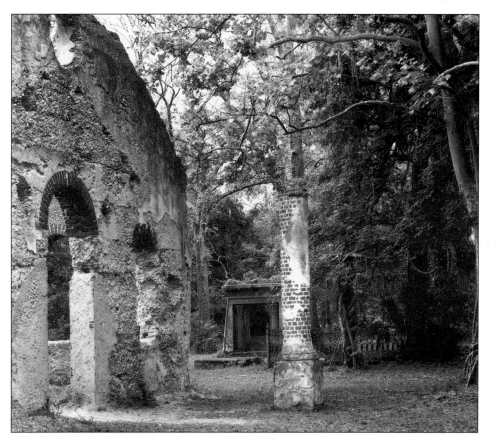

up there and they will pay you what you ask. We got to get them green out when they ready—that our task. Carry them over on the mainland to Hollywood by the icehouse there, repack them, ice up that van, send him to New York. Sometime it be two o'clock in the morning before I get back home. Work and worry so, ain't eat a bite all that while. I thought I was made of steel. Cold, heat nor hunger couldn't bother me. I work forty people for him there. Mostly children. I have maybe six head of older people too. I let them lead the children—Eloise Knight, Emma Scriven, Eloise Daise, some others. Six head of grown people. And Wally Scriven help me some. Besides working the people, I got to count every dollar I spend and put on a big book. Eloise Knight, she help me keep that book.

It was all hand and mule work. He didn't use any tractor or planter except after I had to quit work. I the onliest one to cut ditch bank, line out work, that all fall to me. I go there with my lunch, plenty of it there in the bag or in my lunch pail; I can't eat a bite. Bring every bit of it on back home in the evening. Them children run me most crazy. They mostly fourteen, fifteen years old. Pay them about twenty cent a bunch, it might be rutabaga, it might be turnip, it might be rape. Rape? Yes. I never hear of it before that. A kind of greens. Up the country they used to farm them for cow. Come to find out they good for people. I eat em too. Good. Mike Knight would have them, and corn and other crops. We had to wash them, bundle them, ice them and then pack them in his trucks so he could ship them up to New York. He had some crop coming out all winter long. First one thing and then another. And them children fight, fight, fight. Boys and girls both. They thief, and cheat, and destroy the tools and things.

I get to studying about that, about all the trouble I been to my old man. If they bad, ain't I been bad too? I do some turning round my own self in my day. So I was due to have mercy on them. But that was forty-fifty head of them with only maybe once in a while an old woman or an old man, and I the onliest foreman among them.

One day I come home, it was Saturday in the big day. I come, I lay down in my bed, and I wake up in Roper Hospital. That was in the month of February in nineteen forty-six. Working in the ice house that way I got a very severe kind of pneumonia. Not just pneumonia but gas. I had gas all through my whole entire body. I got so thin I only weighed ninety eight pounds, me that weighed a hundred and seventy when I got married. By now I'm back up to a hundred and forty, but in nineteen forty-six they give me up. I was in a coma in the hospital, ain't know nothing for a week's time. Them forty head of children—tarrify the life from me so!

I gone in in February, come out in March. People come from New York and cook for me, care for me. My sister in law and all. They come to feed me, fatten me up, cook greens and things. They think a whole lot of me. Mike Knight come too after a while. He had bought a patch of greens from Solomon Brown. He want me to go on with the farming work, carry me out to look at that crop. I weak as water. I ain't even get out the truck. I talk to him, give him some good advice and like that, but I work? No sir! Not like that no more. It near about kill me the first time. He see me, how I was and let it go at that.

When I came out, a doctor there put me on disability. Some kind of relief. But what the man was going to give me on that disability was just twenty-five dollars a month, and my wife must go to work. I told him, "My wife can't work. She don't have to go in nobody's kitchen, nothing like that. I ain't well enough to farm, but she could stay there on the farm."

Then he said, "It's up to you. What are you going to do, Willi Yam?"

"Twenty-five dollars? That's all"

"That's all we can do, Willi Yam, and, ah, your wife, ah, Henrietta must go to work."

"I don't know about that. I couldn't tell you about that. Because I have been married a long time and she ain't had to do it. And I don't believe she will. Not like that. She ain't had to do nothing like that."

"Well, Willi Yam, I leave that up to you. I have promised you twenty-five dollars and I don't see how we can give you any more."

"Well. That's all right then. I wouldn't bother with that. I'll try to make it." And I left him and went back to work.

A man on the beach, Mr. Sutcliffe, he hired me for work. His work was mostly in the early summer, before those people move down on to that beach. I couldn't work steady and only once in a while I made a full week, but even so I brought home forty dollars, or if I'm strong, sixty dollars. That's in the week! And there that welfare man said I wasn't fit but to stay home and get twenty-five dollars a month!

I work for Mr. Sutcliffe three months. Then I went to work for Old Man John Flowers by the start of the next year. In January they had the *Cap'n John* ready for me to work on. After I finish with that, I build on to the store Old Cap'n John had on Folly Beach Road, then I build the Edistonian for them, that store they have down by the beach. Then I added two rooms to the Oyster Factory building. I did all that work. I took on every kind of work they have on this island. Good I didn't mess with that twenty-five dollars. Of course I didn't! And my wife didn't have to go to work. I never did mess with nothing like that. What I need, I do it myself.

In nineteen fifty-nine we have a storm, Gracie. Been a dry storm, not much of tide and not much of rain till later. He ain't last like the nineteen eleven storm, but he strong. I weather him all right, here in this house. After he pass on by, I gone to help this one and that one fix up the place. Sometimes it ain't nuttin but put on paper. I gone to help a lady fix her house, Miss Emma Appleton, colored lady. The Red Cross will pay for that job. They bring the material right there to you. Man come out from the central office, he give me a sheet, I check off just how much tar paper, how much lumber, sash, nails and all. I check em off and send it in to them. They got their own truck, bring the stuff right there to Miss Emma Appleton house. He had ask me for my price. I been at that work a long time then. I knew how much time it will take. They send the material but they will not pay you for your labor until you are all done. Maybe they got burned before when men will begin a job and not finish it, or run off as soon as they got the money. But mon! That work a hardship on me!

I work, work, work, pretty soon we are out of food back here and the job ain't done yet. What I'm going to do? The old lady who the work is for, she can't advance me any wage, cause it ain't none of it to her account. And Red Cross? They won't give you a dime, not till you finish. The way I am, I had rather work for little or nothing as to say I can't do it or quit with the task half done. I finally gone to her, borrow twenty dollars against that Red Cross check when I get him. I thank her for that. She give us rations that way until I could finish the work.

Inspector come out from his office on Wentworth Street, he give the job his approval. I get ready and gone into town, eight o'clock next morning on the bus. Bus go out eight o'clock, come back two o'clock. Charlie Johnson and James Reed run that line then. I gone in town to get my check. Why he ain't mail him to me? No, but I must make that hundred mile trip to get him. Inspector could have come out and okay him, go back and have them mail that check to me, or could have fix him up ahead of time so he could have that check in his pocket and give him to you right then long as he satisfy with your work. But no, I must go there. I gone,

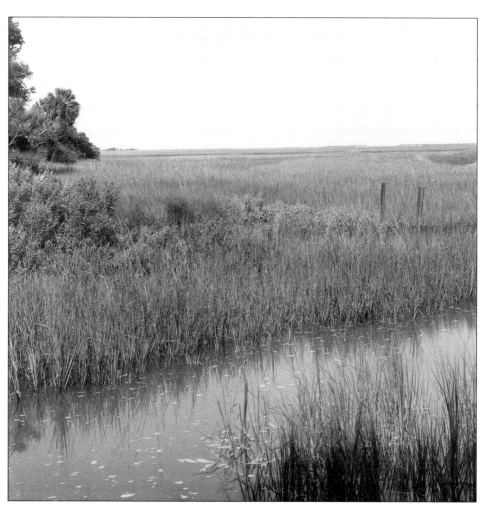

carry the account and they give me a check. I carry that check down street to a grocery store they have there right below the Red Cross office, corner of Wentworth and Coming. Cash that check and buy what little groceries we need, leave them groceries there until the bus come. I ain't going to carry them all over town. Gone away from there, gone on around, walk one block on to Beaufain to my daughter house. I could rest a while, cool out (and my but it was hot! Sun hot, hot, hot), spend the evening until two o'clock when the bus come. I count up, count up—Oh my Lord! Twenty dollars missing! Count again, yes. Well where have I been? Must be I leave him at that grocery store: ain't been no place else. That just the twenty dollars I borrow from Miss Emma Appleton. If I tell her this story, she will never believe me. She will think I am trying to pull a trick. Some trickster wait till people old to go around, try to rob them. Old people? I had rather care for him, work for little or nothing.

"I'm going back to the store, see if I leave him there." Ain't no further than here to the road, less than a block.

The man that run that store, I tell him the whole story, got my receipt and the stub of the check right there in my hand. He recognize it. He got to recognize it. He listen, say, "The best man will make a mistake once in his life," and give me a twenty dollar bill. I bless that man. What a trouble he did save me! I tell you the Name truth now: you got to hunt a long way, have a devil of a time find a man that straight. That's a nice man.

I get home, gone to old lady, pay her twenty dollars back that same day. I ain't a stop that evening till I put that back in her hand.

My daddy and granddaddy used to trade horses. I used to do some horse trading too. When I was born, my granddaddy had seven or eight of all kinds of horses. He used to keep on buying horses. When he died, my old man got about three of them. He would buy and sell, buy, sell and swap until he had a lot of them. He made money that way. I remember the kind of swap he made when he was lucky. He had a stallion; it was the last of the Old Man's own breed which his daddy had developed. My grandfather developed a breed of horses. That breed was here since I was born. After so many years it fell into another man's hand when my daddy swapped off the last horse—a stallion—for a nice-looking grey mare. Even so, it was a lucky swap. It was in nineteen thirty-nine, after Papa had married for the second time. The other man had that nice-looking grey mare and my daddy swap his stallion for that mare and one of the mare's colts. Keep them a while and she drop another colt, a mare colt. She was white and my aunt name her Baltimore. What a big white horse she grow in to! Man ain't know that mare been with colt. Daddy got three horses for one. He paid seventy-five dollars boot, but still it was fine horse trading.

When my daddy died, I got a son of that mare, and Baltimore, and then I went and bought another mare my own self. Neither of those mares ever did have a colt. That big Baltimore live with me fifteen years until she get old and die.

Last of me and horses was a mule. I went and bought an old mule here a few years ago, in nineteen sixty-eight. I got that mule and an old cart from Bunch

Heyward, used to live over there on Shell House Road. I didn't have the mule but a month. Been most done dead when I buy him; I ain't going to pay no more than fifty dollars. It was a poor mule, but for what little farming I was going to do, like clearing some garden and stuff, I could have used it. One day I tie him down by creekside, by the flat gutter here by my house. When I get there he done drowned. That's that. Done dead. Benjie, my son that lives right over there, he bury him right there. I said, "Aww shucks. I ain't going to buy no more horse." He got to pay his way and I ain't going to farm no more. I can't feed no horse out of my pocket.

Benjie, he was born in New York, nineteen twenty-eight. When he was three, four months old he got infantile paralysis. We took him into the hospital; they furnished him medicine and all. He ended up with one shrunk leg; he couldn't use it, he needed a special shoe and all. Then in Roosevelt times, they furnished

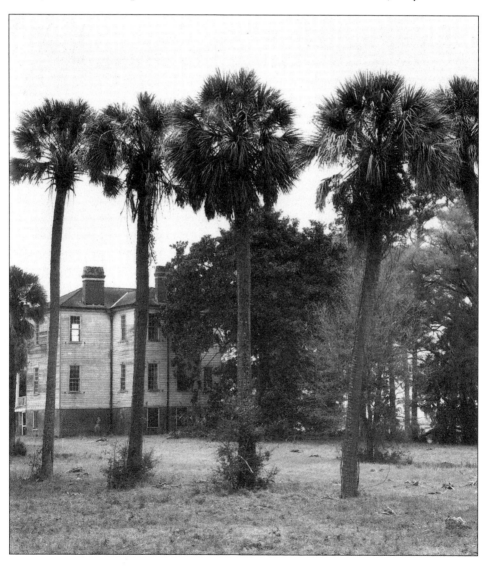

him with shoes, they gave him job training, job and all. Then after a while, he quit with that and went into carpentering. He lives right at the head of my road here now. He is a skilled plumber, carpenter, wire man—all. He can lay brick too.

I raised up my family. Before we ended up we had five boys and five girls—ten children altogether. Then, after they were gone, I raised up a granddaughter and a grandson. Raised them all the way from babies. She finished school here and went to New York. He is in New York this summer, but he will come back the last of next month. School opens here about the twenty seventh of August, and I think he will finish school next year. He is in the eleventh; what he's got is one more after this year. His mother is in New York, so I let him go in summer to his mother. He didn't take many of his clothes, just a couple of pieces, and he will be with his mother until school opens again. I want him to finish here and get the diploma from here before . . . before he goes for good. When he does finally finish, I think . . . think he is gone for good.

Those are two of my grandchildren, the one born here, and the other in New York. I brought them here when they were still infants. If I can get them to stay until they finish school, I can say I at least tried to do something. Have to try all kind of thing. Because it cost us something. When you go down and buy them clothes? Go down and buy them their books and things? It cost so much! Fifteen, twenty dollars at a time!

The man asks me, "How come you keep him here, feed him and care for him so? How come you want him to get a diploma from here?"

I tell him, "Stars in my crown. It will be a star in my crown."

I have forty head of grandchildren, about fifteen great grands. They're scattered all about. Some are in New York. My oldest daughter lives right there. She has three boys. Her youngest is a first class carpenter, lives here on the Island. He works in Charleston every day. He takes the work right off the print, don't need no foreman nor nothing. He is one of them real special men. Yeah! Young, but oh boy! His other two brothers are in New York. One is a preacher and the other is in church work. My oldest daughter only has those three. But the second daughter has made up for her: she has eleven. And with two others, two brothers married two sisters, so they're afraid that family is going to range straight on out.

Care for your own, that's the best thing to learn or know. Care for you own people. I stay with mine—Daddy, Granddaddy, Grandmother, and all—until I bury them. I walk with them, I plant and plow for them, gather the crop. When Daddy ain't home, my mother work right with Granddaddy. Granddaddy, he crazy about them daughter. He plant six task of cotton for each of them, plant tater and all. And he cultivate it too. He care for us.

You must care for you own. My wife tell them children we need wood here, tell them cut wood. And then they ain't done nothing but slip off! My own grandchildren! You better believe I tell them a good warning. "I work for you, I care for you myself all these years. When you see me come to the place where I can't do it no more and your grandmother tells you, ain't nothing to do but go and do it." I tell them so. That's the best thing they could learn and know.

My wife goes up to New York almost every year, but I tell her, "You can make it better than I can." We get up there and I ain't going to stay in one place and she ain't want to go about. She wants to go to her sister's house, or her daughter's house and just stay there. I can't stay at anybody's house that long. I want to get out and go and do something and find out, find out. But now that I can't work, I just don't bother to go there no more. I used to go there, go to one daughter's house, stay there a week or two, then maybe to another and stay an extra week, and all that time I would be afraid of what it would be like when I got back home. I got arthritis and when I would get back here, Sheeeeew! I couldn't even walk! Heh! No, I don't think of going by there any more.

I could do it, I could work in New York. I have a first cousin there. I took care of her, minded her from the time she was a baby. She's the grandchild of Bella, the daughter of Christina, and the only one left out of her family. Mother and father and all died. She has come to own five houses. She can supply me with work there every day. I have been up there and worked as a carpenter three times since nineteen twenty-five, but by now it's too rough. You need a bodyguard just to walk in the streets.

My son-in-law who married my second oldest daughter—they have eleven children and he is the chef cook in a restaurant up there—he works from four in the morning until twelve noon. He lays out the work and all, then he can leave. Nobody knocked him in the head; he goes and comes and gets along fine. But not me. My cousin has a flat on Fifth Avenue I could have for good. Seven rooms. But still I don't want it. She tries to persuade me she ain't got a soul left living there, I am the closest family she has got—but I tell her, "No. I have just me and my wife, let us spend these, our own reposal days at home and forget about New York. That city don't suit me." Every time I go up there I got to send for some grandchildren to come get me. When I leave from there the last time I tell them, "Fare thee well—I ain't come back no more, for work nor play."

When you live in the country, you can help yourself. I raise hogs, raise poultry of all kinds. I have a big hog here, and one up yonder, she is in pig right now. She'll have pigs here in the next two or three weeks. I fish sometimes, but not this month. By next month the bass will bite. In August and September you can always catch a good fish. But in July, this time of year, you go out there, set down two or three hours and come back with two or three little fish. Why do that when I could go and catch eight or nine quarts of shrimp and put them up? I went out and got three quarts of shrimp this morning. I work around here all the time, go in the creek, come out with some fish or oysters. I take on little jobs here or there, yarn a net or nail up some screens or jack up a sill of a house. I keep on doing something all the time, make myself useful. If I sit down long, it gets painful.

This is better, home here. Me and my wife been together all these years now, sixty years. Long water run out me eye how thankful the Lord been to me! I sleep so good here, the world turn over. Like I sleep in that dark rain way back yonder, I was a boy. Such a terrible thunder shower. Middle of the afternoon, it was a Friday. Dark, dark, dark. That same time lightning strike a woman, Old Man Lestin

daughter, over the other side of the creek. I come in the house, my grandmother house. Lay down, gone to sleep. Done night time for me. Later on, I wake up, sunshine, bird sing. I get up I gone out, start my Saturday work. "How come? Sun in west? World been turn upside down while I been asleep." But they show me: sun in the west cause it still Friday. I done the same today. Sleep so good, wake up at two o'clock this afternoon, I figure I done sleep around the clock, couldn't make it out no way, got to call my wife in here, "Hey, old woman! Come here, get me some sense into my head!" She must tell me what day it is. Sleep so good the world turn upside down.

And now I have been living here for the last lifetime, a three and three quarter, a four score of years, a quite a while. I ain't been up to New York from Edisto now for over two straight years. That's all. (*Bubberson Brown.*)

Chapter Five

EDISTO ISLAND
PORTRAIT OF DIGNITY

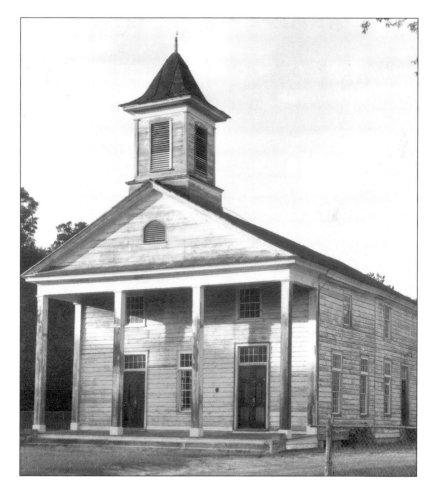

Jesus,
hide me
in a sacred place.
(Traditional Gullah Prayer)

Rose Robinson, grandmother of Eloise Robinson Tolbert, *c.* 1890.

Albertha Robinson, Eloise's sister, New York City, *c.* 1920.

Lafayette and Eloise Tolbert, New York City, *c.* 1930. (The photographs on this page are courtesy of Jenny Beldoe.)

Eloise Robinson Tolbert (1904–1998), Edisto Island, *c*. 1994.

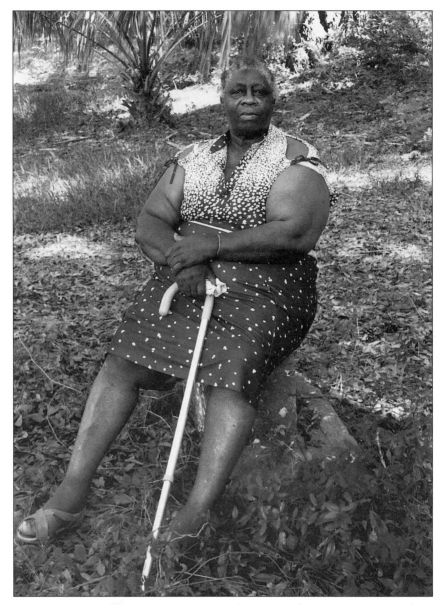

Sarah Pritchard, seated on tabby remains of her grandfather's cabin at California.

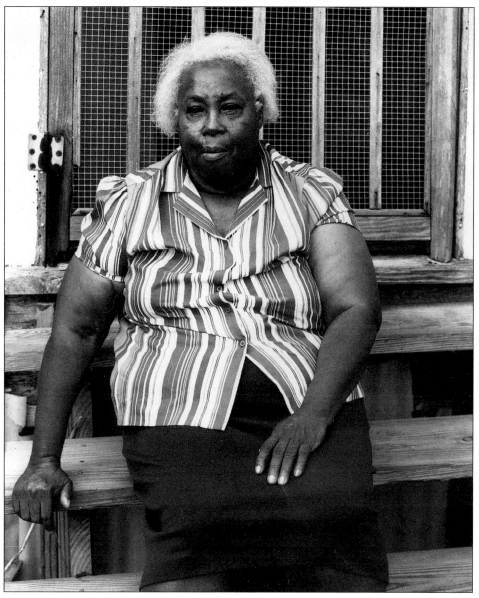

Natalie Reed, raised up by Sam Gadsden.

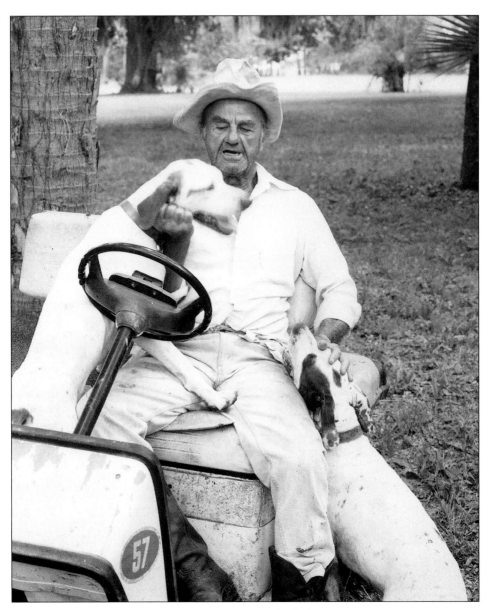

Burnet Maybank, Mitchell Place.

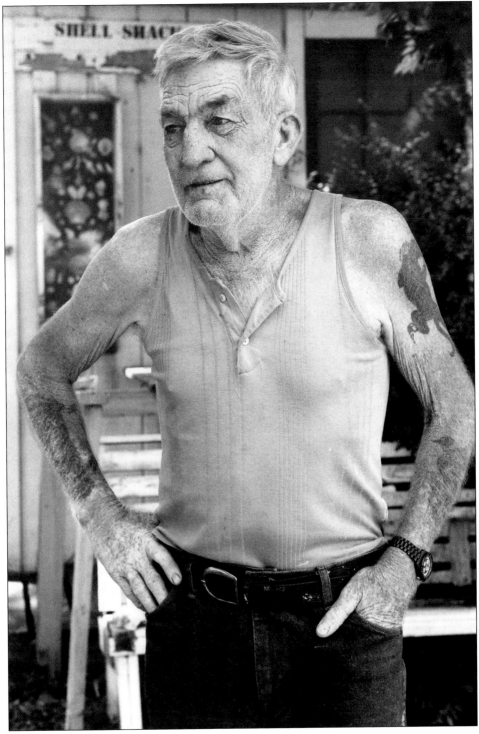

Red Meade, Meade's Boat Landing, Framptons Inlet.

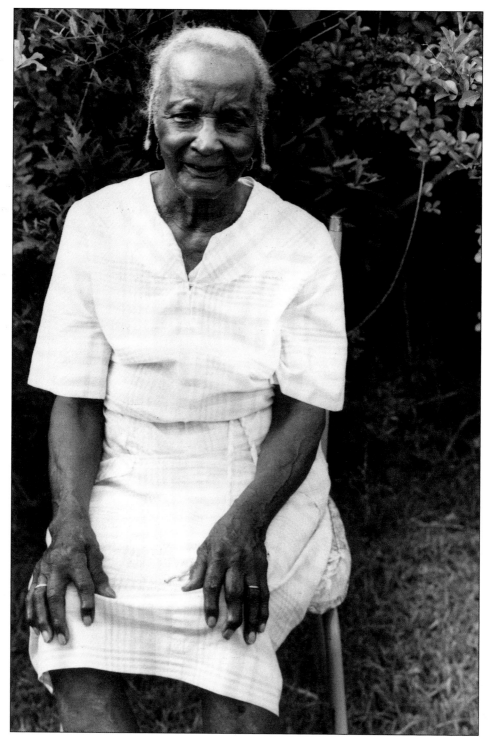

Edith Wright.

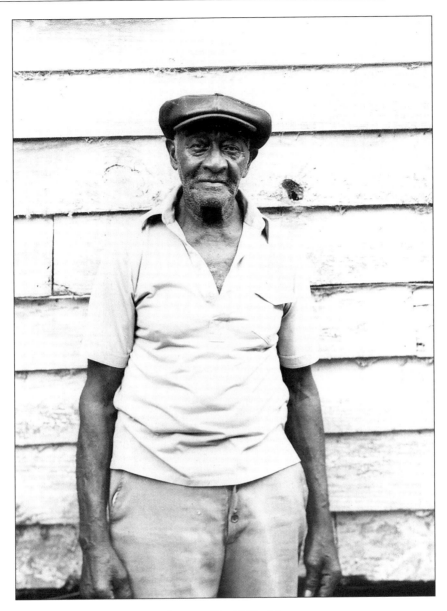

Deacon David Fludd.

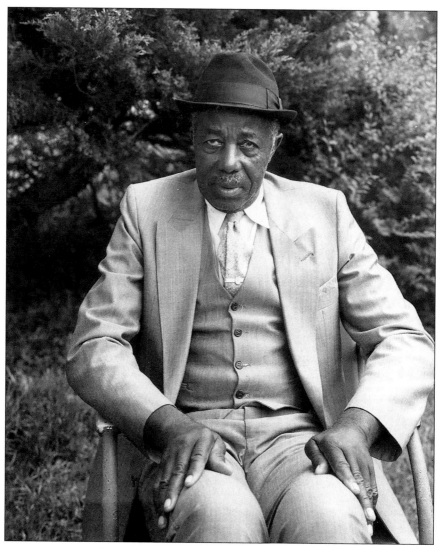

Isaiah "Ike" Hutchinson, Jim Hutchinson's grandson.

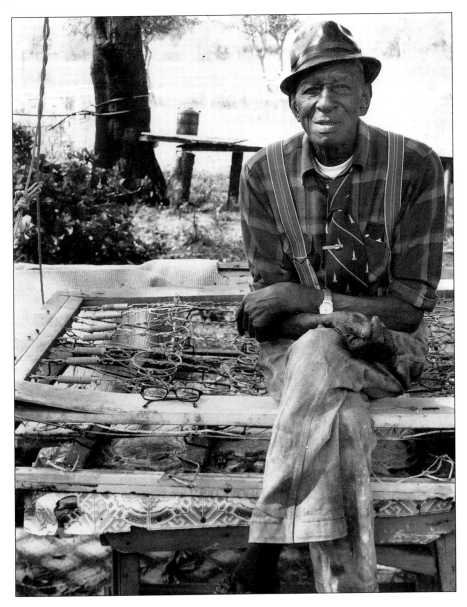

Domerator.

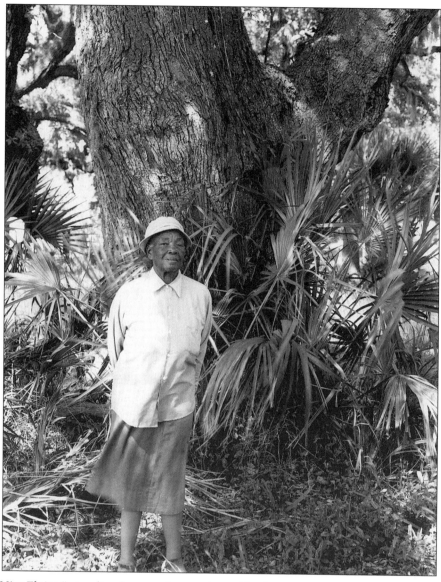

"Miss Eloise," standing by an oak tree planted by her grandfather at Mitchell Place.

"Miss Ella" Seabrook (at age 99), holding portrait of her grandmother, Carolina Lafayette Seabrook, named by General Lafayette when he came to Edisto in 1825.

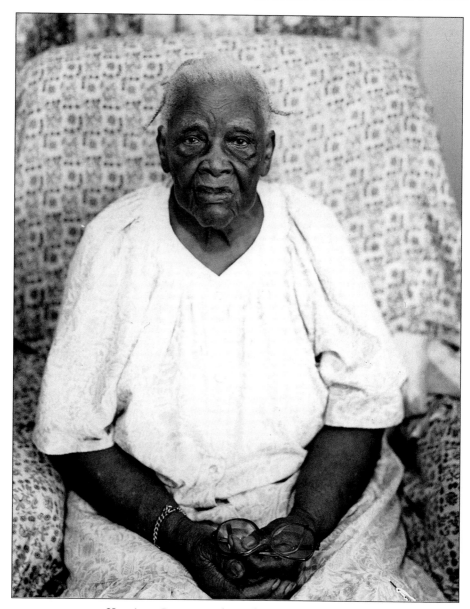

Henrietta Brown, widow of Bubberson Brown.

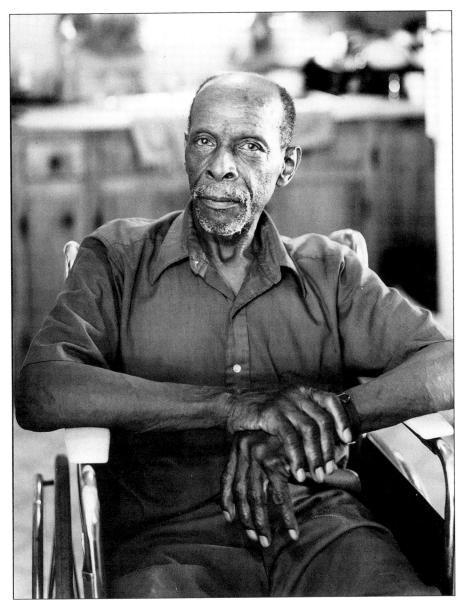

Benjamin Brown, son of Bubberson Brown.

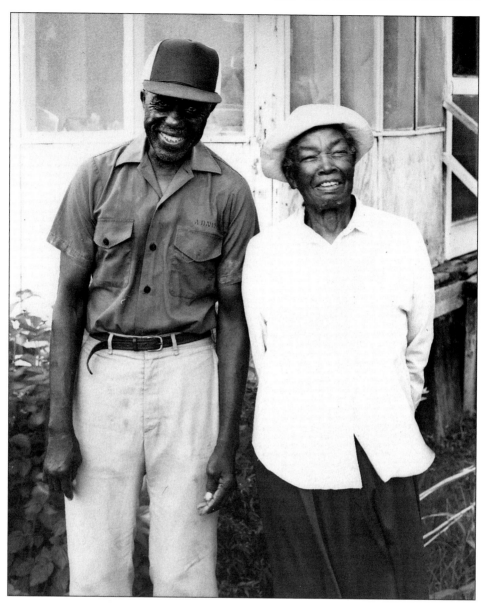

Ike and Eloise, cousins.

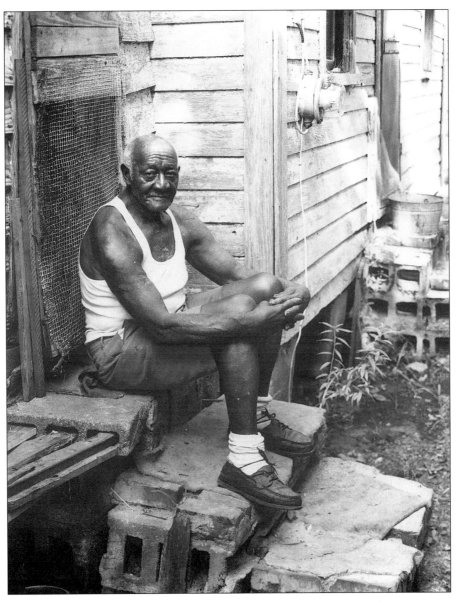

Deacon David Fludd, sitting in front of the house he built.

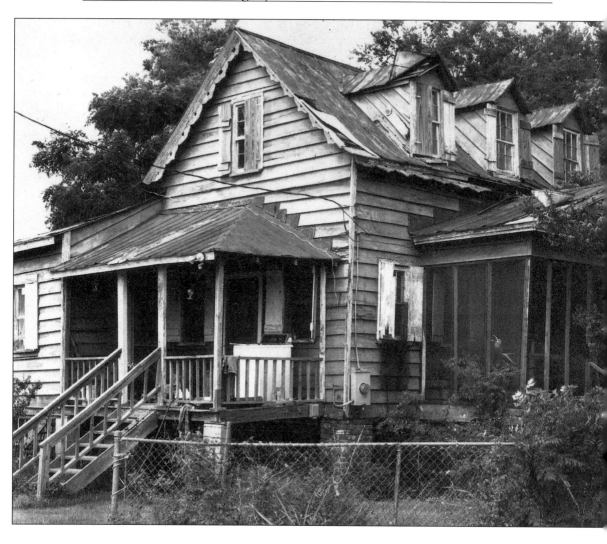

Hutchinson House.

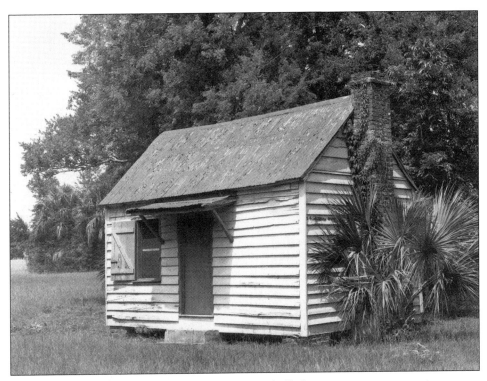

Cook's House, Mitchell Place.

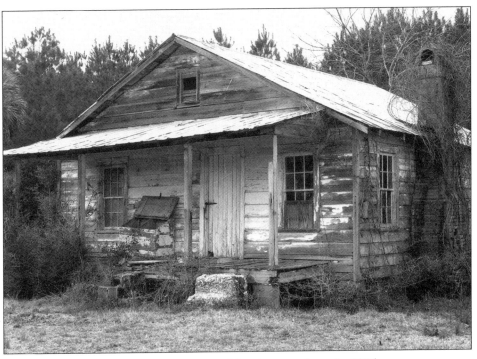

Jim Milligan's Cabin, California, torn down in 1996.

189

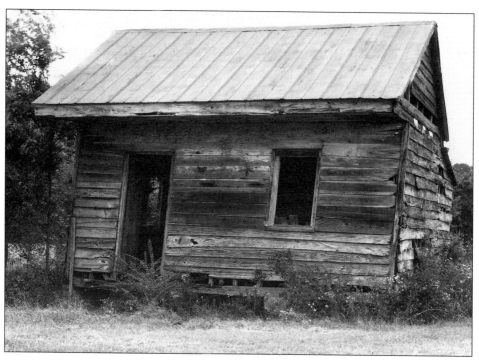

Meggett's House, Mitchell Place.

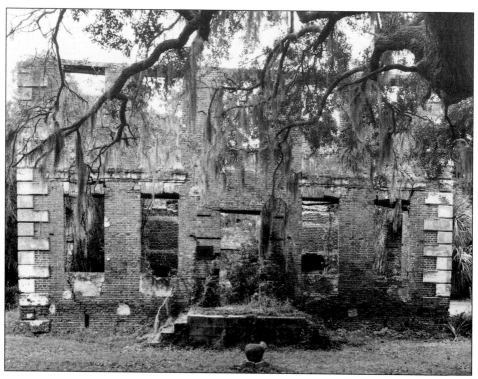

Brick House Ruins.

PHOTOGRAPHER'S NOTES